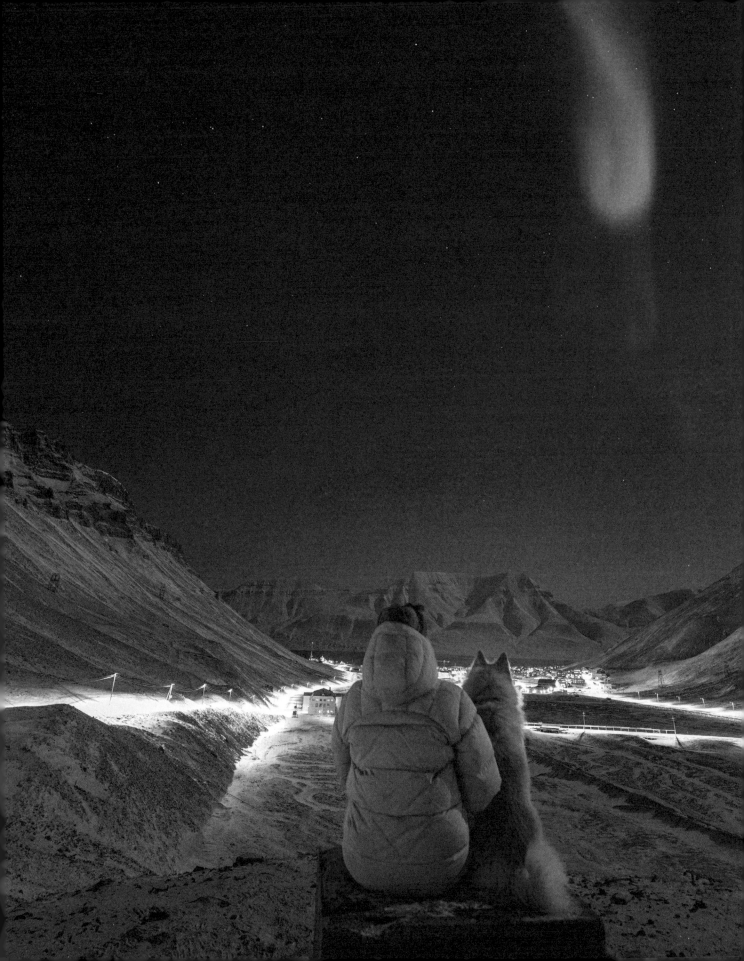

Life on Svalbard

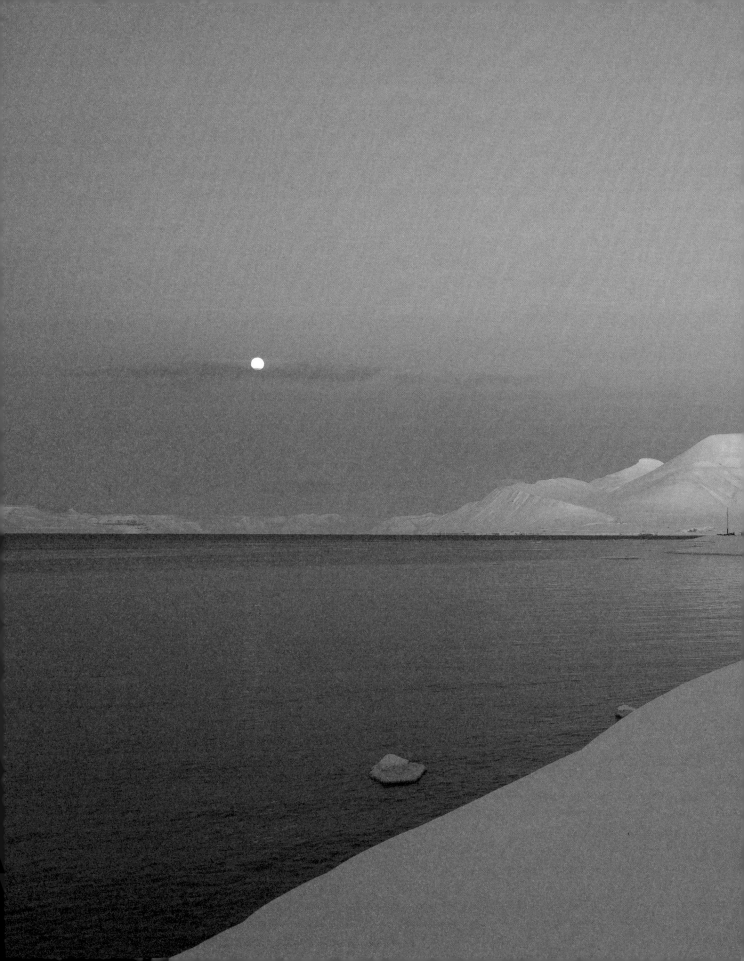

Life on Svalbard

Finding Home on a Remote Island Near the North Pole

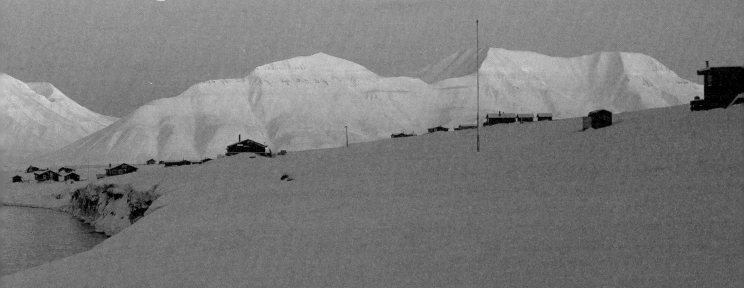

Cecilia Blomdahl

Publisher Mike Sanders
Executive Editor Alexander Rigby
Editorial Director Ann Barton
Art & Design Director William Thomas
Assistant Director of Art & Design Rebecca Batchelor
Photographer Cecilia Blomdahl
Illustrator Claire Rollet
Copy Editor Cindy Nguyen-Pham
Proofreaders Tiffany Taing, Monica Stone
Indexer Johnna VanHoose Dinse

First American Edition, 2024
Published in the United States by DK Publishing
1745 Broadway, 20th Floor, New York, NY 10019

The authorized representative in the EEA is Dorling Kindersley
Verlag GmbH. Arnulfstr. 124, 80636 Munich, Germany

Library of Congress Number: 2024934358
ISBN 978-0-7440-9509-8

DK books are available at special discounts when purchased
in bulk for sales promotions, premiums, fund-raising, or
educational use. For details, contact SpecialSales@dk.com

Printed and bound in Slovakia

www.dk.com

This book was made with Forest
Stewardship Council™ certified
paper – one small step in DK's
commitment to a sustainable future.
Learn more at
www.dk.com/uk/information/sustainability

To you, the reader.
Your presence gives these
pages life. Thank you for
joining me on this adventure
and for being the silent force
that made it all possible.

Contents

Introduction

My name is Cecilia, and I live on Svalbard, an island close to the North Pole.

Eight years ago, I arrived in the small Arctic town of Longyearbyen amid the pitch-black darkness of the polar night. I was in my late twenties and lacked a concrete plan; instead, I was looking for adventure. Little did I know when stepping onto the silent, snow-covered streets of Svalbard that coming to this archipelago in the far north would alter everything I had previously envisioned for my life.

Longyearbyen, the primary village on Svalbard, stands as the last town before the North Pole. The islands that make up the Svalbard archipelago endure a long polar night that stretches on for more than 3 months, plunging the land into complete darkness. This is then followed by an intense polar day season, where daylight persists totally uninterrupted for a staggering 4-month period. And let's not forget about the majestic yet formidable polar bears that roam the tundra surrounding us. Despite these extreme conditions, I daresay I live in the most remarkable place on Earth.

When I first came to Svalbard, I intended to stay for only a few months before returning to my life on the mainland to continue climbing the corporate ladder in a bustling city. However, fate had other plans. I fell in love with a life where the wilderness is at your doorstep and days revolve around exploring it. I found Longyearbyen to be a charming melting pot of people coming from diverse backgrounds who share the common interest of enjoying our breathtaking natural wonders, Arctic wildlife, vast glaciers, and a front row seat to the aurora borealis. This island, though small, offers a life beyond imagination.

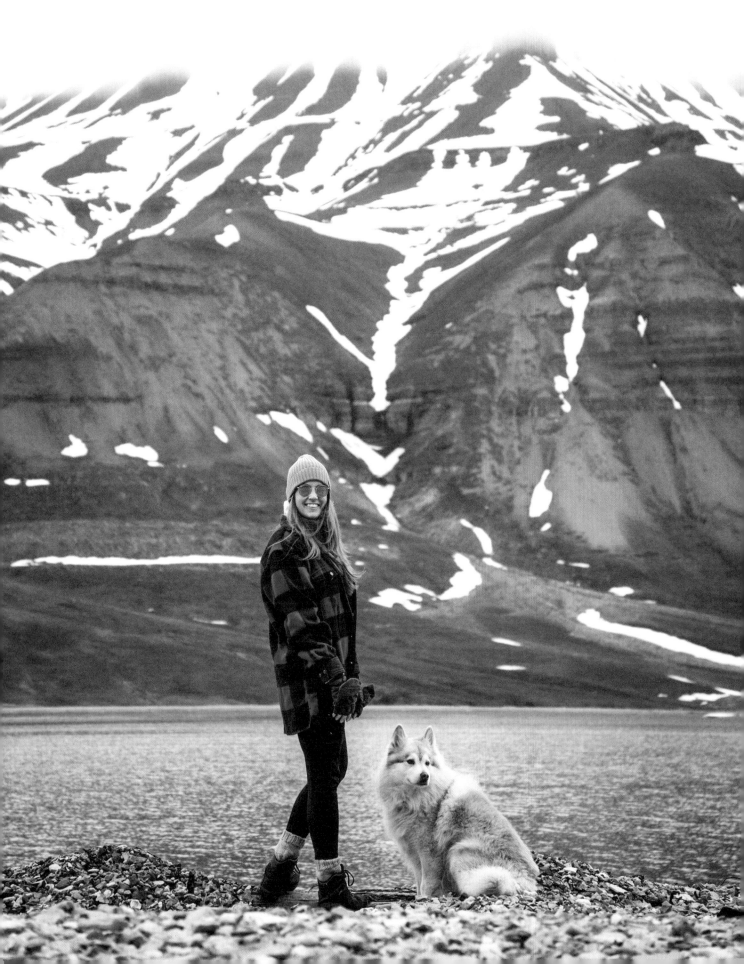

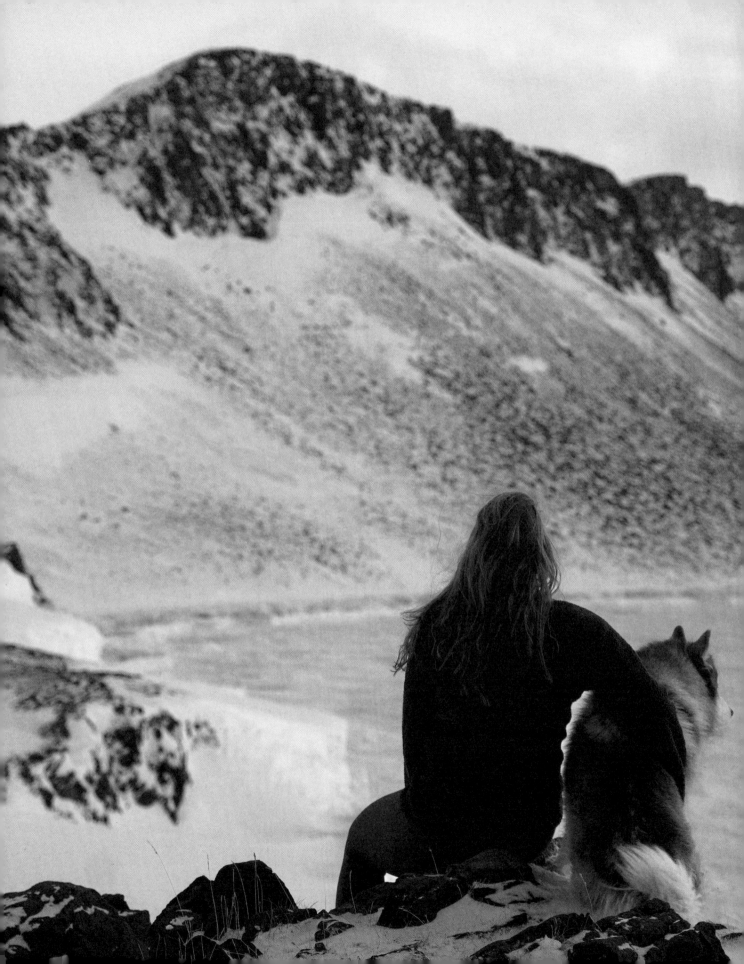

While I have always enjoyed outdoor activities like running, road biking, and hiking, nothing quite prepared me for the adventures awaiting on Svalbard. Suddenly, I found myself trekking mountains in -4°F (-20°C) during the darkness of polar night with a shotgun slung over my back for polar bear protection and spending hours exploring the rugged world of the Arctic on a snowmobile, driving over frozen fjords and through deep, snow-filled valleys. These were experiences I never imagined myself embracing, but moving here opened my eyes to new possibilities and exhilarating challenges.

In this book, I will unveil Svalbard in the same way it revealed itself to me my first year on the island: beginning in the darkness of November's polar night and watching the landscape unfold through the seasons. When I first arrived, Svalbard was draped in darkness. But as the months passed, I witnessed the landscape gradually transform, gaining insight into the resilient local way of life and how those who live here thrive despite the harsh environment. Each change in scenery stirred a corresponding change within me, leading me toward a more nature-connected life marked by a slower pace.

Imagine waking up in our cozy cabin during polar day as you're greeted by the sight of seven majestic glaciers from the comfort of our living room. Or during the other half of the year, imagine you're beside me as I carry a firearm on my shoulder, venturing out with my faithful companion Grim for a walk, all the while keeping a keen eye on the darkened sky and hoping to catch a glimpse of the northern lights. Though I never dreamed of ending up here, I now cannot fathom living anywhere else in the world.

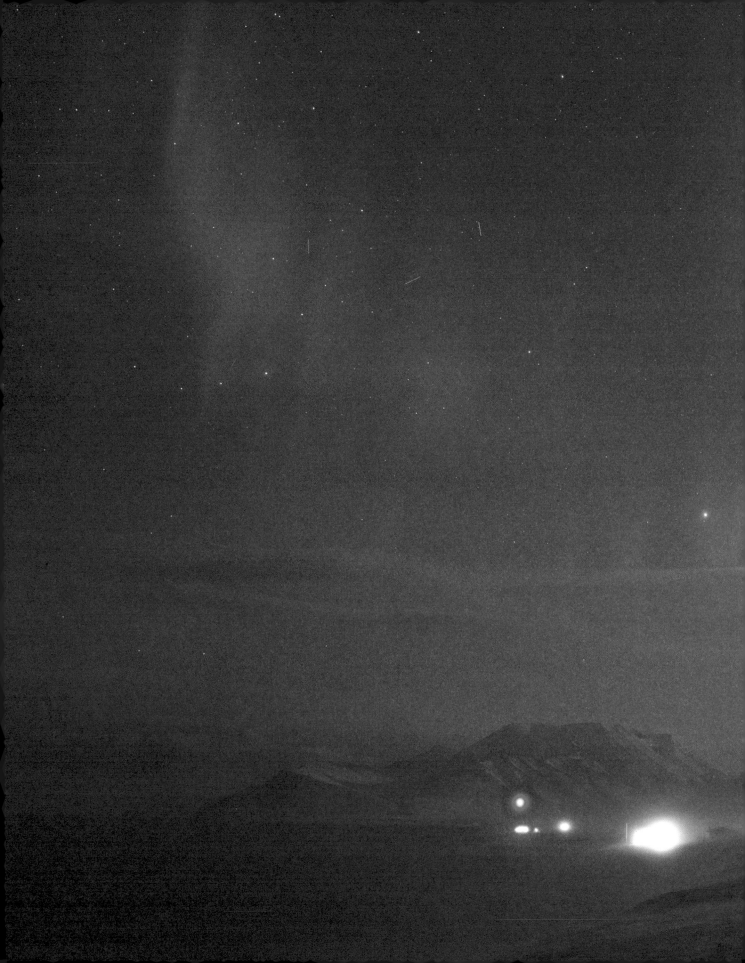

As you delve into the pages of this book and read about my life on Svalbard, I hope my story resonates with you and ignites a spark of inspiration for you to apply to your own life. During my time spent living here, I have learned that life's greatest adventures often lie beyond the boundaries of our comfort zones. By embracing the unknown and challenging ourselves, we can unlock the door to unforeseen opportunities and discover our hidden strengths. Just as I discovered the beauty life can offer living in a remote Arctic setting, may my experiences encourage you to seek out the extraordinary in your own life, wherever it leads you.

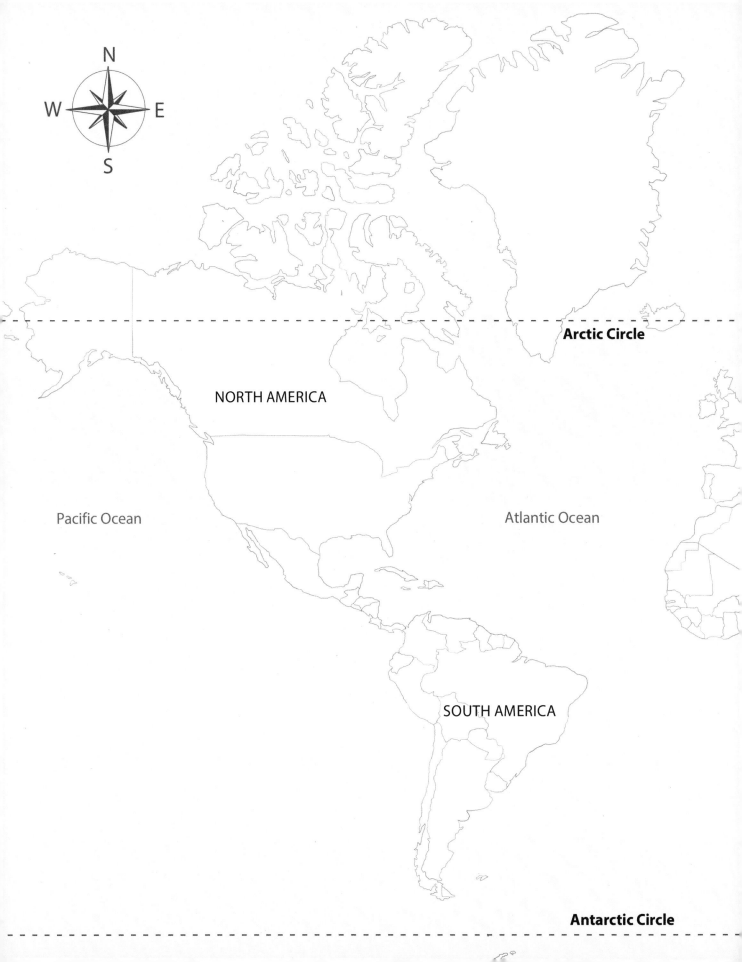

N
W · E
S

Arctic Circle

NORTH AMERICA

Pacific Ocean

Atlantic Ocean

SOUTH AMERICA

Antarctic Circle

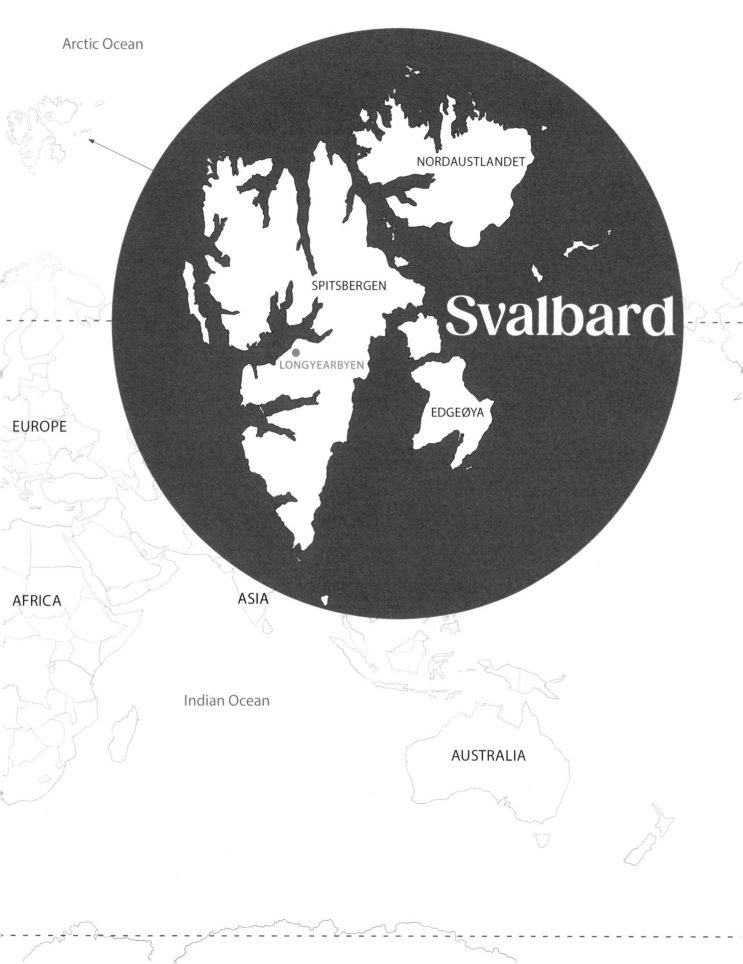

Arctic Ocean

NORDAUSTLANDET

SPITSBERGEN

Svalbard

LONGYEARBYEN

EDGEØYA

EUROPE

AFRICA

ASIA

Indian Ocean

AUSTRALIA

Coordinates

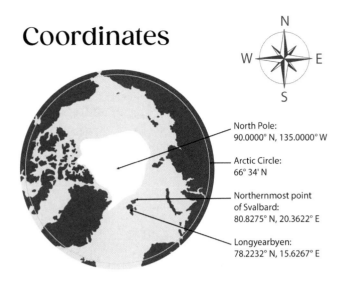

North Pole:
90.0000° N, 135.0000° W

Arctic Circle:
66° 34' N

Northernmost point
of Svalbard:
80.8275° N, 20.3622° E

Longyearbyen:
78.2232° N, 15.6267° E

Distance

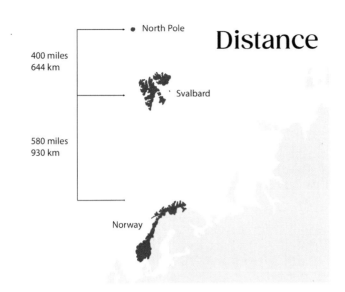

North Pole

400 miles
644 km

Svalbard

580 miles
930 km

Norway

Population

SVALBARD: 3,024

① Ny-Ålesund: 30–130

② Pyramiden: 10-30

③ Longyearbyen: 2,400

④ Barentsburg: 455

⑤ Bear Island: 9

Demographics

**61.1%
from Norway**

**38.9%
Other**

Mostly from Russia,
Sweden, Ukraine,
Thailand, and Phillipines

Size

Nordaustlandet

Spitsbergen

Barentsøya

Edgeøya

Total Svalbard land area
23,955 mi² / 62,043 km²

Spitsbergen
15,075 mi² / 39,044 km²

Nordaustlandet
(North East Land)
5,576 mi² / 14,442 km²

Edgeøya (Edge Island)
1,959 mi² / 5,074 km²

Barentsøya (Barents Island)
497 mi² / 1,287 km²

Other smaller islands
(combined)
848 mi² / 2,196km²

Highest Mountain

Newtontoppen 5,620 feet / 1,713 meters

Glaciers

More than 2,100 cover
14,128 mi² / 36,591 km²
59% of Svalbard's total land area

Seasons

JANUARY · FEBRUARY · MARCH · APRIL
MAY · JUNE · JULY · AUGUST
SEPTEMBER · OCTOBER · NOVEMBER · DECEMBER

Light

24/7 darkness
84 DAYS
→ 23% of the year

24/7 daylight
99 DAYS
→ 27% of the year

Sunrise + sunset
182 DAYS
→ 50% of the year

First sunrise of pastel winter
11:30 AM, February 16

Last sunrise of sunny winter
1:15 AM, April 18

First sunset of golden autumn
12:09 AM, August 25

Last sunset of golden autumn
1:30 PM, October 25

Temperatures

73.4°F (23°C) Highest temp.
recorded on Svalbard, July 2020

February and March are often the coldest months with temps down to -13°F (-25°C)

-51.3°F (-46.3°C) Lowest temp.
recorded on Svalbard, March 1986

JANUARY	FEBRUARY	MARCH	APRIL
16 / 3 °F	15 / 2 °F	15 / 2 °F	20 / 8 °F
-9 / -16 °C	-9 / -17 °C	-9 / -17 °C	-7 / -13 °C

MAY	JUNE	JULY	AUGUST
31 / 24 °F	41 / 35 °F	48 / 41 °F	46 / 39 °F
-0.5 / -4 °C	5 / 2 °C	9 / 5 °C	8 / 4 °C

SEPTEMBER	OCTOBER	NOVEMBER	DECEMBER
38 / 31 °F	28 / 20 °F	23 / 13 °F	18 / 7 °F
3 / -0.5 °C	-2 / -7 °C	-5 / -11 °C	-8 / -14 °C

Temperature averages for Longyearbayen, Svalbard, and Jan Mayen

Important Years

1906 Longyearbyen founded

1920 Barentsburg founded

1925 Norway sovereignty over Svalbard

1926 Roald Amundsen reaches the North Pole

1973 Polar bears become a protected species

Species

SVALBARD GLOBAL SEED VAULT
1,214,827 samples

SVALBARD REINDEER
Around 22,000

WALRUSES
Around 5,000

POLAR BEARS
Around 300 are found on the Svalbard archipelago, with 3,000 in the greater Svalbard area.

OTHER ANIMALS
Arctic fox, sibling vole, Svalbard rock ptarmigan (the only bird to live on Svalbard year-round) are also found.

SEALS
The ringed seal is the most common type found on Svalbard, with a population estimate of 100,000. Bearded seals, harbor seals, and harp seals are also found.

WHALES
Species present year-round include: bowhead, beluga, and narwhals.

Migratory whale species most commonly seen arriving for Arctic summer: minke, fin, humpback, killer, and white-beaked dolphins.

MIGRATORY BIRDS
Species commonly seen during Arctic summer: Atlantic puffin, snow bunting, black guillemot, northern fulmar, and common eider.

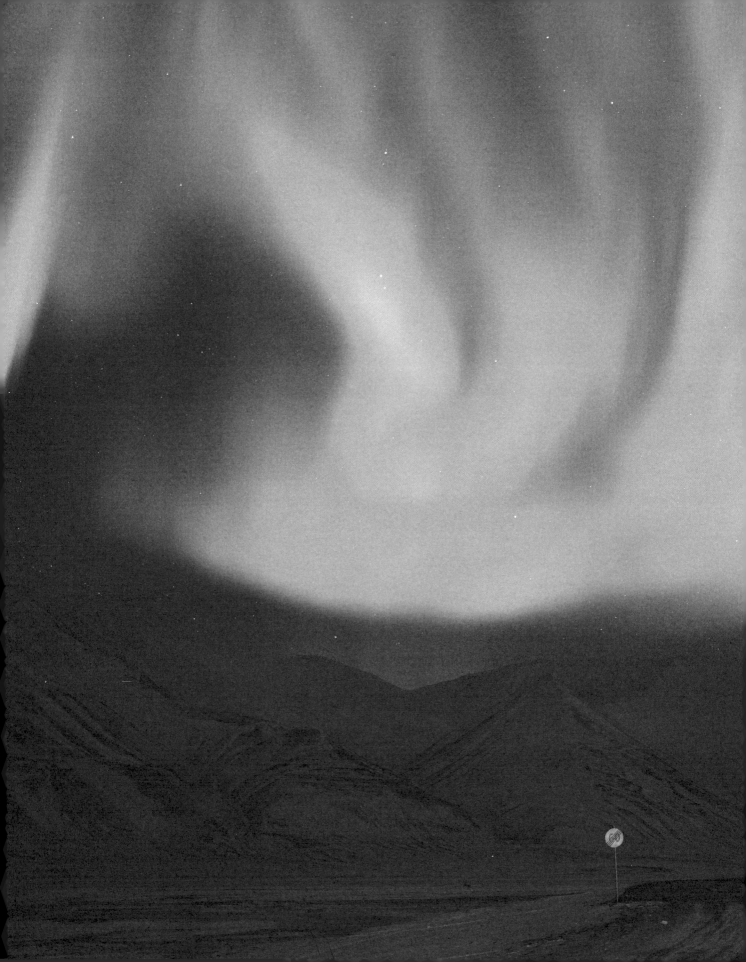

Polar Night

E ach year in late October, the sun says goodbye for the final time, plunging Svalbard into a state of uninterrupted darkness. Anyone who lives here won't see the sun rise over the archipelago again for another 4 months.

This period is called *polar night* or, as it's often referred to by the locals, the "dark season." While it might seem like a dreary situation, this season carries its own kind of magic. You can eat breakfast with the stars and go to bed with the moon as your night-light.

This lasting darkness also provides the unique opportunity to witness the elusive northern lights at any hour of the day. You might even be lucky enough to see them dancing gracefully above the village of Longyearbyen on your walk through town. This extraordinary season immerses you in a world that feels like it's straight out of a fairy tale, where the boundaries between day and night are beautifully blurred.

Making My Way to Svalbard

The first time I heard of the Arctic island I now call home was in 2015, when some of my colleagues in Gothenburg, Sweden told me about their plans to go to Svalbard to work in the restaurant business. I was initially puzzled, as up until this point I hadn't been aware of the island's existence. This was especially surprising since it was governed by our neighboring country of Norway. When my colleagues mentioned it was a place where polar bears roam and the locals deal with extreme seasons and endless daylight or total darkness, I knew this was the kind of adventurous place I wanted to visit.

For my entire adult life, I had lived in larger cities. I was following a similar path that my dad had by climbing the corporate ladder. I realized that following this path had me pursuing a dream that aligned more with societal expectations rather than my own personal aspirations. The appeal of the bustling city life and the traditional career path kept me on track with what I thought I should do, without really exploring what truly mattered to me.

Right out of high school, I had started working within hospitality, purposefully steering myself away from the university route, which I knew wasn't for me. When I made this decision, it was because I didn't want to *be* anything specific, and I never really excelled in school anyway. The realization that I was on the wrong path only dawned on me later, once I moved to London and secured a job that could have been the beginning of the successful career I had envisioned. Unfortunately, I didn't like anything about this London life. It wasn't so much the job, as I genuinely enjoyed hospitality, but there was something else I couldn't really pinpoint at the time that didn't feel right.

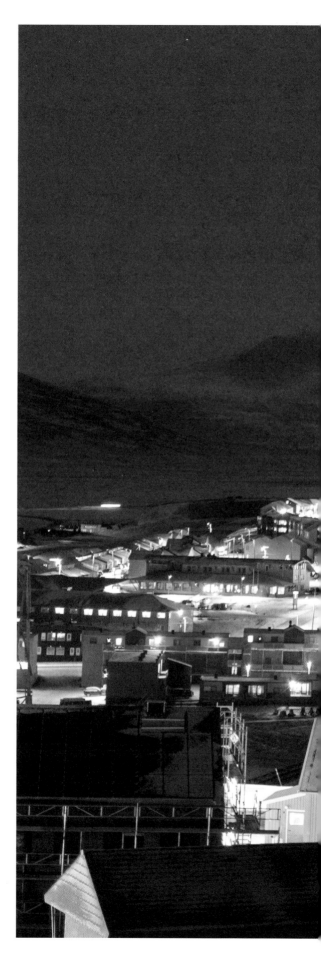

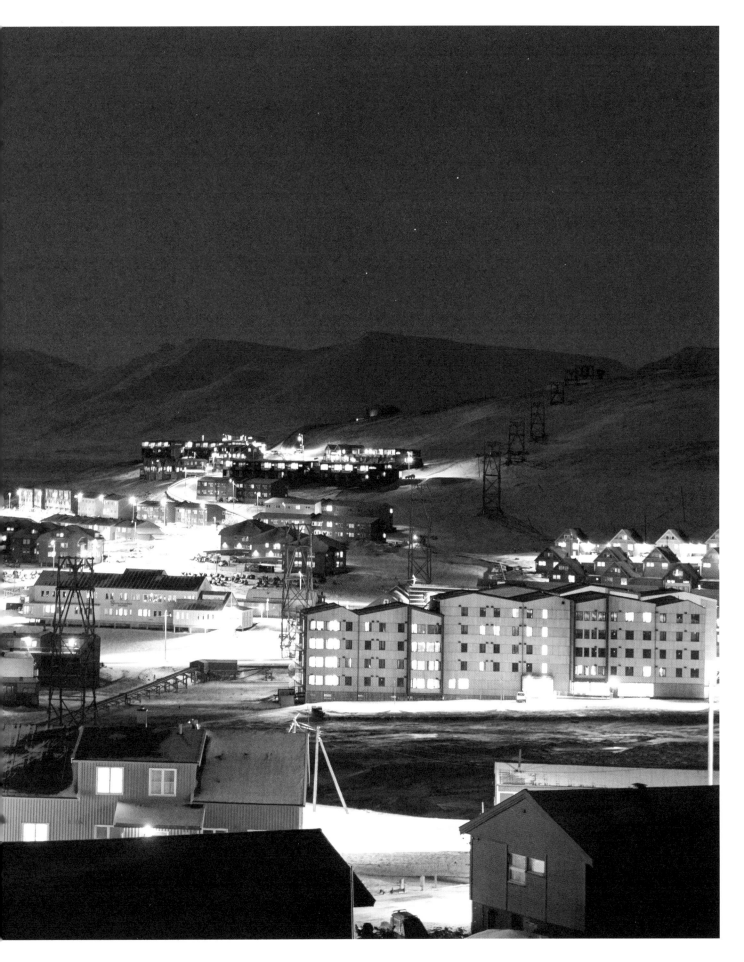

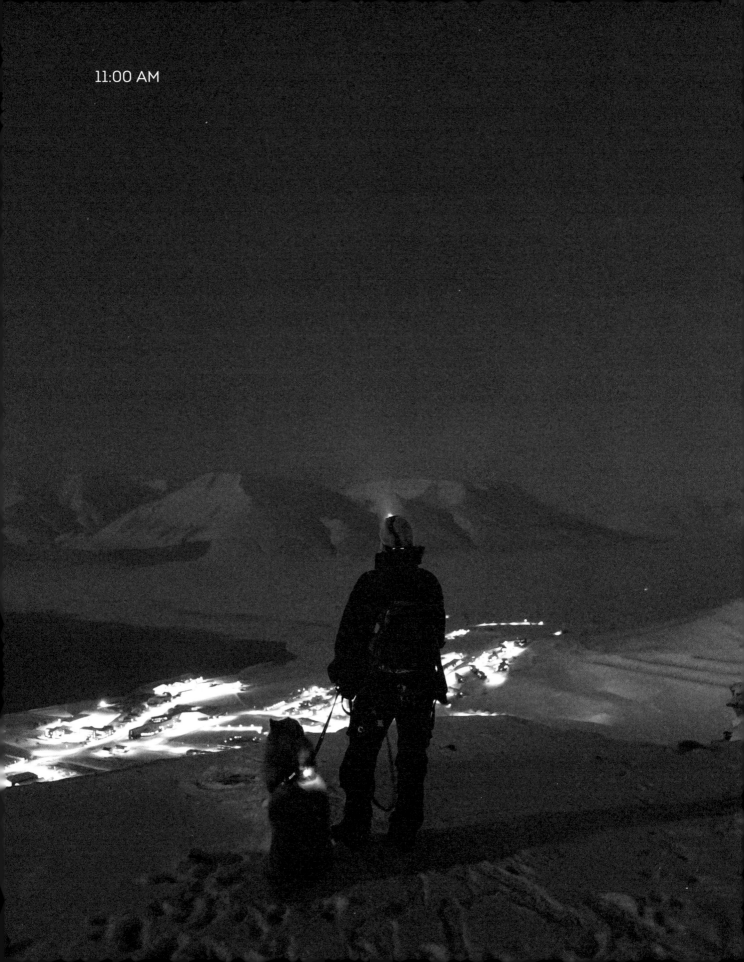

The first time I heard of the Arctic island I now call home was in 2015.

This revelation jolted my original plans, leading me to leave London and return to Sweden for a while. Back in my home country, I continued to work in the hospitality industry, but I also made time to go on a bunch of adventures. Hiking in Norway's beautiful mountains with my best friend was like stepping into a living postcard, surrounded by breathtaking views at every turn. And then one time, I impulsively teamed up with a stranger for a 26.1-mile (42-km) swim-run just 2 days before the race. There was also the time I went road biking along Portugal's coast with my mom. We biked over mountains and along sun-soaked beaches, making pit stops for a *meia de leite* (coffee with milk) in every enchanting town we encountered. However, our enthusiasm for gin and tonics during dinner later that evening resulted in a rather painful 43.5-mile (70-km) ride back home the following day.

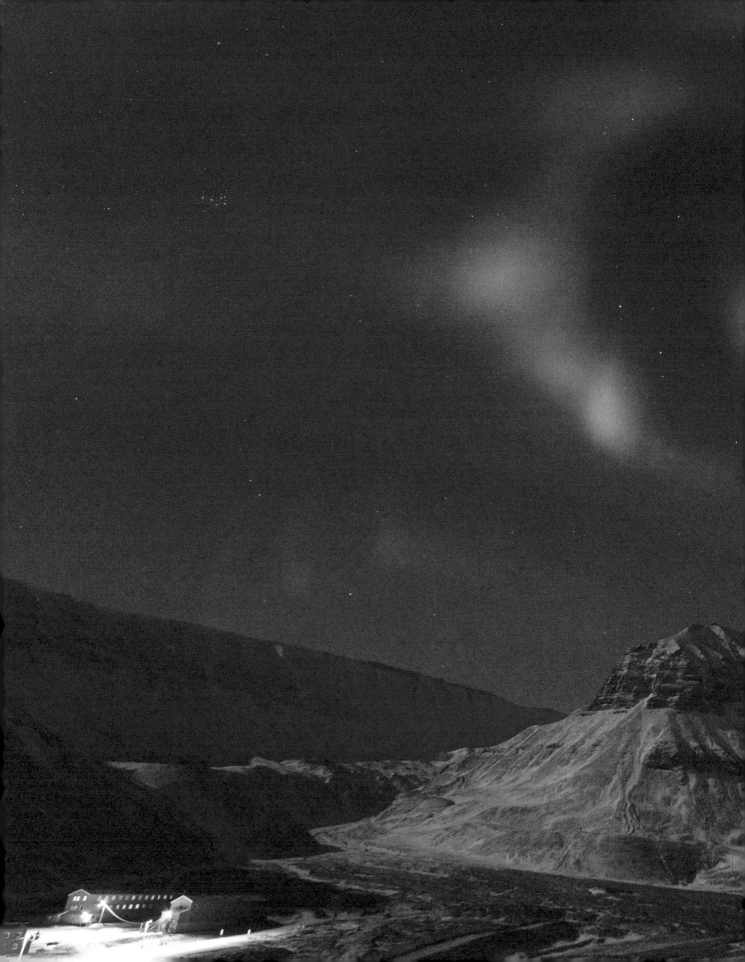

When I reflect on the memories I made during my early twenties, it brings a smile to my face, but sometimes, you just need a reset to pave the way for a new plan. So when my colleagues began discussing their move to an island near the North Pole, I was all ears. I managed to get a job at the same restaurant they'd been hired at, and 3 months later, I found myself boarding a flight to Longyearbyen, Svalbard.

As I arrived in Longyearbyen for the first time in November, the town greeted me in total darkness, and a sense of calm washed over me. At this moment, I knew I was finally stepping onto the right path.

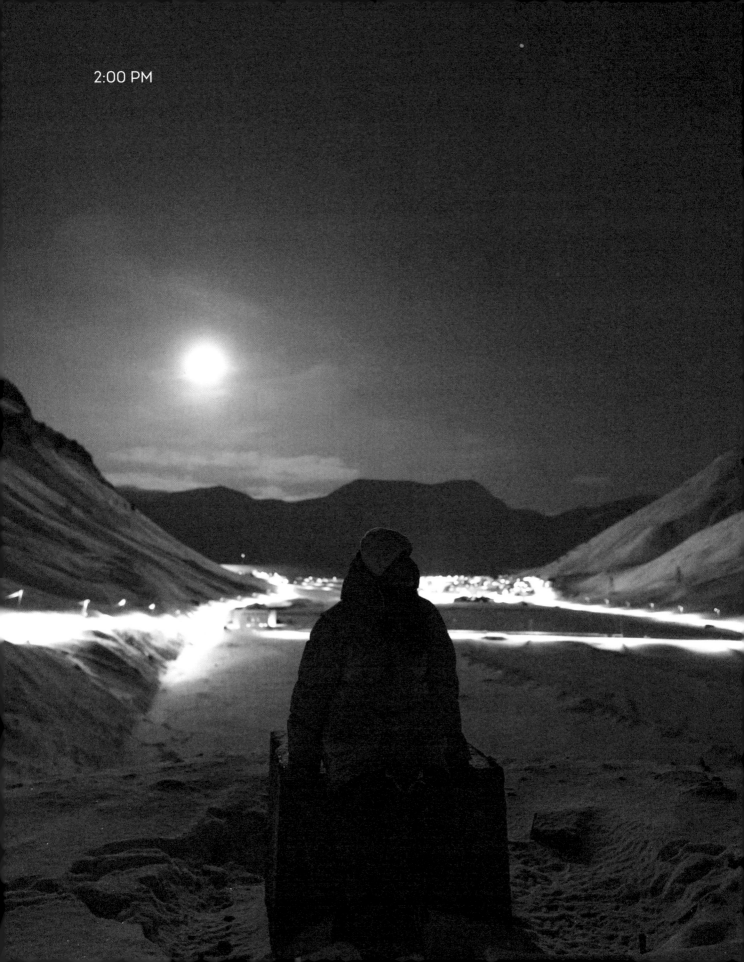

2:00 PM

Embracing the Darkness

The drive from the Longyearbyen airport to the apartment where I'd be staying proved to be a swift one and didn't offer much insight into where I was going to be spending the coming months. Peering out the taxi's windows, I was met by darkness. The sky was pitch black in all directions, the faint glowing lights of Longyearbyen was the only brightness visible as we drove toward the town's center. Within 5 minutes of getting into the taxi, I found myself standing outside my new home—a somewhat-shoddy apartment building in the middle of town.

From where I stood, I had a clear view of the village and the mountains that encircled it. It dawned on me that Longyearbyen is nestled within a valley, the mountain walls that surround it serving as a kind of protection against the elements. I dropped off my belongings in the apartment and decided to go for a walk through town in the early afternoon darkness. It was a chilly day at 5°F (-15°C) with no wind, and the sound of my footsteps was muffled by the thick layer of snow on the ground. One thing stood out to me right away: the deafening silence.

As I walked further, I noticed a couple strolling along the main street under the glow of lights that were lining the path, creating what looked like an illuminated maze in the darkness. Faint shrieks of joy from kindergarten children playing outside in the fenced-in playground area reached my ears as a reindeer crossed the street right in front of me and proceeded to graze in the deep snow. *This is a magical place,* I thought to myself.

Before I had moved up here to the far north, I'd done some research and learned about polar night, so I had a better understanding of what to expect. Although I tried my best to prepare, I don't think I fully understood what complete darkness would entail. The idea of experiencing this long period of darkness was both intriguing and a bit daunting to me. I had envisioned a twilight sky tinted in shades of dark blue, something reminiscent of the early winter evenings I'd lived with in Sweden. I was quite unprepared for the sheer intensity and darkness that is polar night.

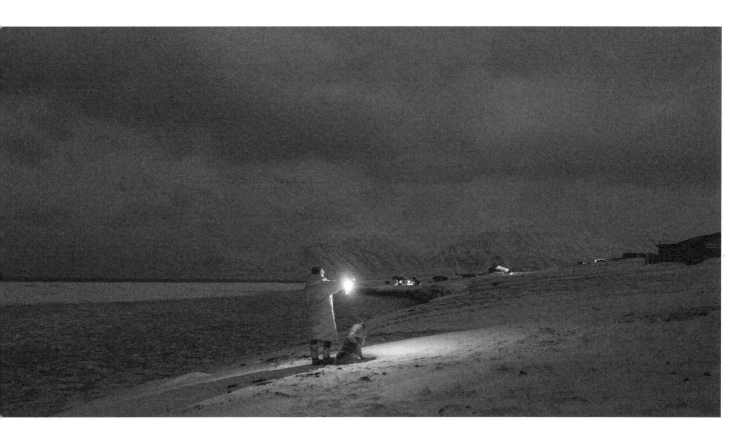

What Is Polar Night?

Polar night is the season that takes place each year inside polar circles when night lasts for more than 24 hours. This phenomenon occurs in the Arctic and Antarctic Circles due to the Earth's rotation in relation to where the sun is positioned. Because the Earth rotates on a tilted axis at 23.5 degrees, there are periods of the year when the areas located in the polar circles on the top and bottom of our planet are either completely obscured from or completely exposed to the light of the sun.

Some latitudes are not situated far enough north to experience continual total darkness. Instead, these locations experience polar twilight as their brightest periods during this season, which replaces their daylight. Svalbard is far enough north to feel the full effects of polar night and witness nearly 3 months of complete darkness between the middle of November and the end of January.

When the Earth has orbited 180 degrees to the other side of the sun and the planet's axis has us angled toward the sun instead of away from it, we are exposed to a prolonged period of daylight we call the "midnight sun." This period occurs in Svalbard between mid-April and mid-August.

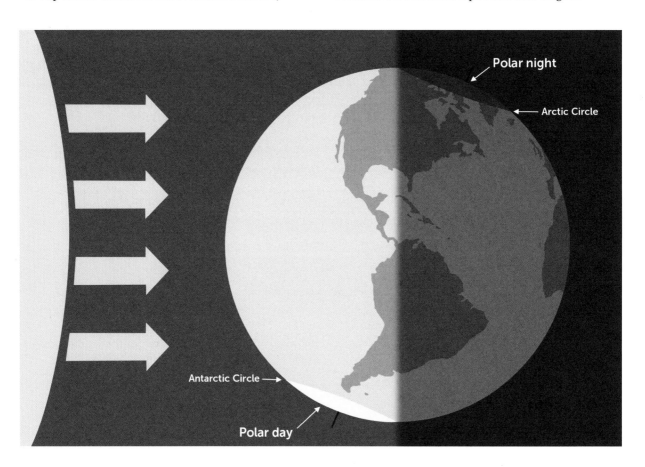

Svalbard is far enough north to feel the full effects of polar night and witness nearly 3 months of complete darkness.

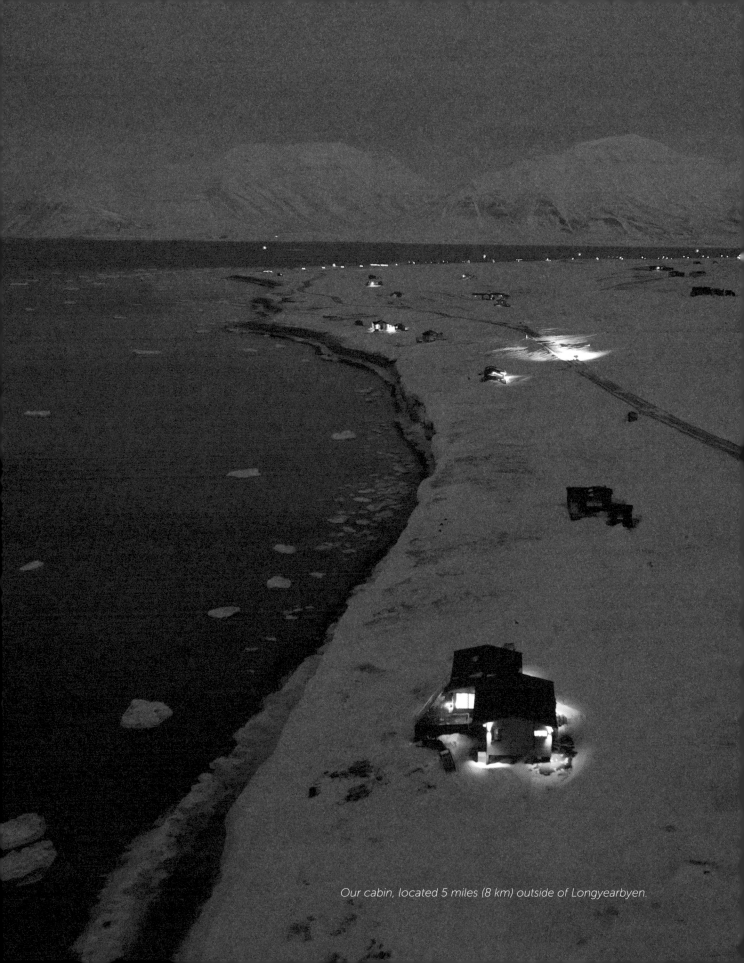

Our cabin, located 5 miles (8 km) outside of Longyearbyen.

Finding Home in the Far North

At 78 degrees north, which is about 12 degrees further north than the lower boundary of the Arctic Circle, Svalbard is no stranger to polar night. Throughout this period of darkness, the sun remains hidden from us. The sun's position is so distant that no light reaches Svalbard at all, casting the sky into a perpetual state of pitch-black darkness. Here, only the moon, the stars, and the occasional appearances of the northern lights offer up some natural light for us during this everlasting night.

Although you might assume this time of year is the most challenging period for the locals who call Svalbard home, I quickly learned after my arrival that it is a season many people appreciate. The town of Longyearbyen carries on with daily life in the usual manner. The only notable difference is that everyone walks around with a headlamp permanently attached to their heads.

Since Svalbard lacks an indigenous population due to its remoteness and how far north it is, a substantial majority of its residents have moved here by choice. Longyearbyen, the largest town on the archipelago, is typically viewed as a place to find employment for a while, rather than a place to make into your lifelong residence.

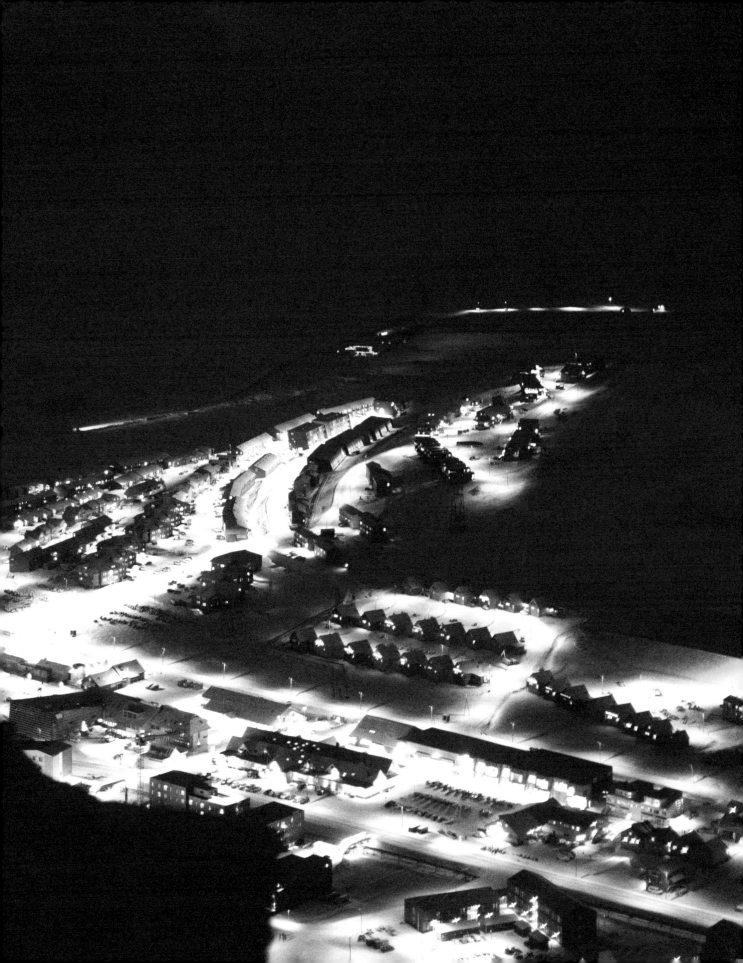

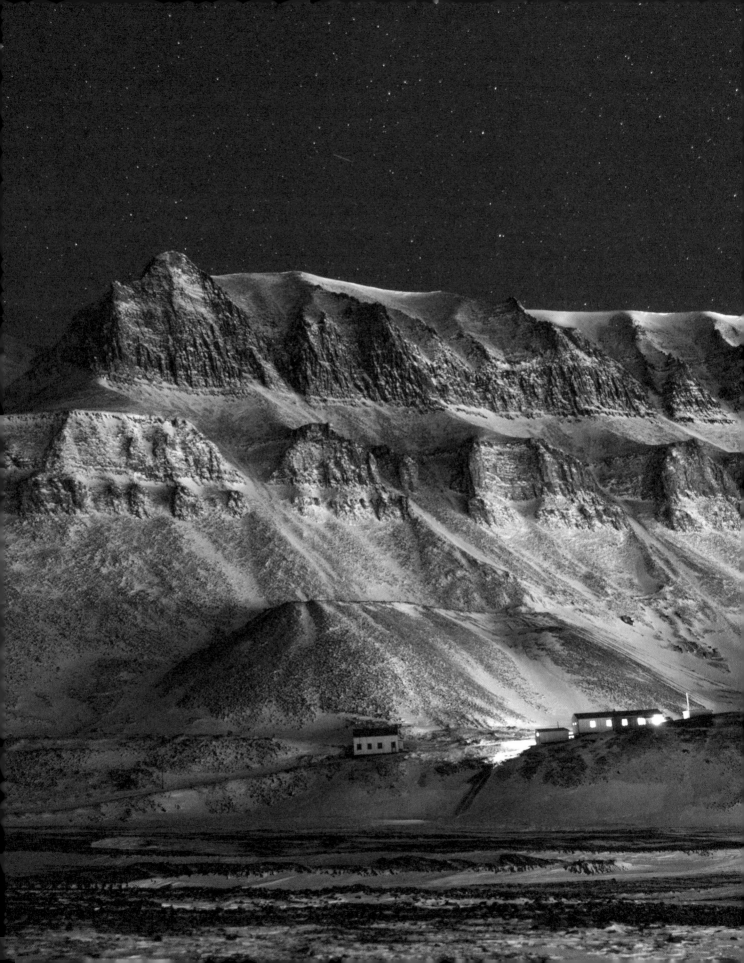

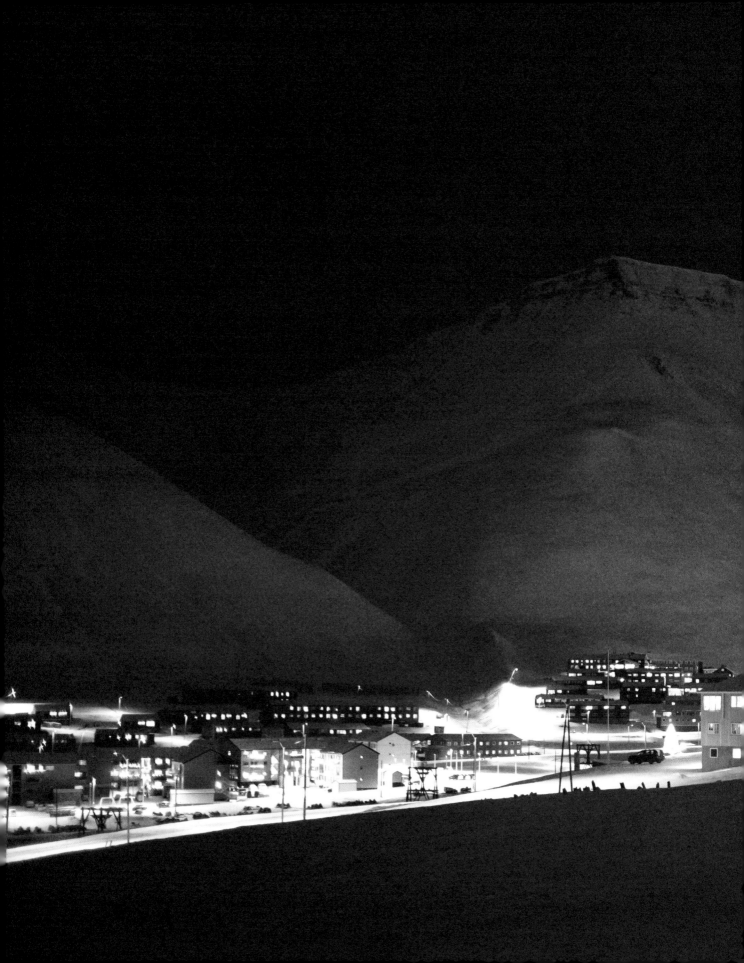

Midday darkness: Longyearbyen captured during polar night, when you cannot tell the difference between day and night.

I was bitten by the Svalbard bug.

I believe the choice people make to live here significantly influences how we approach the various seasons, especially polar night. Those who can't embrace the extended darkness usually don't remain here for very long. Longyearbyen is full of individuals who have relocated here for all kinds of reasons, but I've found that they often share a deep appreciation for nature. This comes in handy when learning to adapt to life on Svalbard, as the forces of nature play such a powerful role in shaping our daily lives here.

When I first came to Svalbard, I had only intended to stay and work for a few months, but much like many other people who have come here, I was bitten by the Svalbard bug. Eight years after first moving to this island, I'm still here.

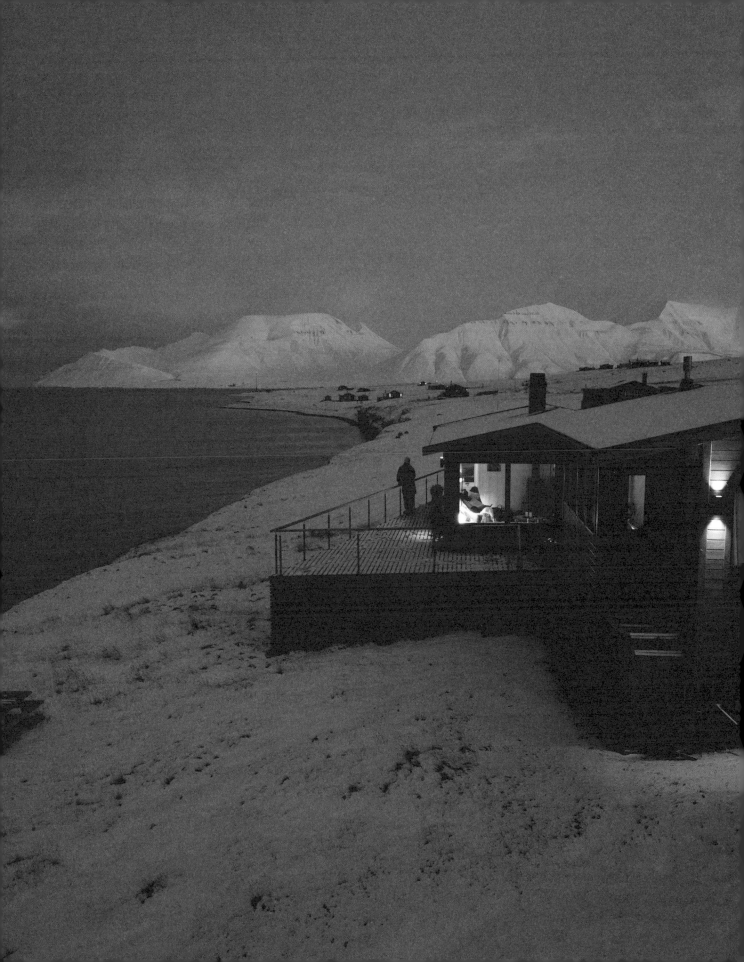

The Season of Stillness

I once read an article about a journalist who traveled to Longyearbyen to write a piece about polar night. His goal was to gather insight from the locals about the challenges of living through the long, dark period. He anticipated that he would hear about how it was the worst time of the year. To his surprise, most people he interviewed shared their appreciation for the enchanting polar night. They described how our village transformed into an even closer-knit community during this time, and many people highlighted the beauty of the polar night season. They shared tales of the calm and peaceful atmosphere and how life in the darkness seems to follow a slower, more relaxed rhythm.

Living this far north in a place marked by extreme weather and seasons, you learn to appreciate it all. Each season has its own special magic, and I believe it would be a shame if we only longed for the more standard seasons that we don't have. I'm not implying that everyone here loves polar night, but since we've all chosen to live here in this distinctive place, we have to take it for what it is. There's so much you can miss out on if you don't embrace Svalbard's unique seasons!

Personally, I enjoy the polar night tremendously. I find it to be serene as it's a wonderful time to unwind and enjoy life at a slower pace. I savor the calm it brings. While I may not be as fond of the long months of midnight sun during polar day, I realize that too is part of the experience living this far north. I try my best to consider every season as part of the Arctic's magic.

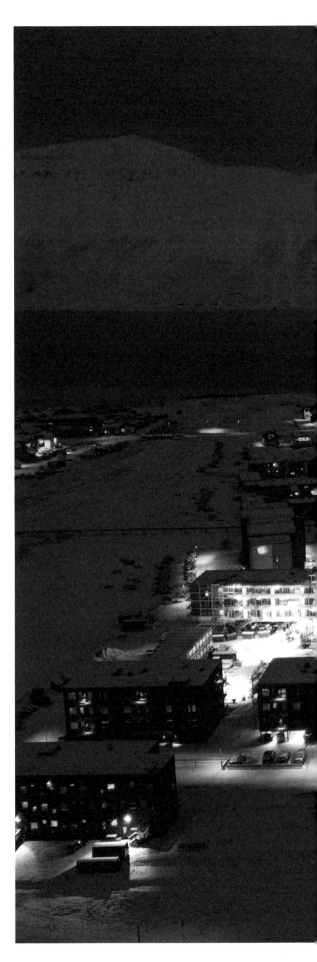

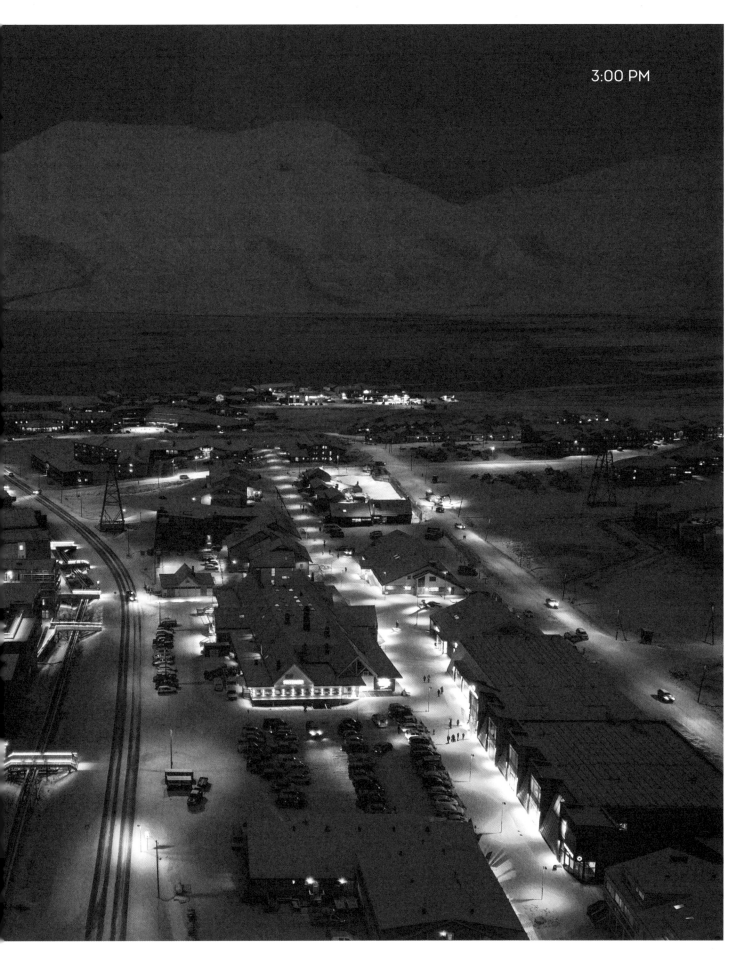
3:00 PM

I've always believed that our mindsets and approaches to each season, particularly winter, significantly influences how we feel about it. Before the darkness of polar night fully sets in, I make a conscious effort to create a warm and cozy atmosphere in our living space. This includes hanging up a lot of string lights—the delicate, copper-wire ones that resemble Christmas lights. I put them up everywhere, hanging them along the ceiling, nestling them inside glass vases, and discreetly placing them behind the books on our bookshelf. I love the ambience they create and the extra bit of light they provide during our darkest days. They just make me happy!

However, it's not only about transforming your living space; it's also about embracing the elements of winter. There have been studies that prove just how important our seasonal mindsets are. I was lucky enough to speak with Kari Leibowitz, a health psychologist with a PhD in social psychology from Stanford, who spent a year conducting research on this topic at the University of Tromsø, located 200 miles (322 km) north of the Arctic Circle. She discovered that having a positive attitude toward winter, which includes how people think and feel about the season, is directly linked to their well-being. When someone has a positive outlook on winter, they're able to feel happier and more personally fulfilled during the season. Kari conducted a survey at the end of January 2015, surveying 238 Norwegians living across Norway and Svalbard. The survey results showed that people who have a more positive wintertime mindset also tend to be happier overall!

I view winter as a season brimming with opportunities. When the first snow arrives, it brings a refreshing, crisp scent. I love how the world becomes a bit quieter with a thick layer of snow on the ground, highlighting the sound of snow crunching underfoot as I walk. Despite the absence of daylight during our winters, I look forward to my daily walks with my dog, Grim, which we take in complete darkness. In winter, I often feel an even stronger connection to nature too, as it offers such an unfiltered and authentic experience. The combination of darkness, freezing temperatures, and frequently harsh weather can be tough for anyone venturing outside. Yet, it's precisely this ruggedness that I value, allowing me to fully embrace the outdoors not just on the easy days.

I'm aware winter isn't always a flawless, postcard-perfect wonderland with pristine white snow. In Svalbard especially, we encounter our fair share of challenging weather during the winter season. On those days when we face intense snowstorms that cover the roads in thick, gray slushy snow and leave me questioning the durability of our windows, we opt for a slower pace to get by. After a day of work, we snuggle indoors and relax by watching a good movie as the storm rages outside. Winter is the ideal time to indulge in the little activities that bring you comfort and joy, like enjoying that extra cup of coffee, lighting a nice candle, or diving into your favorite video game (for me, it's *Stardew Valley*). As you aim to cherish the beauty in the little things, the broader picture of the whole year and the changes that come with each season start to become more beautiful as well.

Winter is the ideal time to indulge in the little activities that bring you comfort and joy.

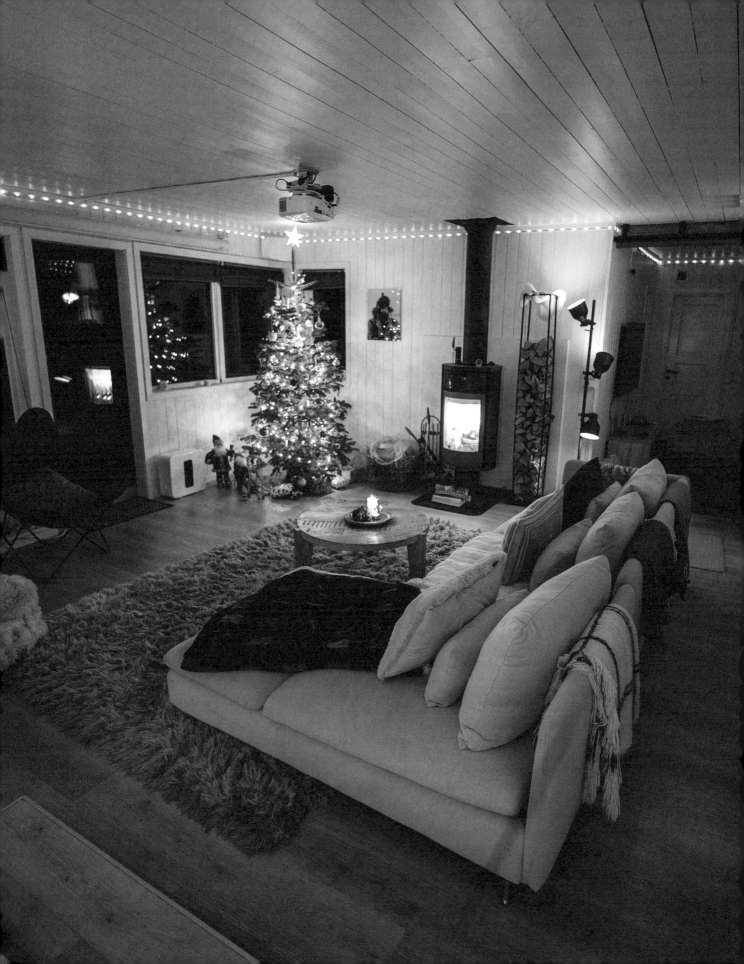

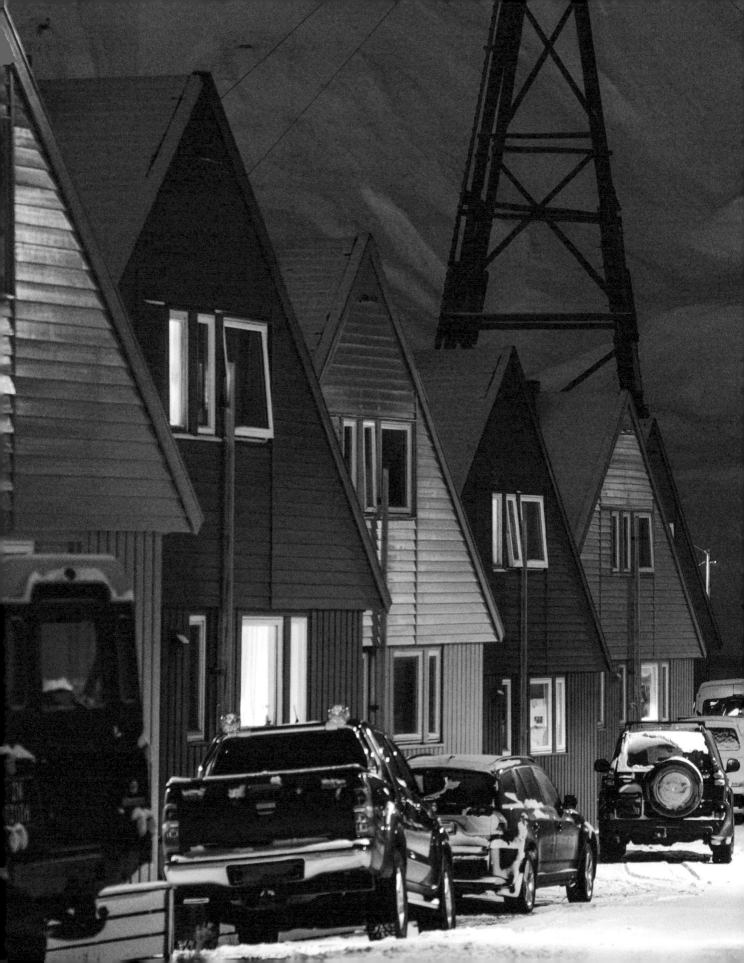

LONGYEARBYEN

Longyearbyen

From the very start, the remarkable sense of community found in the town of Longyearbyen made a big impression on me. Although Svalbard is governed by Norwegian law and Norwegian is the official language, more than 50 different nationalities call this island home. This mix of cultures makes the community diverse and interesting, forming a colorful blend in our Arctic surroundings. As the main village on the archipelago, Longyearbyen is home to approximately 2,400 residents. It is a remote place and is famous for being the world's northernmost settlement with a population of over a thousand people, which only makes it more special since it is full of people who have come from all the corners of the world.

While you might assume that the name "Longyearbyen" was inspired by the island's lengthy seasons, it actually pays homage to its American founder, John Munro Longyear. Longyear City, as it was known until 1916, was established in 1906 due to the rich coal deposits found in the nearby mountains. In 1916, the Norwegian company Store Norske Spitsbergen Kullkompani assumed control of the mining operations that had been put in place, and the settlement's name was changed to Longyearbyen, which translates to "Longyear Village."

With coal mining in the process of being phased out as the main industry, other fields of business are taking over. In particular, tourism and research are becoming major industries in Longyearbyen. Uniquely, the Svalbard archipelago operates as a completely visa-free zone, as outlined in the Svalbard Treaty, which was signed on February 9, 1920, and put into effect on August 14, 1925. It currently boasts 46 signatory nations. This treaty acknowledges Norway's sovereignty over Svalbard, including *Bjørnøya* (Bear Island), and stipulates that Norwegian law governs the archipelago. Additionally, the treaty grants specific rights to the signatories, permitting their citizens to live and conduct business here, as well as engage in hunting and fishing within the archipelago's boundaries.

2:00 PM

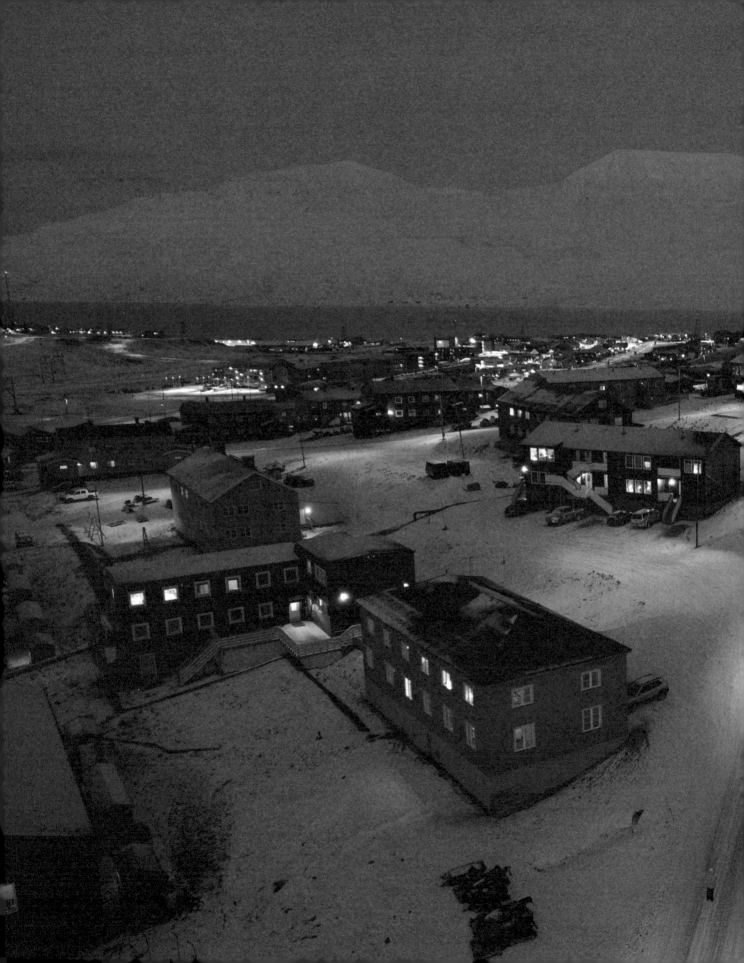

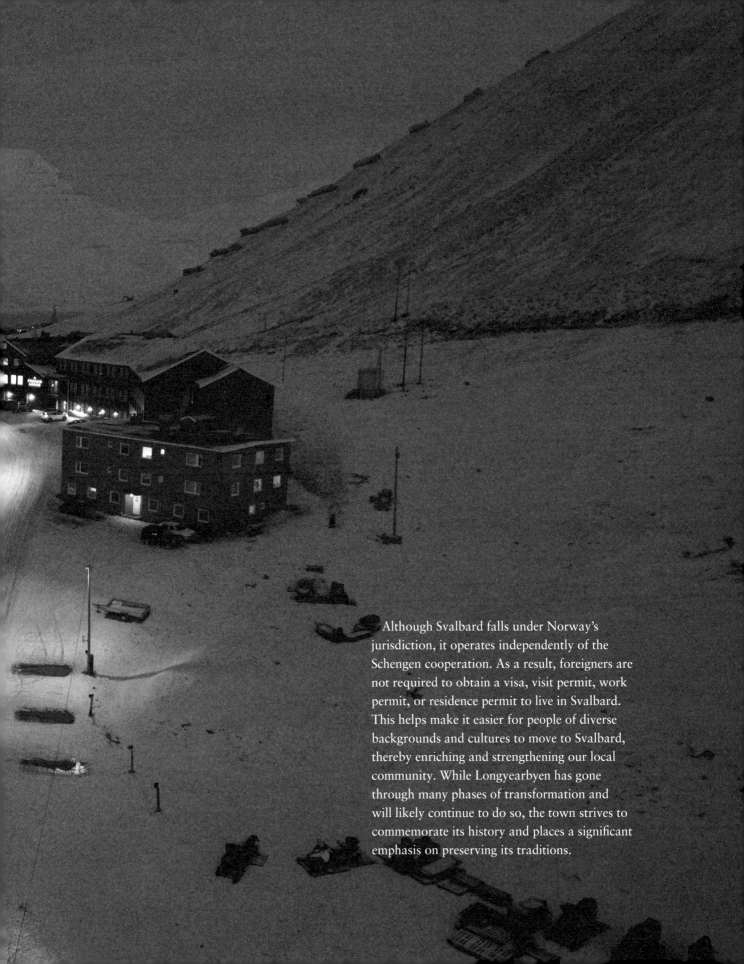

Although Svalbard falls under Norway's jurisdiction, it operates independently of the Schengen cooperation. As a result, foreigners are not required to obtain a visa, visit permit, work permit, or residence permit to live in Svalbard. This helps make it easier for people of diverse backgrounds and cultures to move to Svalbard, thereby enriching and strengthening our local community. While Longyearbyen has gone through many phases of transformation and will likely continue to do so, the town strives to commemorate its history and places a significant emphasis on preserving its traditions.

My first job in town was working as a booking manager at a venue named *Huset* ("the house"), which is renowned for its rich and intriguing history, as well as its famous wine cellar. When I worked here, I often wandered through the corridors of this historic establishment, pausing to study the countless photos on the walls from bygone eras. Seeing these images caused me to reflect on what life would have been like living here without the existence of the modern technology that now connects us with the rest of the world. Working at Huset served as the ideal introduction to Svalbard's culture, providing a deeper understanding of how this community came to be.

Established in October 1951, Huset was the community center of Longyearbyen. Due to its central location at the time, it earned the endearing title of "the heart of the city." It was a neutral space that both the mine workers and the officials could enjoy, thereby bringing different social classes together. Many of the numerous photographs

adorning the walls of Huset capture the early mining era. The building has had a diverse history since then, serving as everything from a makeshift airport terminal, an emergency hospital, and even a school, before eventually evolving into the restaurant it is today, known for its fine dining, bistro offerings, and banquet services. It was at Huset where I first met my partner, Christoffer. He worked there as well, beginning as a chef and later transitioning into the logistics department of the business.

Huset is at the center of one of the most heartwarming and cherished annual traditions that beautifully embodies our community spirit: the day when we welcome Santa Claus back to Longyearbyen. According to local folklore, during winter, Santa Claus lives in an old, closed-down mine nestled within a mountain that overlooks Longyearbyen. Throughout the year, it remains deserted while Santa is away, with the windows dark and entry forbidden to all. On the first day of Advent each year, he makes his grand return, turning on the lights in his home and placing a wooden post box at the mountain's base—especially reserved for the eager wish lists of children. While this event may be geared more toward the younger generations, I attend every year.

Everyone in town is invited to gather outside Huset for this special event. It's here that torches are handed out, and all the town's streetlights are turned off. As we walk together on the streets cloaked in darkness with only our torches to light the way, I'm always filled with a sense of childish wonder and joy. We head down to the town's main street, where we celebrate the lighting of the Christmas tree. Since no trees grow this far north, the tree is gifted from the Norwegian mainland. This tradition is particularly uplifting during the winter season, as it reminds me of the joys of living in a small, close-knit town. The sense of community is even stronger here when polar night sets in, because it feels like the village belongs solely to us residents for a few months since this time of year has far fewer tourists.

Gruve 2 Nissen *translates to "Mine 2 Santa."*

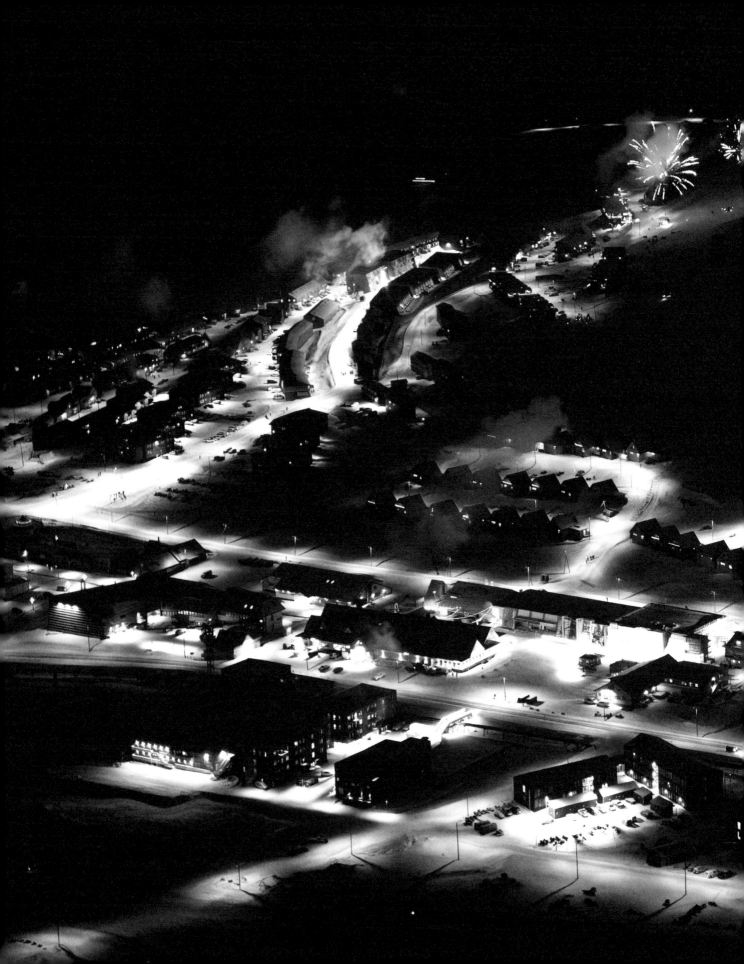

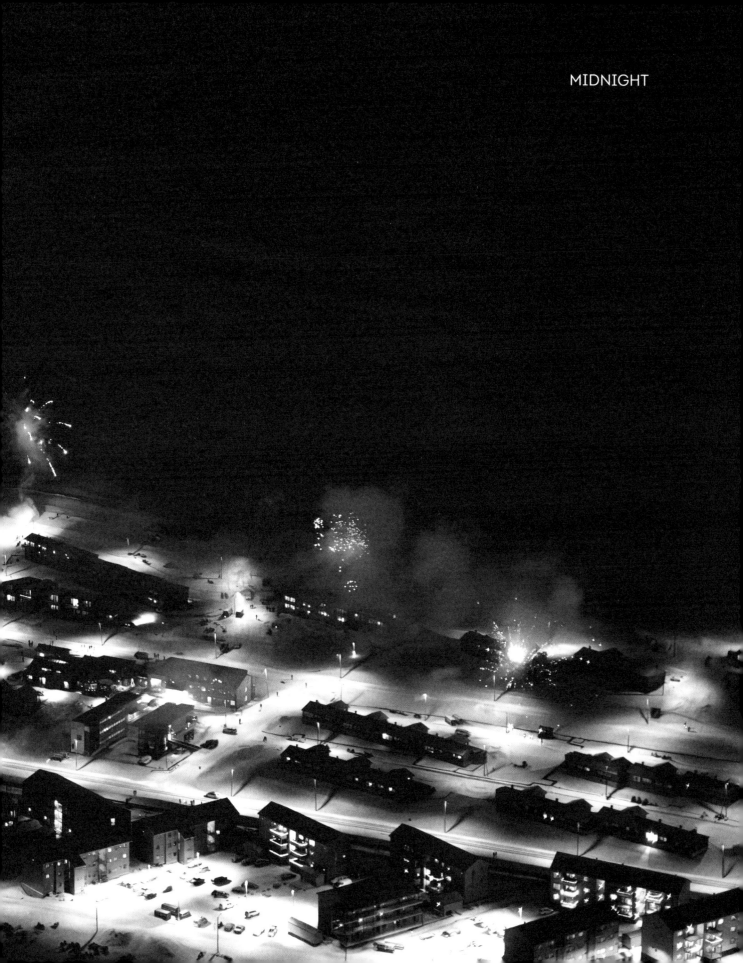

MIDNIGHT

Northern Lights

I can only imagine what it must have been like to witness the northern lights centuries ago when people didn't have any understanding of why they occurred. Picture standing beneath a clear sky, totally mesmerized by the vivid spectacle of a bright green aurora gracefully dancing across the darkness. What do you think would cross your mind if you saw this kind of magical show without knowing why it was happening?

The term "aurora borealis," as this phenomena is commonly called, comes from the name of the Roman goddess of dawn, Aurora, with the second word derived from the Greek god of the north wind, Boreas. Legend holds that Aurora would ride her chariot across the sky, the first light to show up, notifying her celestial siblings—the sun and the moon—about the start of a new day. This is one of many ancient stories and myths that are woven around this elusive phenomenon.

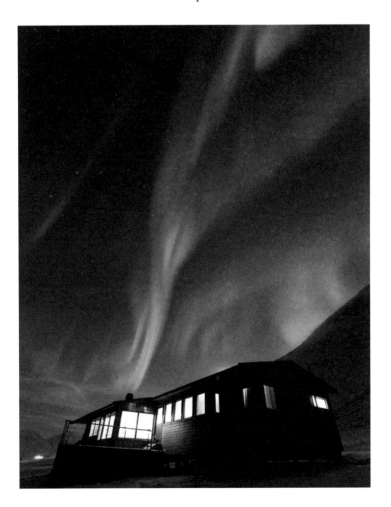

Given the otherworldly nature of the aurora borealis, it's no wonder that many cultures around the world have created myths and legends to try and explain these mysterious lights. Whenever I see them, I often find myself standing in silence, speaking only in hushed tones as I reflect on the belief that the crackling noise the aurora borealis sometimes makes holds the voices of spirits attempting to communicate with us, the people of Earth. According to this legend, whoever hears these noises should respond to them in a gentle, whispering voice. I have yet to hear the northern lights make any sound, but maybe next winter will be different.

Given the absence of light pollution near our cabin, it's the perfect setting to fully appreciate the northern lights without interruption. Our cabin sits 5 miles (8 km) away from the main village, in an area void of streetlights. When the polar night sets in, the darkness blankets everything, and the only twinkles we see are the faint lights coming from a handful of neighboring cabins, several hundred yards away. Numerous times, I've swung our cabin door open to find the sky aglow in green hues. Throwing on a beanie and an enormous puffy down jacket over my pajamas, I step outside for a front-row seat to the show.

One thing I've learned during my pursuit of capturing the notoriously unpredictable northern lights is the necessity for patience. The first hint of activity brewing in the sky may take hours to develop into the full spectacle of lights. I regularly find myself bundled up and sitting outside in the darkness, waiting. On certain nights, the aurora borealis may last for only a fleeting moment before the sky settles into its usual darkness, while on others, it can take over the entire night sky. Despite the uncertainty of where or when these lights may appear, you can sense their impending arrival in the air. It's often on crisp, cold, and quiet evenings that the most magical shows happen.

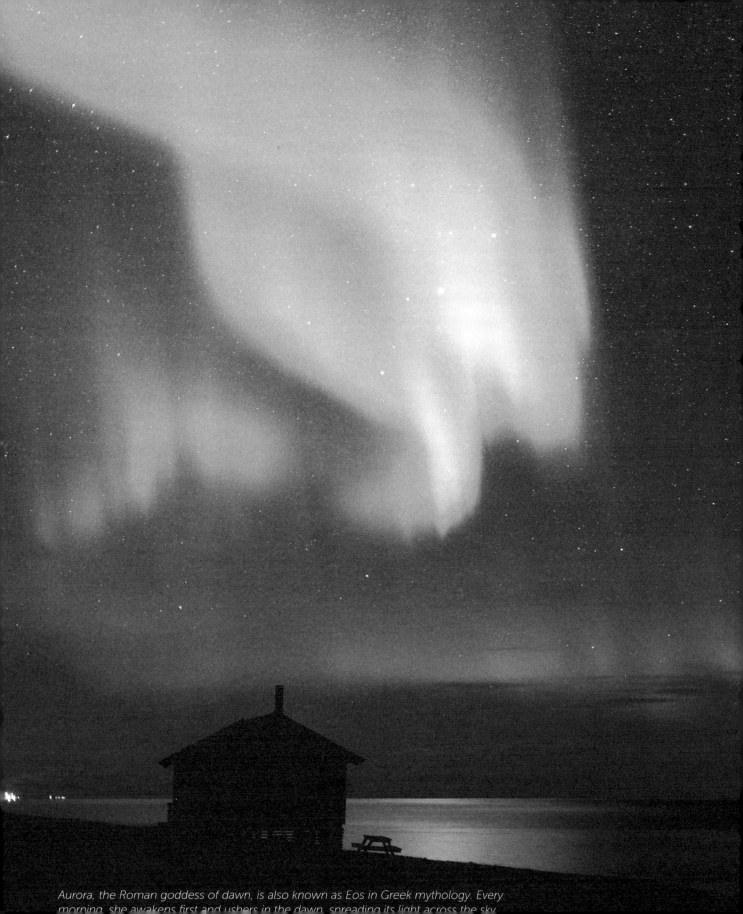

Aurora, the Roman goddess of dawn, is also known as Eos in Greek mythology. Every morning, she awakens first and ushers in the dawn, spreading its light across the sky.

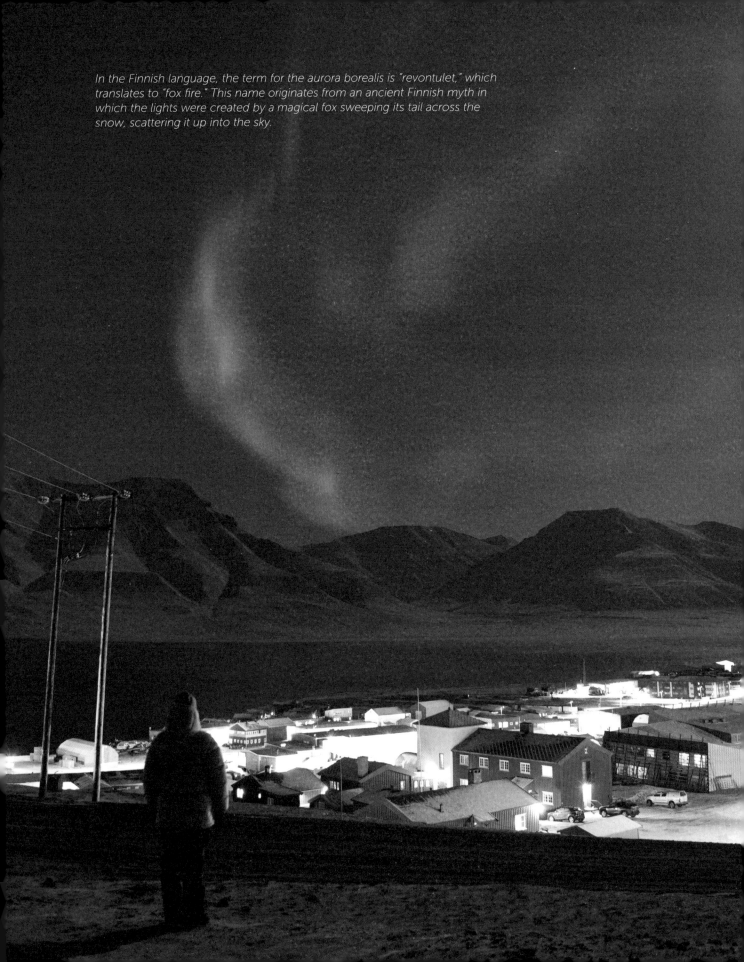

In the Finnish language, the term for the aurora borealis is "revontulet," which translates to "fox fire." This name originates from an ancient Finnish myth in which the lights were created by a magical fox sweeping its tail across the snow, scattering it up into the sky.

Polar night provides an excellent opportunity for observing the aurora borealis, as the permanent darkness allows us the possibility of witnessing the lights at any time of day. This unique aspect also makes Svalbard an ideal location for studying the aurora. On a mountain just outside of Longyearbyen lies the Kjell Henriksen Observatory, recognized as the world's northernmost aurora borealis station. In the winter season, anyone can remotely connect to one of their cameras to get a look at the current conditions of the night sky and, with some luck, the northern lights.

These otherworldly lights are undeniably one of the main reasons why I adore polar night so much. They enhance the already magical atmosphere of the season tenfold!

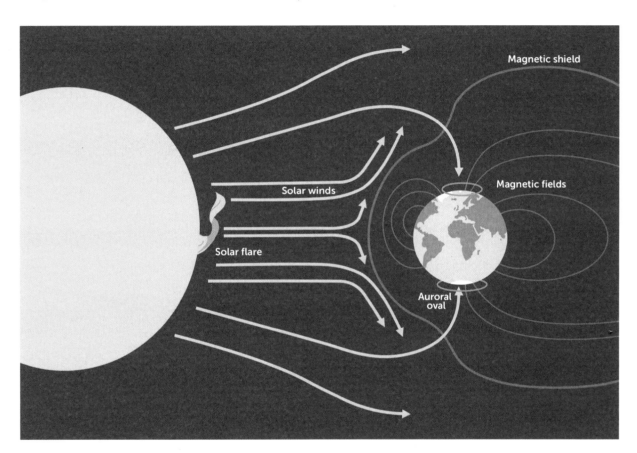

What Are the Northern Lights?

The northern lights occur when charged particles (electrons and protons) collide with gases in Earth's upper atmosphere. These collisions generate tiny flashes, filling the sky with colorful light. As billions of these flashes occur in quick intervals, the auroras seem to be dancing across the night sky. In essence, the auroras occur when an interaction between Earth's magnetic field and solar wind takes place.

These otherworldly lights are undeniably one of the main reasons why I adore polar night so much.

Although green is the most common color found in the northern lights, fortunate viewers might witness the aurora borealis in varied shades of pink, red, blue, purple, and even yellow. The colors vary based on both the altitude of the northern lights and the variety of gases in our atmosphere. For instance, green auroras occur at the lowest altitude, making them the most visible color, whereas a red aurora signifies a collision between solar storm particles and oxygen atoms at an altitude of up to 186 miles (300 km) or more from the ground.

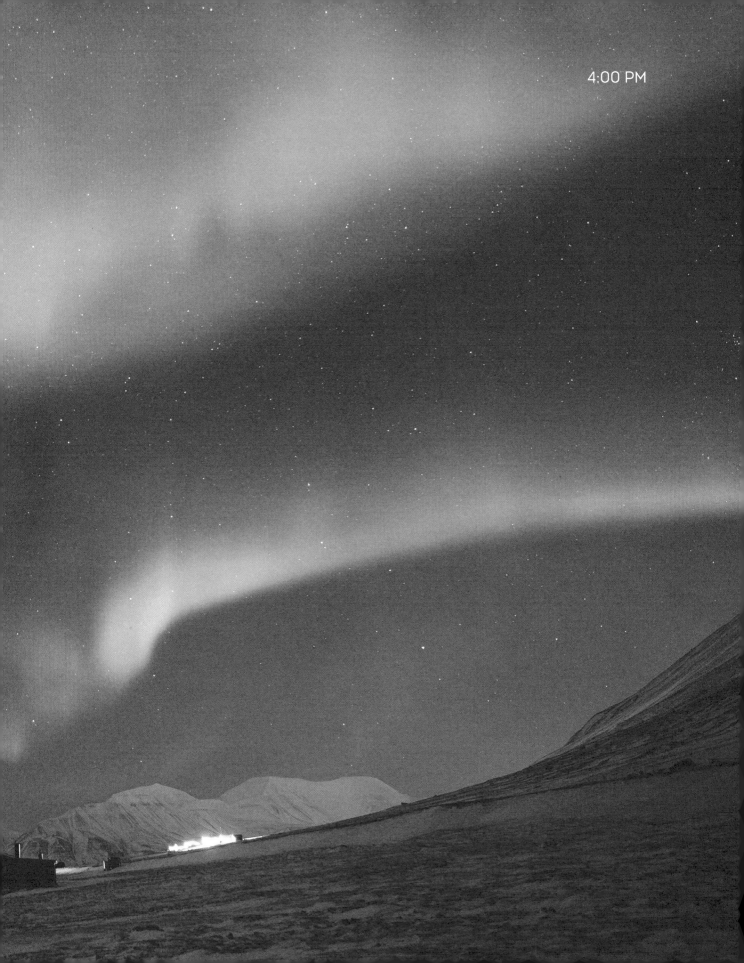

An Unexpected Morning

It has been 70 days since the sun last set on Svalbard, 70 dark, peaceful days here in the far north. A little more than 30 of these days have been pitch black, with no light reaching us at all. We wake up to dark skies, eat lunch with the stars, and go to bed with only the moon as a night-light.

After more than 30 days of waking up to complete darkness, imagine my disbelief when I walked outside this morning to bright pink-and-purple skies. *What is that?* I said to myself as I stood outside in my pajamas in 0°F (-18°C), peering at the bright horizon. It looked so out of place that my immediate feeling was almost that of fear. *What month is it? Isn't it December?* There shouldn't have been any light for a few more weeks. I stood there, gazing for several minutes before it dawned on me. I had seen this before.

This rare phenomenon was something we had witnessed only a handful of times over the last few years on Svalbard. The warm colors I was seeing were caused by polar stratospheric clouds. Within these clouds, ice crystals split the sun's rays, and when the clouds were positioned just right between Svalbard and the Scandinavian mainland, red light was directed toward us, resulting in a beautiful, pinkish sky.

I hurriedly called Christoffer and Grim to join me outside to marvel at the stunning morning sky. Christoffer has already spent a decade on Svalbard, so even though he still admires nature's beauty, he perhaps doesn't possess the same childlike awe as I do. After all, he is a 47-year-old Norwegian Viking. I wrapped myself up in my usual puffy down coat and headed outside with Grim tagging along. For my well-being, there's nothing quite as vital as spending time outdoors during the dark winter days, and what could be better on a morning like this?

Settling by the glowing embers of the open fire I'd kindled, I gazed up, witnessing a subtle streak of northern lights beginning a graceful dance in the sky above me. I spent the entire rest of the morning outside, watching the pink glow take over the dark sky, feeling very lucky to witness such a unique phenomenon! The red sky lingered for a few days before gradually fading away, ushering our world back into the familiar darkness of the polar night.

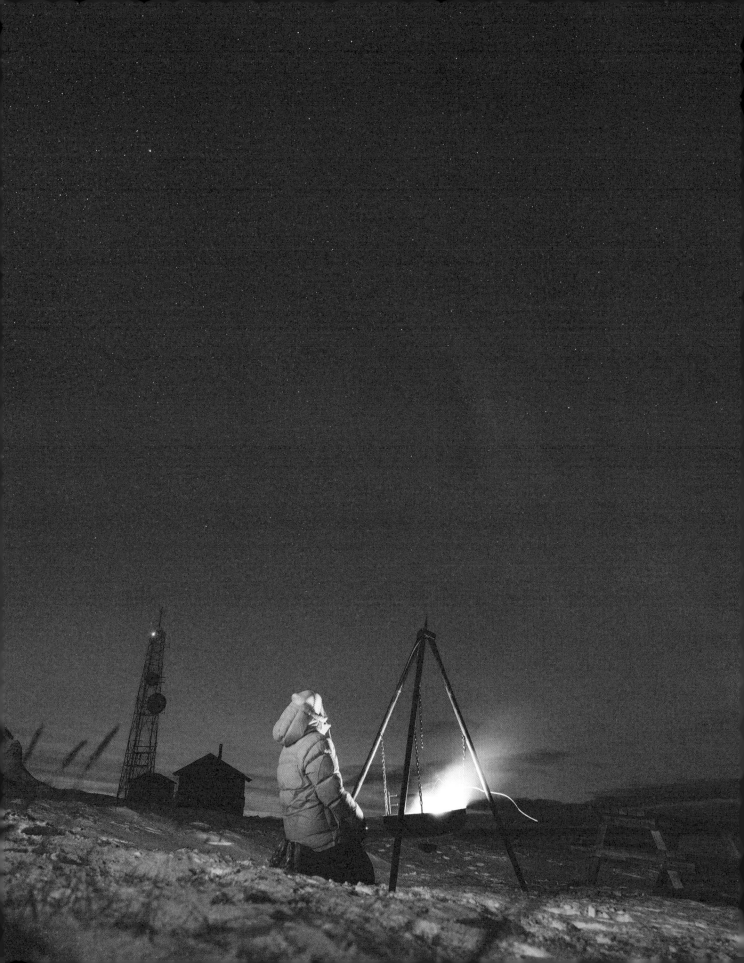

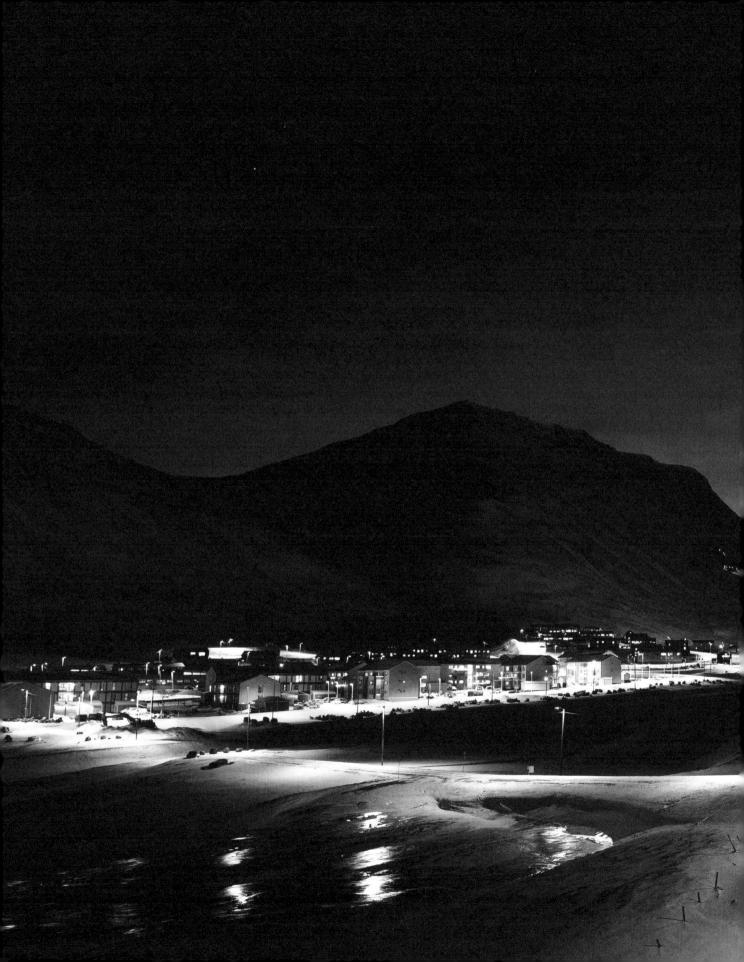

Pastel Winter

In February, the light returns to Svalbard, slowly waking the island from its polar night slumber. Emerging from the long darkness is nothing short of spectacular. After so many months without seeing the world around us, we must reacquaint ourselves to our surroundings.

As the sun climbs toward the horizon, the heavy blanket of darkness that enveloped Svalbard during polar night begins to lift, making everything look dreamy and magical. The sun's gentle glow paints our world in soft colors. The subtle contours of the landscape, once hidden, now come to life under vibrant hues. It's not exactly full daylight but more like a beautiful, soft light that transforms our world anew. With each day that passes, the first sunrise since October grows closer. Finally, on the sixteenth of February, the sun comes above the horizon once again.

This period, which leads up to the return of regular hours of daylight in mid-March, when we have distinct day and night, is commonly referred to as our pastel winter. This time is all about transformation and rejuvenation. When this season arrives, it always feels like a new beginning for Svalbard.

Blue Hour

As January nears its end, a long-awaited moment graces the Arctic landscape: a glimpse of sunlight. The sun climbs to a position that's closer to the horizon's edge, which allows light to spill out over our icy landscape for the first time in months, coloring the darkness in the west a deep tangerine. The transition from darkness to daylight isn't instantaneous. When it first returns, the light lingers for a few minutes, just long enough for us to get a glimpse of the rays glowing in the horizon, creating a gradient sky of orange, pink, and blue. It's a beautiful time of year, when light meets dark, the stars twinkle against the newly colored sky, and the sun reminds us of her full impending return in a few weeks' time. As these brief moments of light fade, the entire world around us takes on a mesmerizing deep-blue hue. The blue is so rich it almost feels like you could stretch out your arms and gather a handful, like something out of a dream.

In the weeks leading up to the sun's full arrival, a prolonged period of civil twilight known as blue hour takes over. At lower latitudes elsewhere in the world, blue hour generally occurs right after sunset and before sunrise, usually only lasting between 20 and 90 minutes each time. Here on Svalbard, the entire month of February is blue hour due to the extended long hours of the dreamy blue light that show up again and again each day.

Our morning coffee on the deck of our cabin once again comes with a breathtaking view of our surroundings, a sight I have surely missed during the darkness of polar night. The snow-draped mountains and majestic glacier fronts that were once mere dark silhouettes across the fjord are now unveiled by the emerging light. Hiorthfjellet, the striking mountain backdrop of Longyearbyen, is distinctly visible, bathing in these rich February hues. Elsewhere on Svalbard, our epic landscapes slowly start coming back into the light.

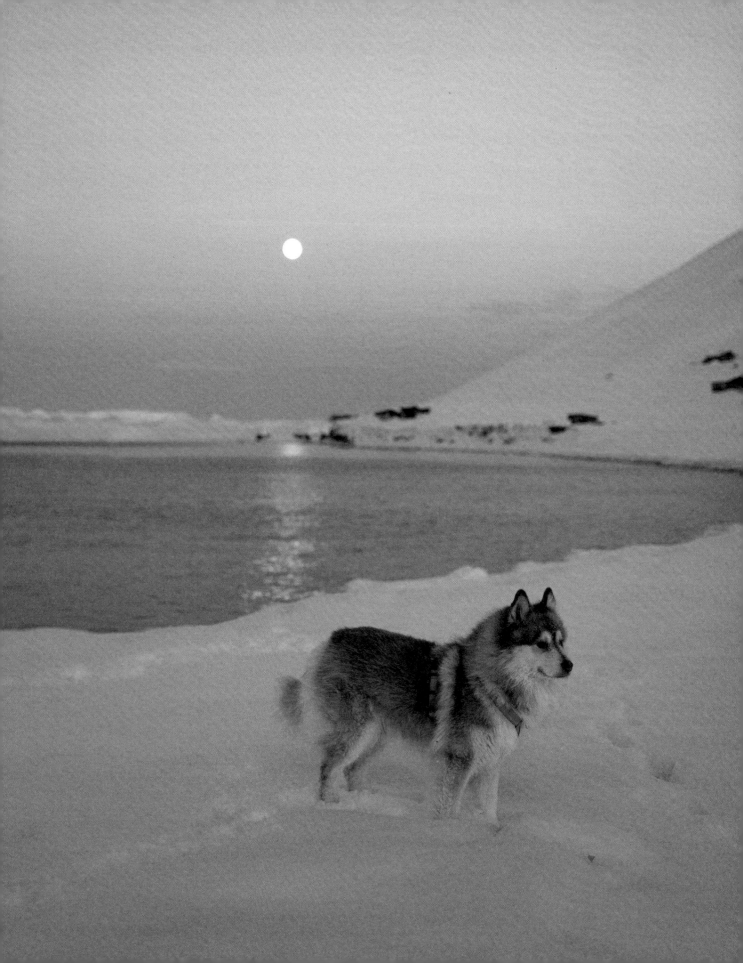

Having lived in a monochrome world for so long, all the colors that arrive during this period feel bold and amplified.

I find this season to be profoundly poetic. There's something that feels spiritual about being reintroduced to the light after living in the darkness for such a long period of time. And this is coming from someone who does not typically consider herself to be a spiritually inclined person. During blue hour, we come back into the light with a fresh perspective. Having lived in a monochrome world for so long, all the colors that arrive during this period feel bold and amplified.

It was this ethereal blue light that initially sparked my passion for photography. During my first year on Svalbard, I purchased my first drone equipped with a camera. The bird's-eye view of the Arctic I was able to see with this new device immediately captivated me. Witnessing the intricate patterns of frozen glacier streams, walruses drifting on pristine, white ice floes against the deep blue sea, and unobstructed panoramas of our island was surreal. After experimenting with aerial photography, I took the plunge and decided to make my first professional camera purchase to fully embark on a creative journey to capture Svalbard's beauty.

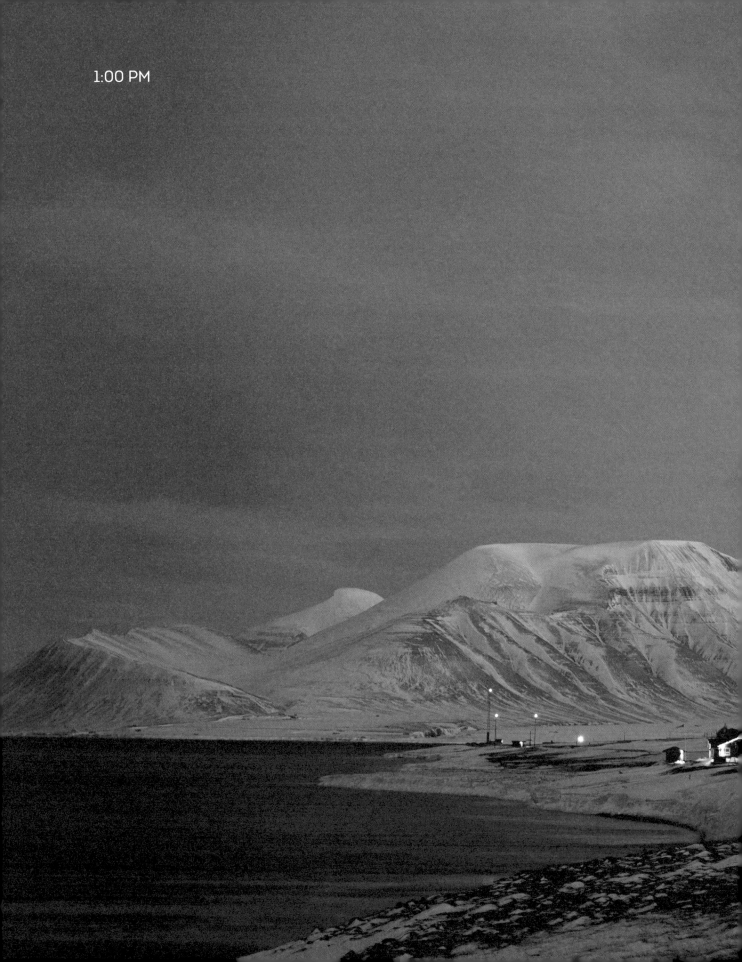

1:00 PM

This decision to take up photography as a new hobby led me to a life-changing experience. As I delved into the world of photography, I started sharing my photos on my social media accounts, giving insight into what life is like on Svalbard. My online presence began gaining momentum and was further defined when I shared a short video of me walking with Grim during polar night, a dancing aurora above us and polar bear tracks beside us. I captured the scene with my phone in a very simple format, posted it, went to bed, and woke up the next day to find out it had gone viral. This marked the turning point of my journey on social media, and led me to where I am now, sharing my extraordinary life here on Svalbard with millions of people around the world.

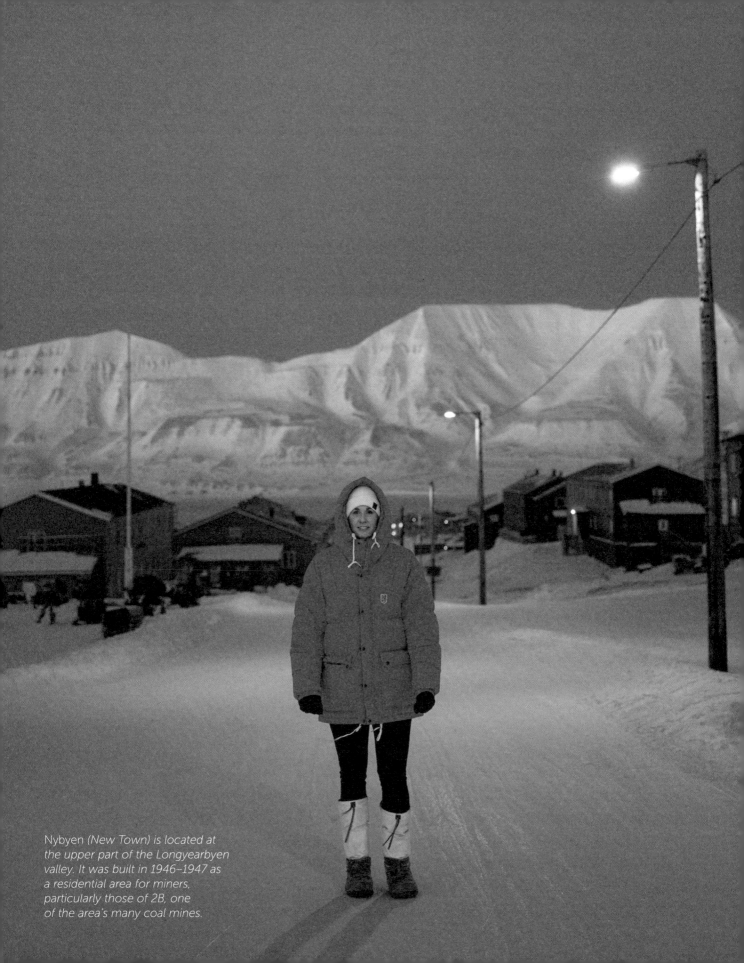

Nybyen (New Town) is located at the upper part of the Longyearbyen valley. It was built in 1946–1947 as a residential area for miners, particularly those of 2B, one of the area's many coal mines.

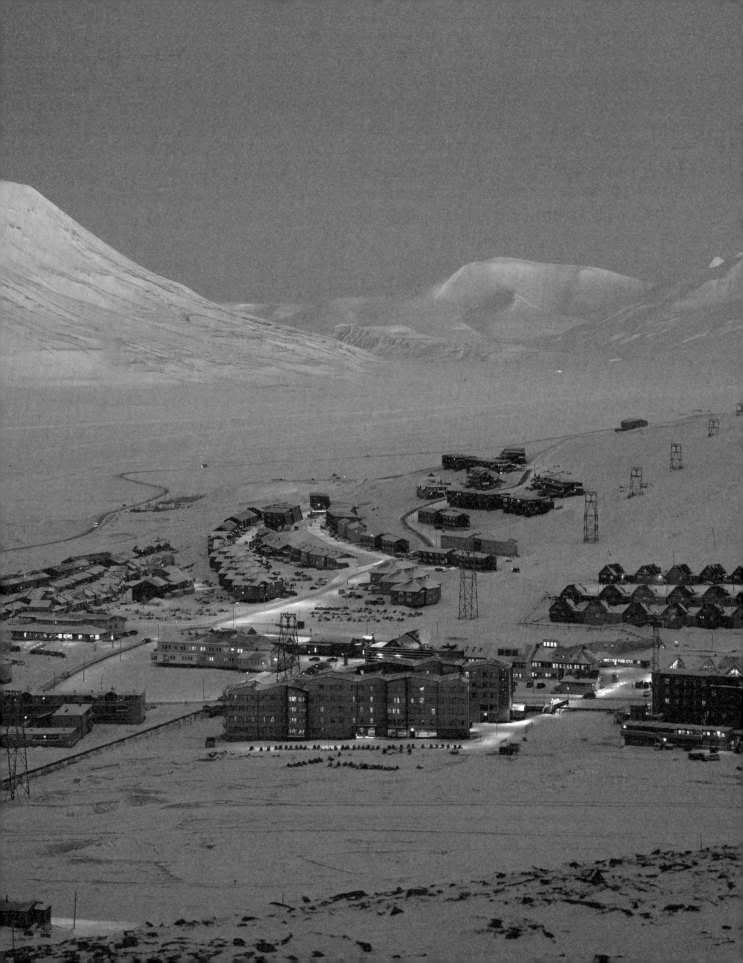

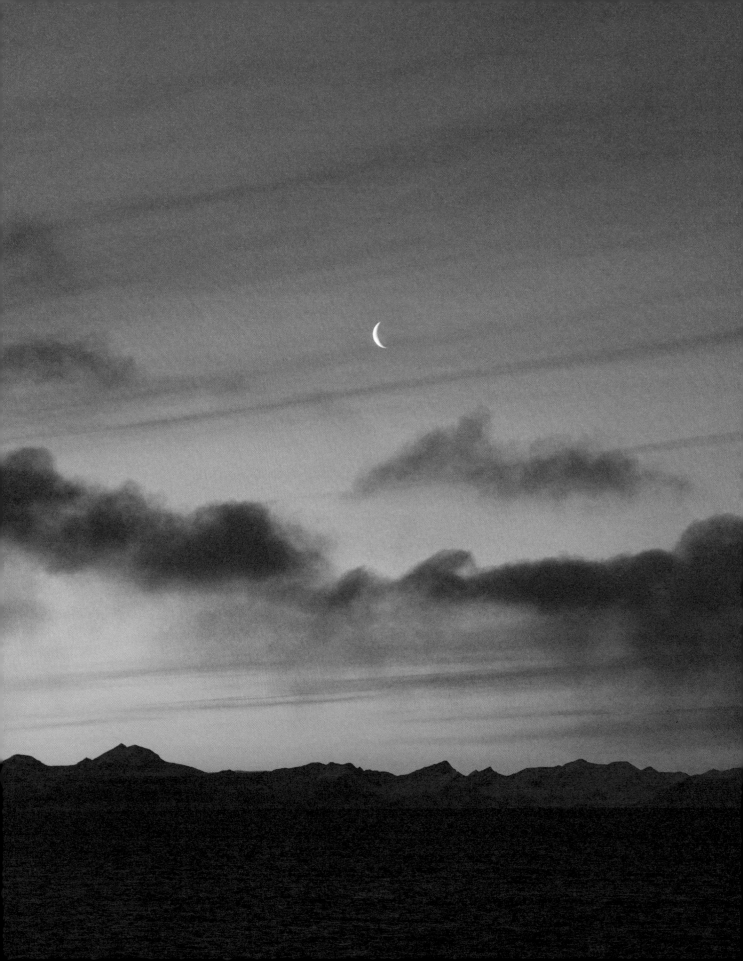

Twilight

During the weeks before and after polar night, the magic of blue hour takes center stage. At this time of year, the sun is positioned just below the horizon, so the blue particles of light are bent by the atmosphere, resulting in our Arctic landscape being colored in rich blues.

The term "blue hour" describes this natural phenomenon, which is typically observed during civil twilight and the early stages of nautical twilight, around dawn or dusk. Twilight refers to the time before sunrise and after sunset when the atmosphere is partially illuminated by the sun. There are three types of twilight: civil, nautical, and astronomical, which are all defined by how far the sun is below the horizon.

Civil twilight, the brightest phase of twilight, stands in contrast to astronomical twilight, the darkest, which occurs just before or after night.

Although the order of twilight phases remains the same globally, their duration varies based on your geographical location. On Svalbard from the middle of November to the end of January, the sun never reaches a position of -6 degrees, which means we experience no civil twilight and no blue hour during this period. By January 30 though, civil twilight returns marked by a faint glow appearing on the horizon. As the sun climbs higher with each day, the blue hour returns.

How long blue hour lasts depends on the latitude and the season. In areas that experience polar night during winter, the sun might not move higher than 4 to 8 degrees below the horizon at noon, creating a blue hour that can last for several hours.

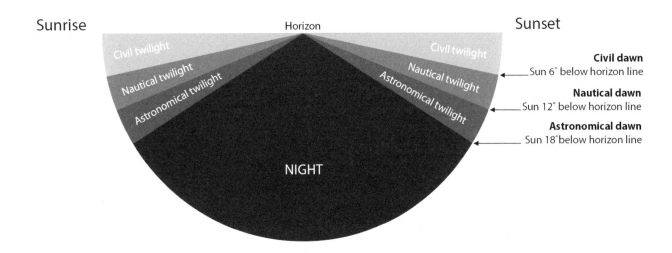

Polar Bears

It's a dark and blustery morning on Svalbard. The snow flurries outside have completely covered the small, square windows in our door. I stand in the hallway, contemplating whether I should put on another layer of clothing. After a brief deliberation, I opt not to. The worst of the snowstorm has finally subsided after a few days of fierce winds, leaving behind a fresh blanket of snow.

I lace up my hiking boots, generating a slight sweat beneath my thick, wool thermals. Wrapped in my cozy down jacket and wearing substantial wool accessories, I'm now prepared to face the weather. Grim, my furry companion, is well-suited to handle the -4°F (-20°C) with his winter fur. As we step outside for our morning walk, I swing my firearm over my shoulder. Here on Svalbard, we never venture into the wilderness without a firearm in case we need to protect ourselves from polar bears.

We stroll along the unlit, snow-covered road, relying solely on my headlamp to guide the way. Glancing around, I notice my light suddenly catch the glimmering eyes of a presence high up on the mountainside. I cast a quick glance at Grim to gauge his response. He remains content, preoccupied with sniffing around the snowdrifts, occasionally casting an untroubled glance into the distance. *It must be a reindeer*, I tell myself, relieved by his nonchalance. We continue our walk, heading further into the deep morning darkness.

Svalbard is an island that's known for its extreme beauty and wilderness, but it is also home to one of the planet's largest predators: the polar bear, often hailed as the king of the Arctic. The Svalbard archipelago is estimated to be inhabited by approximately 3,000 bears, of which around 300 reside in Spitsbergen, the largest island of the archipelago, where I live. These remarkable animals can be found anywhere in the Svalbard region, all year-round.

When I was first preparing to move here, the idea of polar bear danger seemed so distant and surreal, it didn't even register as a real concern. The notion of encountering these huge, potentially dangerous bears and needing to carry a firearm with me whenever venturing outside the village was simply unfathomable. Yet, now as I step outside our cabin for my daily walk with Grim, the act of slinging my firearm over my shoulder has become second nature. The governor's office on Svalbard urges all individuals venturing beyond settlement boundaries to be equipped with suitable tools to deter polar bears. The government website advises: "Anyone traveling outside settlements must be equipped with means of scaring off polar bears. The office of the Governor of Svalbard asks you to carry a firearm with you, as well as a signal pen or flare gun."

Polar bears find themselves at the very top of the food chain since they don't have many natural predators. The polar bear has been protected by international law since 1973, and any engagement in hunting, baiting, tracking, feeding, or causing disruption to polar bears is deemed a criminal offense. The firearms we carry on Svalbard are strictly reserved for life-threatening situations, and in the unfortunate event that they must be used, a thorough investigation will follow. Beyond the village boundaries, it is our responsibility to avoid polar bears. Actively seeking them out is prohibited by law.

The likelihood of encountering a polar bear on our daily walk remains low, but it's never nonexistent. During the four years I've lived in our cabin, it has only happened to me once. It was an especially cold winter that year, with the fjord outside becoming entirely frozen. Grim and I were returning from our daily walk when we noticed a figure moving across the ice, several hundred feet away. To our amazement, it was a polar bear making its way across the frozen fjord.

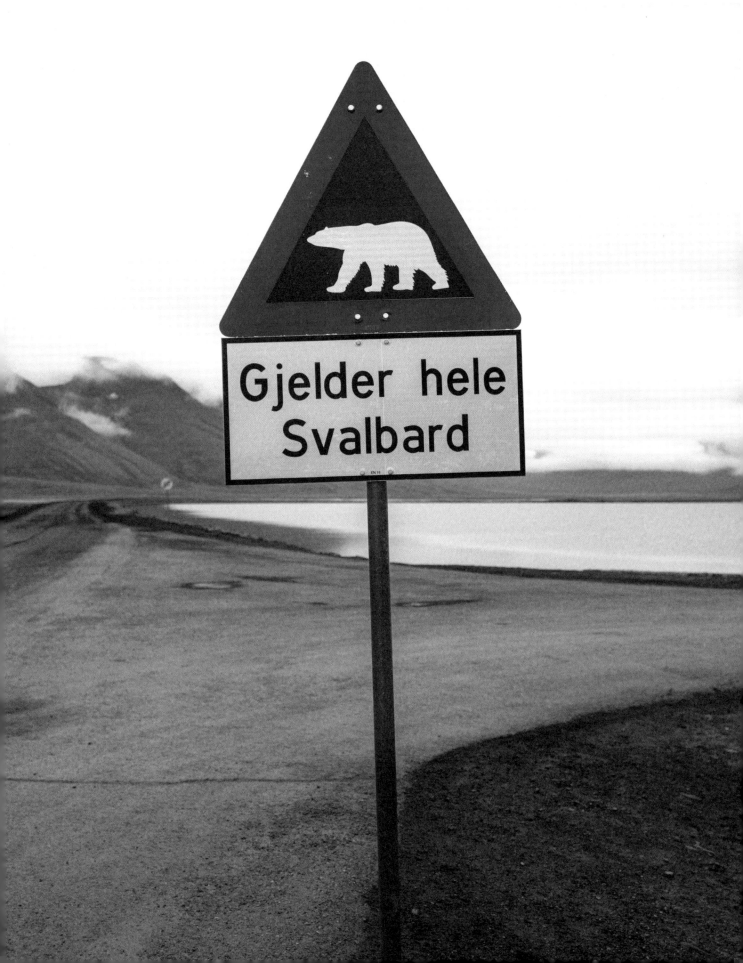

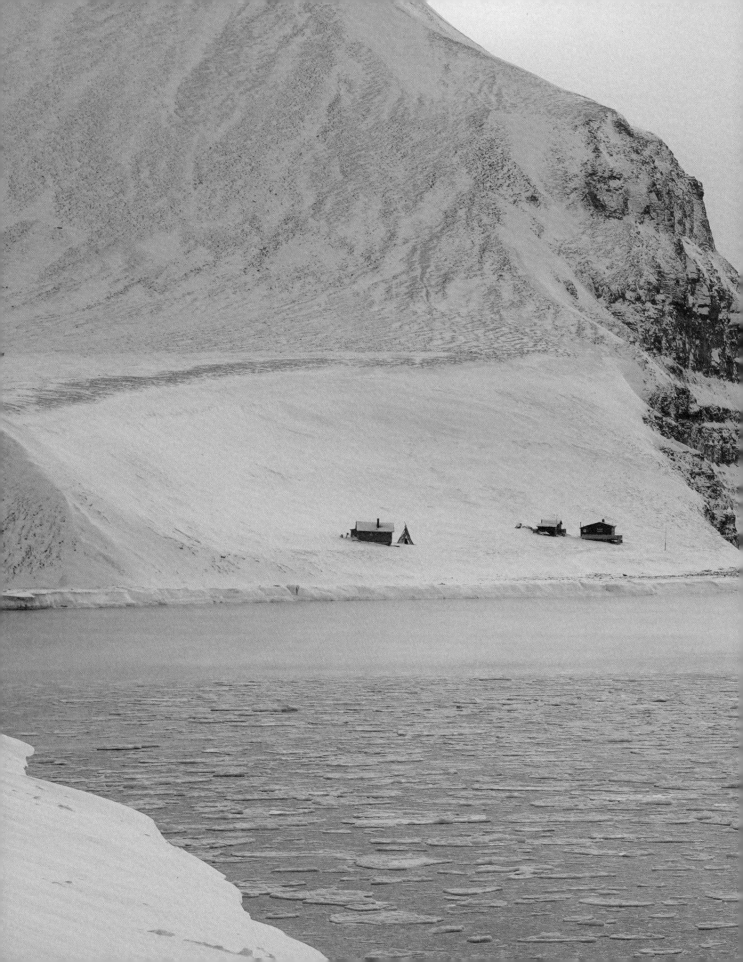

In situations like this, the protocol is to promptly notify the government, and more importantly, to maintain a safe distance. I watched for some time as the polar bear playfully hopped from one ice floe to another and continued its journey into the adjacent Bjørndalen, ultimately vanishing into the depths of the valley.

At the village's edges, you'll encounter signs that serve as a constant reminder of the polar bear presence, emphasizing the necessity for polar bear protection beyond the designated "safe zone." Inside the village, it's not necessary to carry a firearm, and it's strictly prohibited to walk around with a loaded one while in town. Nevertheless, there's no guarantee that a polar bear won't occasionally wander through Longyearbyen. While polar bears are generally deterred by the bustling sounds of our village, their keen sense of smell and natural curiosity may still entice them to explore the streets of Longyearbyen.

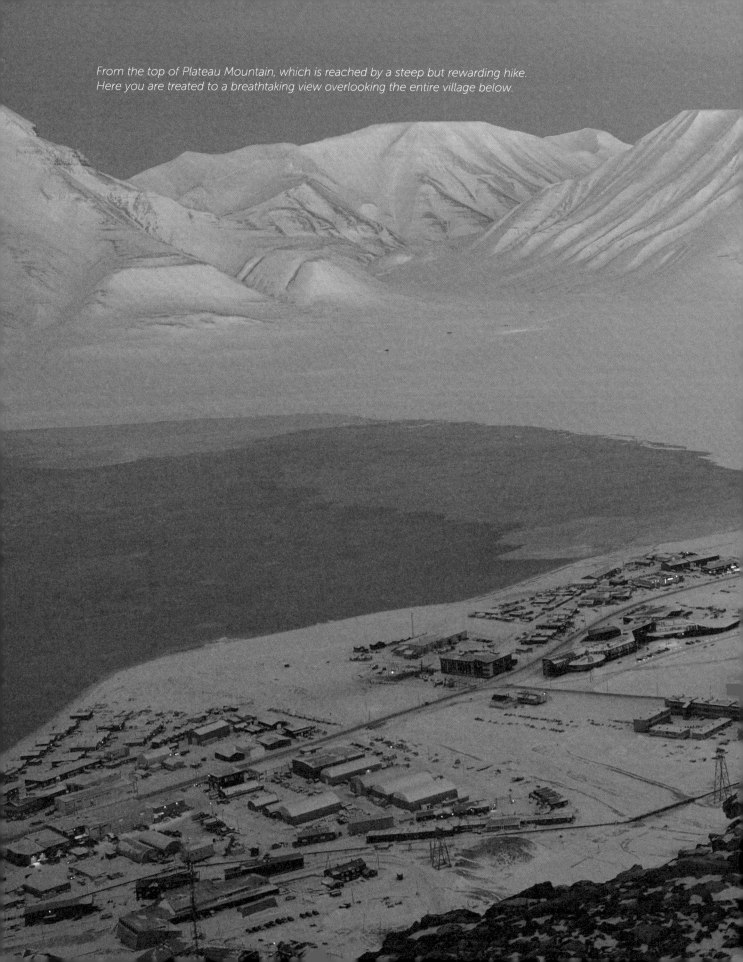

From the top of Plateau Mountain, which is reached by a steep but rewarding hike. Here you are treated to a breathtaking view overlooking the entire village below.

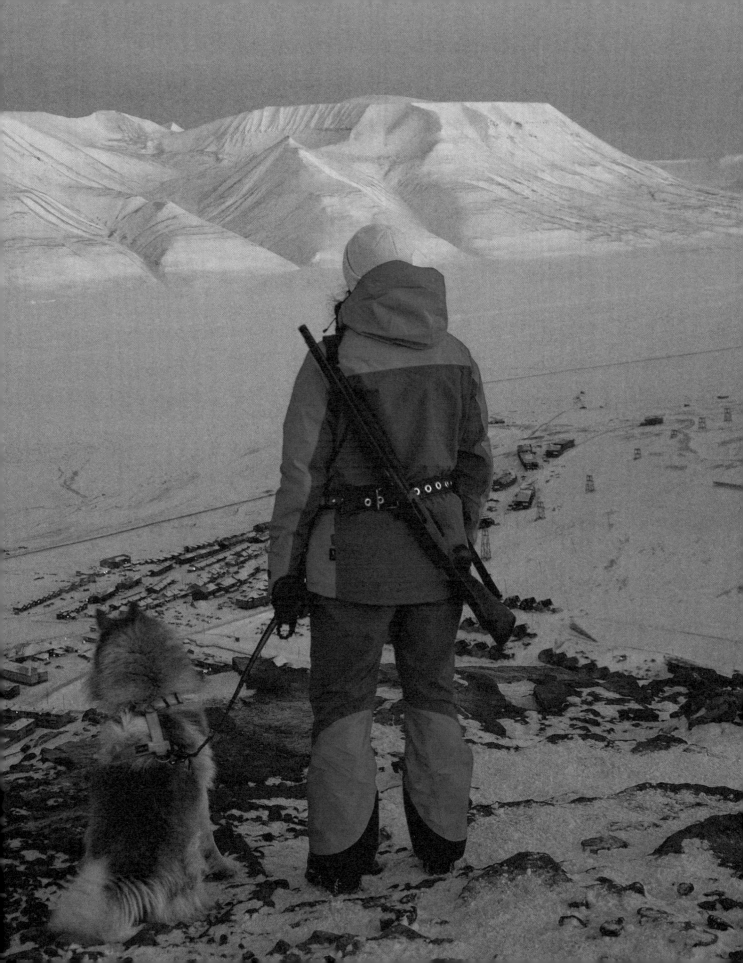

We must exercise extreme caution in our surroundings and show the utmost respect for the environment in which we live.

After a curious polar bear was spotted going on a leisurely stroll through our kindergarten building's front yard many years ago, a decision was made to put up fences around the school to further protect the children. These fences also serve to prevent reindeer from encroaching too close, as they frequently meander through town. Funnily enough, I believe this fence may be more beneficial for the reindeer's safety. They are easy-going creatures, and the fences shield them from any potentially overwhelming interactions with the children. While nobody was hurt in that interaction with the polar bear, the same cannot be said for every encounter.

Occasionally, there are fatal run-ins with polar bears, as was the case a few summers ago. In this tragic event, a person working at a campsite below the airport was killed by a polar bear while inside their tent. This devastating incident left the entire town in shock, serving as a stark reminder of the danger posed by these animals. This is why we must exercise extreme caution in our surroundings and show the utmost respect for the environment in which we live.

Witnessing the incredible polar bear in its natural habitat is undeniably awe-inspiring, as long as it's done from a safe distance. Our snowmobile journeys sometimes provide a wonderful opportunity to spot one. Watching from afar—often miles away—as a polar bear hunts for ringed and bearded seals on the sea ice is an experience I don't take for granted. And I'll never forget the time when we were at a secluded cabin, a 2-hour snowmobile ride from Longyearbyen, and two polar bear cubs decided to explore our snowmobiles. We had to resort to opening the window and shouting "No!" which promptly sent them scurrying away. Hopefully, that will be the sole instance where I find myself in such proximity to a polar bear.

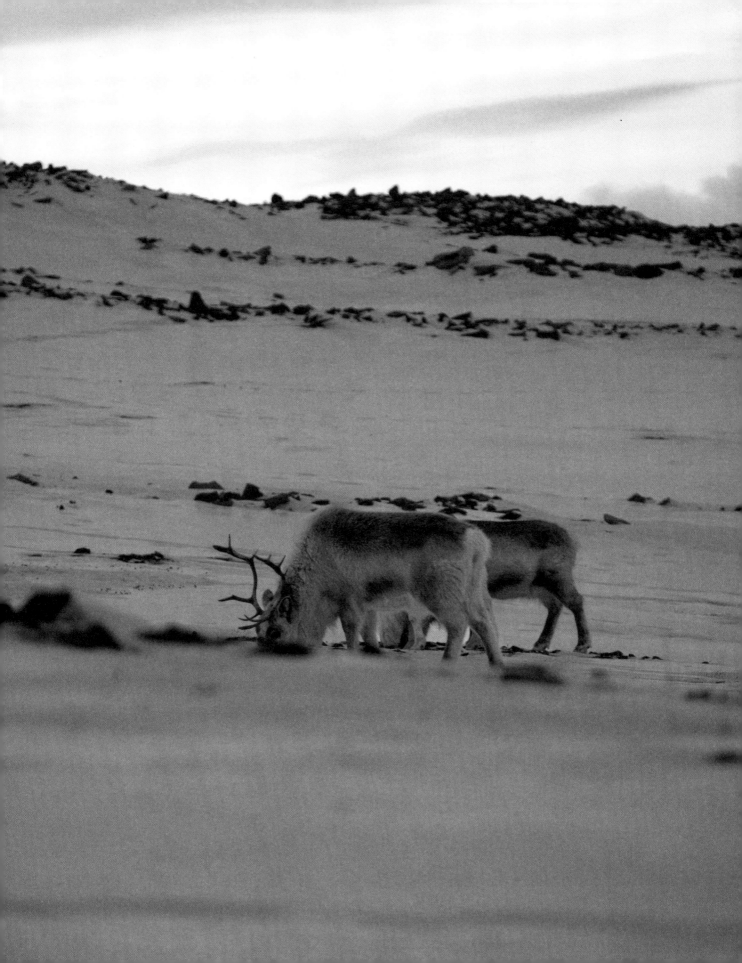

DIARY ENTRY
FEBRUARY 20

Cabin Trip in Agardh Bay

We left Longyearbyen around 10 a.m. to drive our snowmobiles to the east coast and spend a few days in a small, remote cabin in a location called Agardh Bay. We loaded up our snowmobiles and sleds with all the essentials for our off-grid adventure, including firewood, water, food, and gasoline. As we left home, our thermometer displayed a freezing -22°F (-30°C) degrees! The drive out was one of the coldest I've ever experienced. We only got about 10 minutes into our 2½-hour snowmobile drive before I had to put another jacket on top of my already massive puffer jacket.

You might be wondering, *You already live in a cabin in a pretty remote place—why go to an even more remote one?* Well, that's precisely what life here is all about, and we absolutely love it! There's something special about going completely off-grid for a few days to just enjoy the silence and experience life without distractions—to fully live in the now and have an adventure. My friend Linn also joined us on this trip, as we embarked into the Arctic wilderness to kick off cabin season!

Getting around Svalbard presents challenges due to the absence of roads leading out of Longyearbyen. The first part of our journey was relatively straightforward, mostly following the valley leading out of Longyearbyen for 25 miles (40 km) eastward. However, even the simplest paths can become perilous traps during severe weather, which was why we planned our trip entirely around the weather conditions. Light snowfall can quickly escalate into a whiteout, completely obscuring visibility and making it impossible to see where you're driving. Under these conditions, many accidents have tragically taken place, with people inadvertently veering off cliffs, resulting in serious injuries or even fatalities. Routes often wind through rugged mountain passes and snow-clad glaciers, and relying on GPS becomes crucial to navigate the perilous terrain.

After driving for a total of 52 miles (84 km) through the gorgeous blue light of February, we arrived at our destination just as the sun was setting across the fjord. It was our first time seeing a glimpse of the sun since October last year. As it slipped behind the mountain, it cast us into an even deeper shade of the typical wintry blue light this season is famous for. I find this time of year to be even more disorienting for my daily rhythm than polar night. We have daylight, but when the sun sets midday, it's easy to mistake the darkness of 3 p.m. for nighttime.

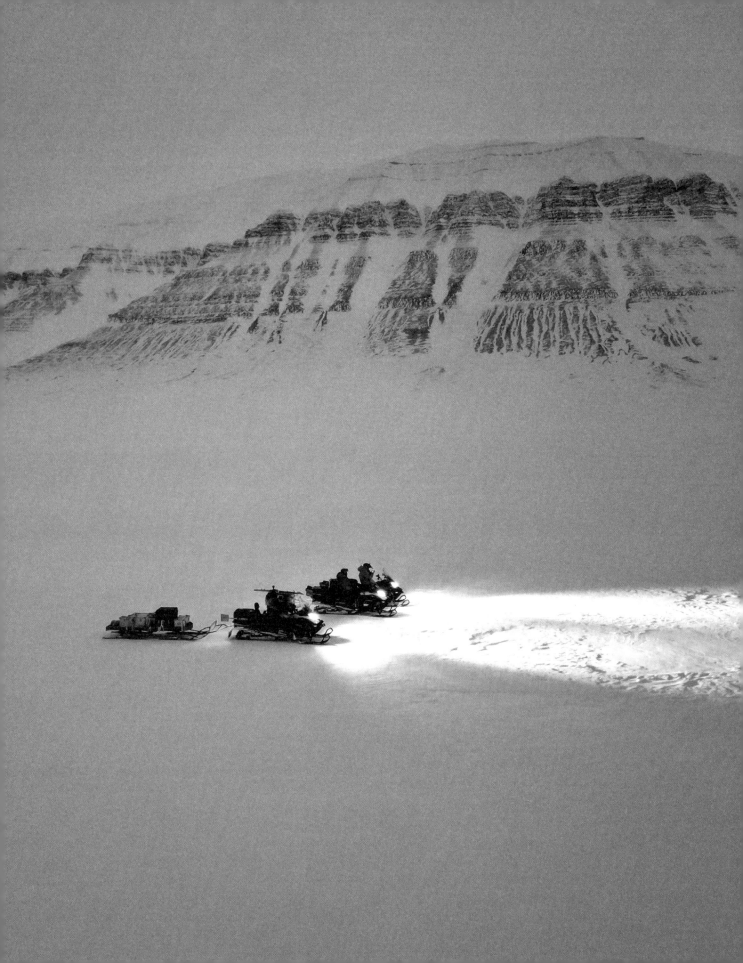

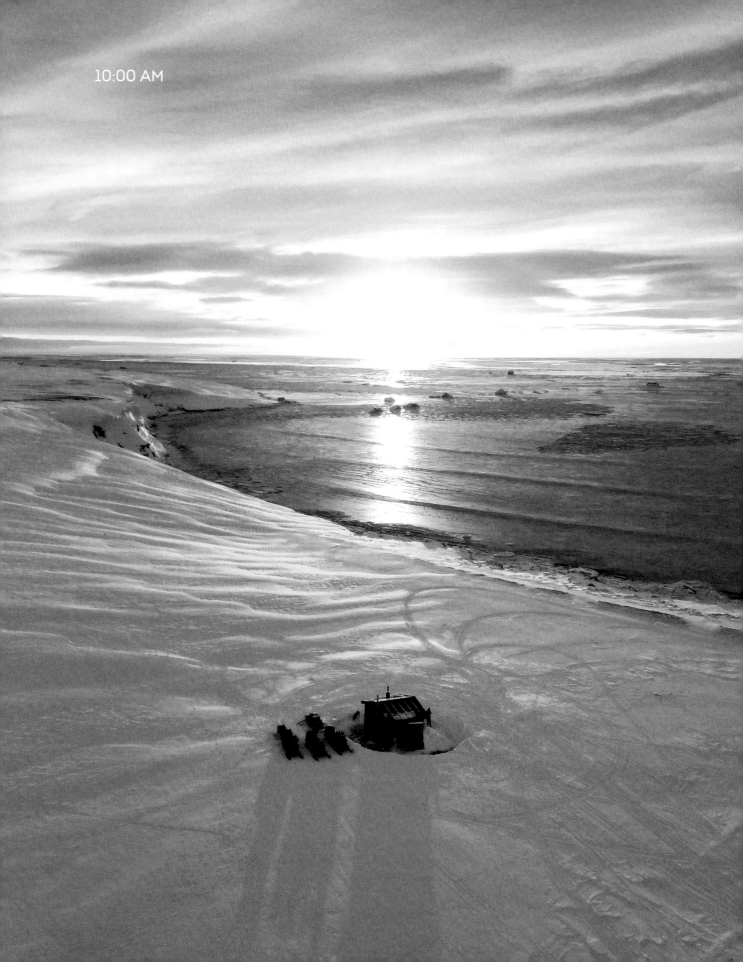

AGARDH BAY

After driving on the snowmobile for 2½ hours in freezing temperatures, it felt like heaven to come inside the cabin and light up the fireplace. I needed warmth to thaw my hands and feet! The cabin appeared to be in good condition. The sturdy wooden boards covering the windows to protect them were all still intact, showing no signs of any recent polar bear break-ins. The sight of wooden window covers torn off the wall is always a telltale sign of a polar bear trying to get inside. I was relieved, since during another cabin trip to Calypsobyen, which was a 5-hour drive from town, we arrived at the cabin only to find that a polar bear had broken four windows. We utilized Styrofoam found in one of the rooms, along with a blanket, to fashion a temporary window to keep the heat inside. Given that these cabins are in remote areas, you learn to improvise with available resources. That was another very cold trip.

The first day was a bit of a slow one, as everyone felt quite tired from the journey. We spent the afternoon inside, talking, drinking coffee, and enjoying some food. This year hasn't been particularly cold so far, which means the fjord outside the cabin only has a thin layer of ice, unlike the usual solid sheet. We haven't seen any tracks or signs of polar bears around, but we always keep our eyes open when out in these very remote places on Svalbard.

As night fell over our little cabin, I went outside to use the outhouse and found the entire sky was glowing with northern lights! I called Linn to join me. We spent hours in our pajamas, watching the aurora borealis dance across the sky in the darkness of the night.

The next day when we opened the doors, we were met with something we hadn't seen in a very long time: the morning sun! Since we were on the east coast, we had an unobstructed view of the horizon and the sunrise. The sun rays bounced off the winter landscape, making the snow sparkle and creating shadows.

The long and arduous Svalbard seasons give you a great appreciation for things like this. The first rays of sunlight after 4 months of going without make you feel like you are meeting up with an old friend you haven't seen in a while. Even though so many things have happened since you last saw each other, you pick right back up where you left off.

Stargazing

As the light slowly returns, our real winter arrives. February and March are the coldest months here on Svalbard, with temperatures often dropping below -4°F (-20°C) and getting as cold as -22°F (-30°C). While the allure of staying indoors by the fire during this season is strong, the regularly clear skies makes it an ideal time for one particular activity: stargazing. The night sky becomes incredibly bright and full of stars. It's the best stargazing you can imagine, with the stars shining brilliantly against the dark winter night. I can't recall ever seeing a night sky as clear as it is during this time of year on Svalbard. We get to witness the northern lights dancing, satellites zooming across the sky, and the Andromeda Galaxy shining brightly, clearly visible to the naked eye.

I've always been deeply fascinated by the night sky, so picture my amazement stepping outside on a clear, cold evening to see what feels like every single star shining up in the sky. It's like standing on the doorstep to the galaxy. While I'm still a beginner in the realm of astrophotography, I have really enjoyed trying to get better at night-sky photography. It demands patience and encourages you to embrace a slower pace, allowing you to fully immerse yourself in the present moment. I often refer to nature as my form of therapy, and this becomes particularly apparent during the moments I spend outdoors beneath the night sky, capturing its magic with my camera.

It's the best stargazing you can imagine, with the stars shining brilliantly against the dark winter night.

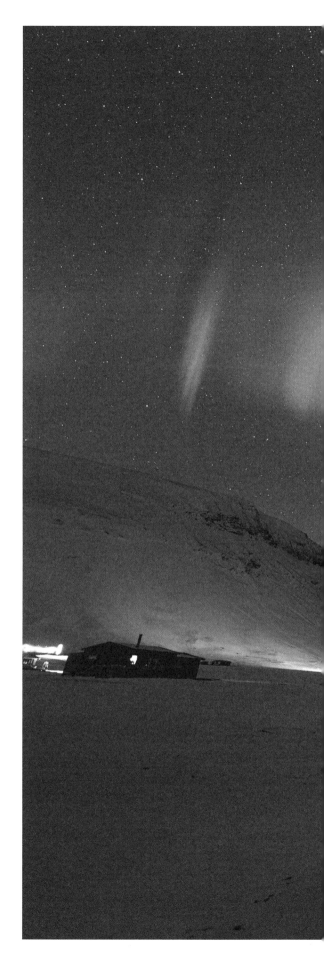

On my drive back from the village at 5 p.m., I was greeted by an awe-inspiring sight: the sky above our cabin was ablaze with the dancing colors of the northern lights. I had to pull over and step out of my car to fully appreciate the breathtaking display.

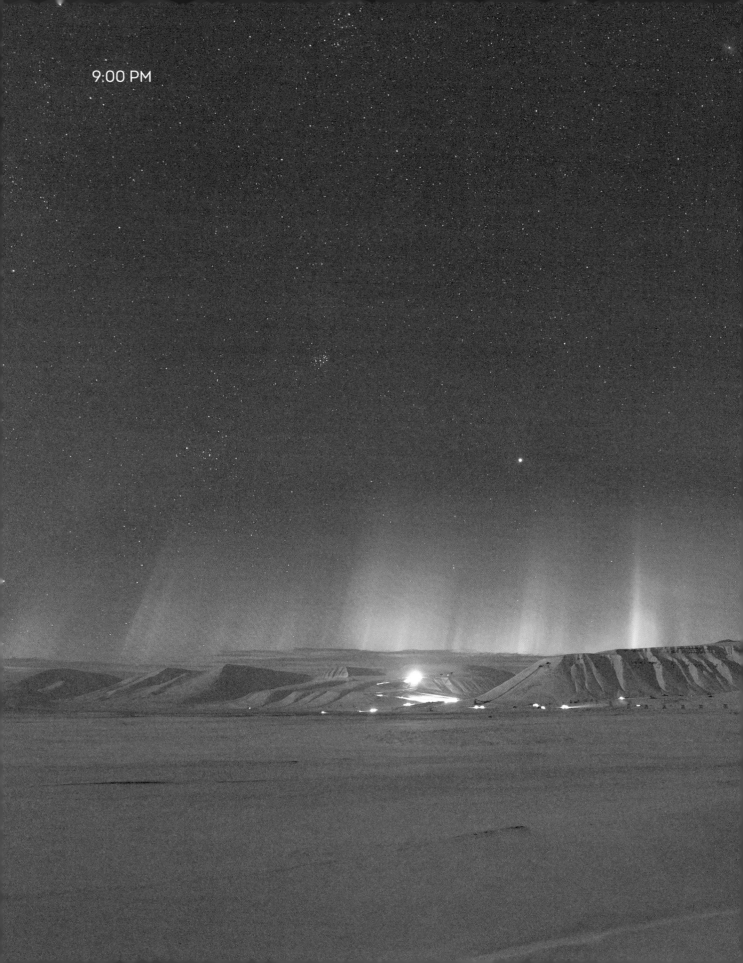

9:00 PM

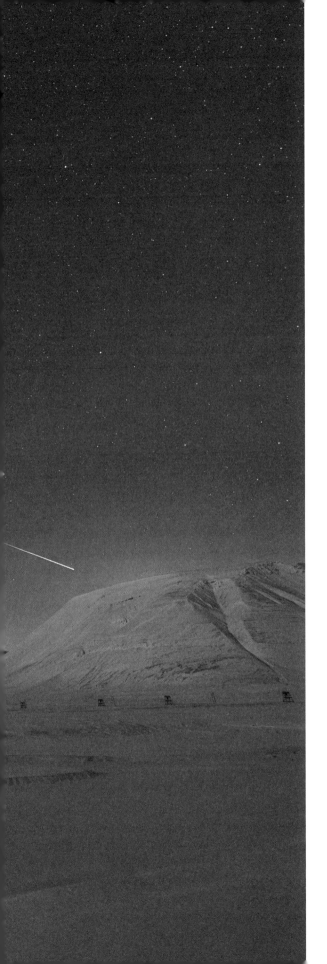

Starting out with astrophotography can be exciting and daunting, but having the right equipment can make a huge difference. If you want to take up the hobby of night photography this winter, let me share some of my beginner tips! Here's my list of must-haves:

- **Camera:**
 A DSLR or mirrorless camera with manual settings.

- **Lens:**
 A fast and wide-angle lens with a low f-number (e.g., f/2.8 or lower) for capturing more light.

- **Tripod:**
 A sturdy tripod to keep your camera steady during long exposure shots.

- **Dark-sky location:**
 A location away from light pollution for clearer and more vibrant shots.

- **Star map or app:**
 A star map or a mobile app to help identify constellations and celestial objects.

- **Headlamp or flashlight:**
 A red-filtered headlamp or flashlight to maintain night vision without disrupting others.

- **Warm clothing:**
 Multiple layers of warm clothing, especially if you plan to shoot in colder climates.

- **Patience and practice:**
 Night photography can be challenging, so take your time to experiment and learn from each session. It's a great idea to write down the settings that worked best for you so you know how to approach it next time. Enjoy capturing the beauty of the night sky, and remember, practice makes perfect!

Moving into Our Cabin

While I might portray life in Longyearbyen as somewhat idyllic, every place has its challenges. Throughout my time here, one persistent issue has been the housing shortage. Like many others, I found myself hopping between short-term apartments while in search of a more permanent accommodation.

My partner, Christoffer, and I bought our cabin when we had to leave the apartment we were borrowing from a friend and still hadn't found any other available house to move into. Upon seeing a listing for this cabin on our local Facebook page, we thought, *A cabin 5 miles (8 km) outside of Longyearbyen with no running water—this sounds like a great idea!*

Living in the village was fantastic, but moving out to the cabin expanded my Arctic world, making it feel significantly larger. What used to be a mere 30-second commute transformed into 10 minutes. I now had the luxury of listening to an entire song before reaching my destination. It might sound like a joke, but I assure you, it's not (well, maybe just a little bit). Svalbard boasts only around 37.3 miles (60 km) of roads in total, and everything in town is contained within a 2.5-mile (4-km) radius, which is why I didn't need to own a car during my first few years on the island.

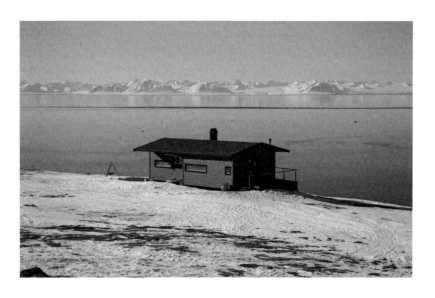

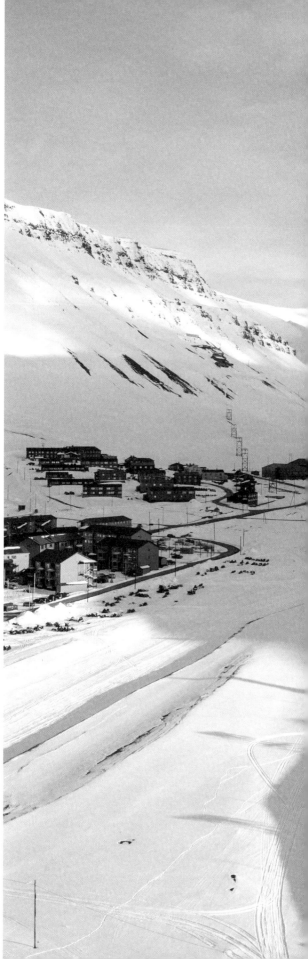

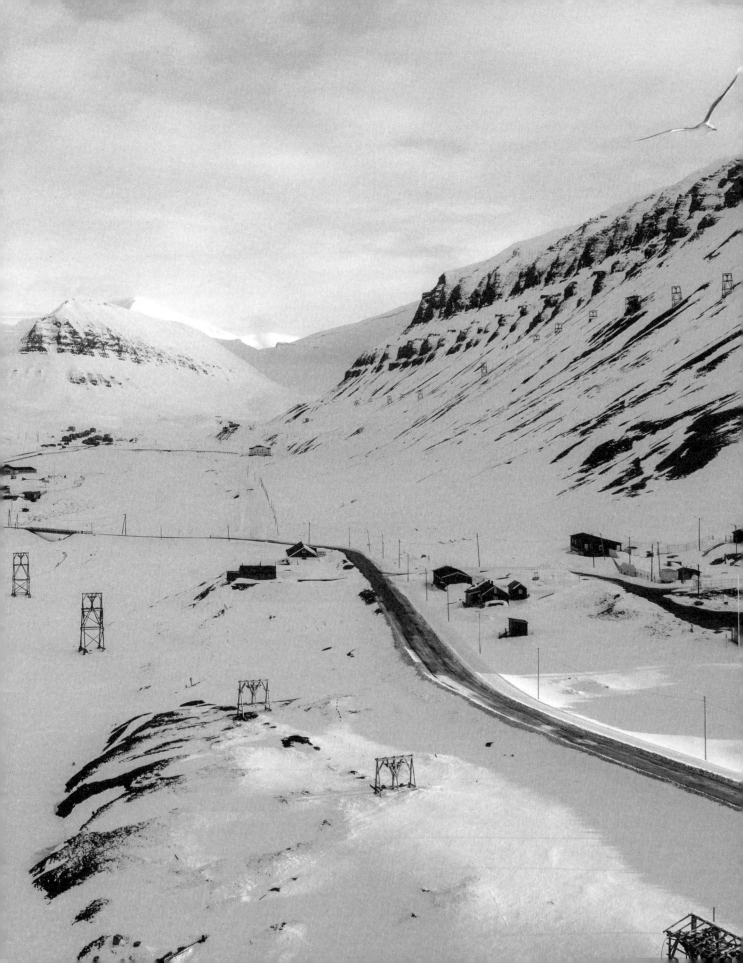

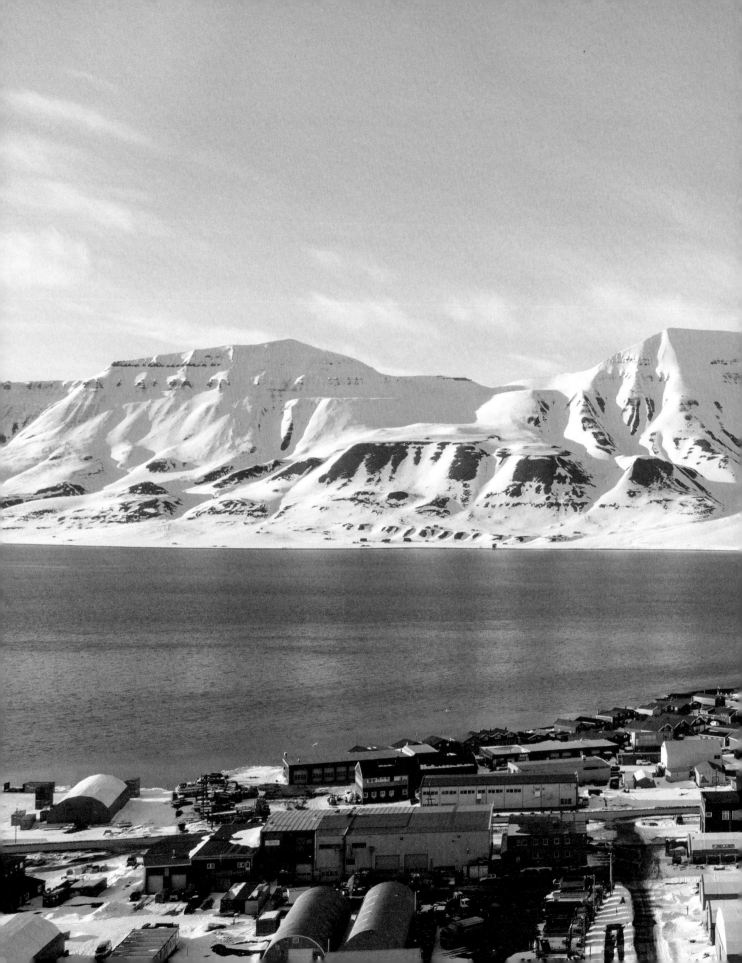

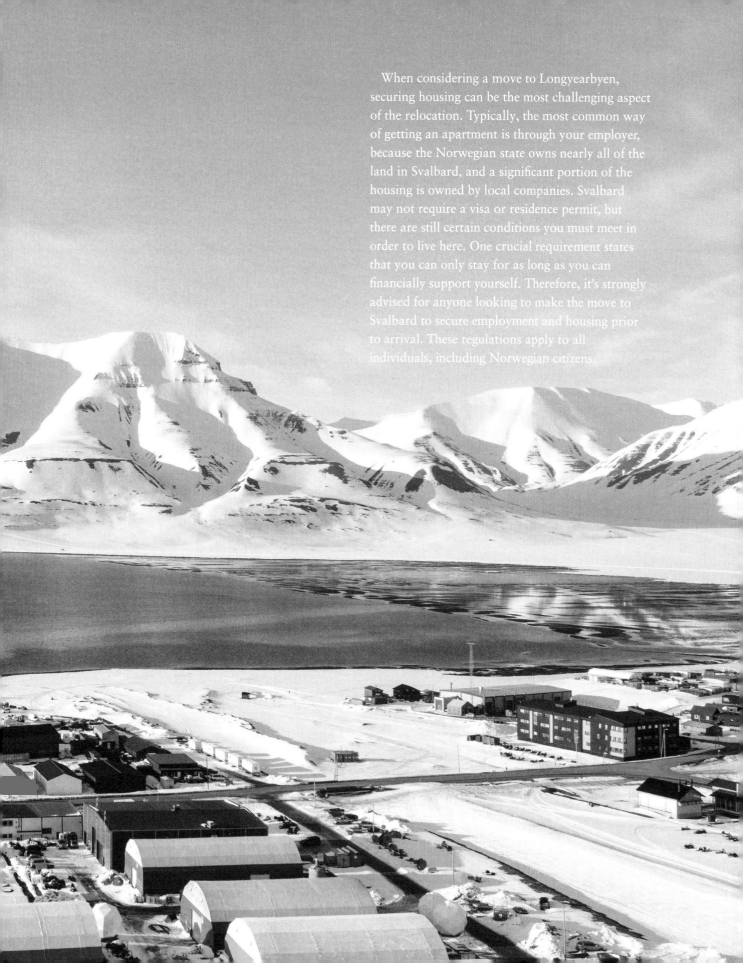

When considering a move to Longyearbyen, securing housing can be the most challenging aspect of the relocation. Typically, the most common way of getting an apartment is through your employer, because the Norwegian state owns nearly all of the land in Svalbard, and a significant portion of the housing is owned by local companies. Svalbard may not require a visa or residence permit, but there are still certain conditions you must meet in order to live here. One crucial requirement states that you can only stay for as long as you can financially support yourself. Therefore, it's strongly advised for anyone looking to make the move to Svalbard to secure employment and housing prior to arrival. These regulations apply to all individuals, including Norwegian citizens.

Our new home quickly turned into our own personal slice of paradise.

A modest dirt road extends into our cabin area on the outskirts of town. The road passes by the island's only commercial airport and is the sole route in this direction, spanning roughly 3 miles (5 km). Here, the cabins are scattered along the coastline and nestled at the foot of a tall mountain, offering excellent protection from the prevailing southerly winds. Our cabin perches just 16.4 feet (5 m) above sea level, right at the edge of a cliff overlooking a breathtaking view of Isfjorden Fjord. The fjord is framed by towering mountains and vast glaciers that stretch from the distant horizon, cascading into the ocean on its far side.

When we moved into our cabin, it had one bedroom, a modest living room, a small kitchen, a makeshift bathroom, and a tiny storage room, and it lacked running water. This required us to do our laundry at a friend's place and to use the town's local gym when we needed to shower. Yet somehow, our new home quickly turned into our own personal slice of paradise. Enjoying my morning coffee with a view of seven glaciers through our living-room window was a dreamlike scenario I hadn't even imagined possible. It's not uncommon to open our front door to find a family of Svalbard reindeer grazing on the tundra, while the eerie calls of Arctic foxes echo from the mountainside down to where our cabin is located along the coast, much to Grim's irritation.

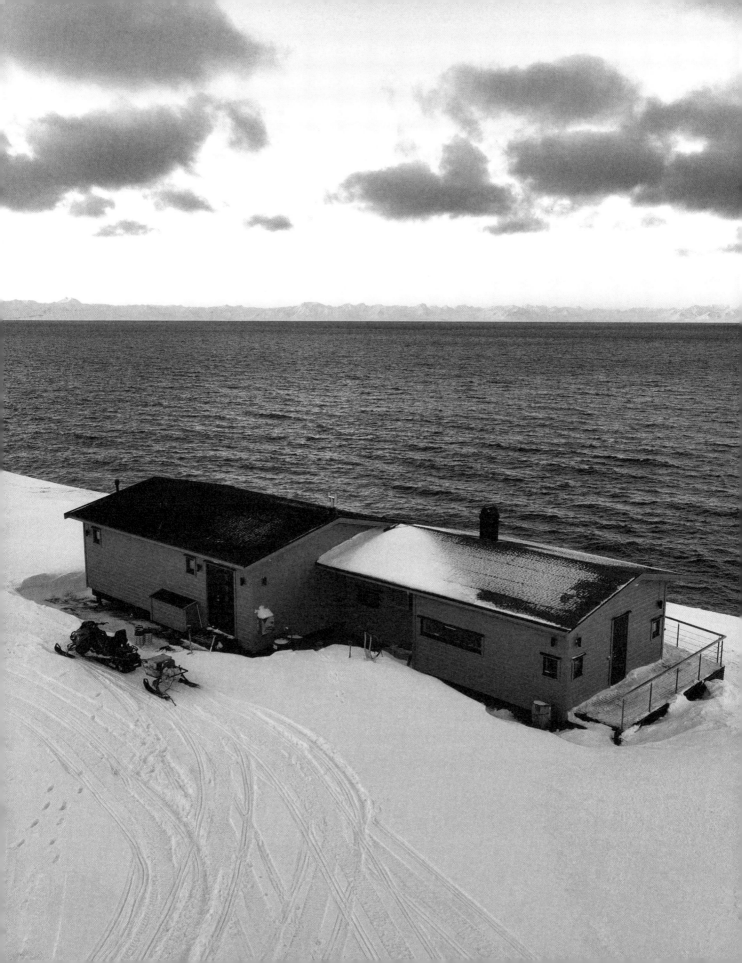

Since first coming to our cabin, we've expanded it to double its original size, an ambitious but ultimately successful project. In addition to the usual challenges of navigating permits, building restrictions, and other logistical hurdles of a construction project, Svalbard's unique nature presents additional challenges. In Svalbard, a major portion of the land is covered in permafrost, aka permanently frozen ground. This requires building structures on piles to anchor them into the ground, ensuring stability. Given our proximity to the water's edge, we count ourselves fortunate that our neighbor, a geologist, meticulously surveyed the area before purchasing her cabin, confirming its solid rock foundation. This reassures us that our home won't succumb to erosion and slide into the ocean in the years ahead.

We're still not connected to either the sewer or water line, but we've built an independent cabin system, complete with an in-cabin water tank. As for our bathroom solution, we've opted for something suitably named "Cinderella," which is an incineration toilet that efficiently burns your business. A clever off-grid solution!

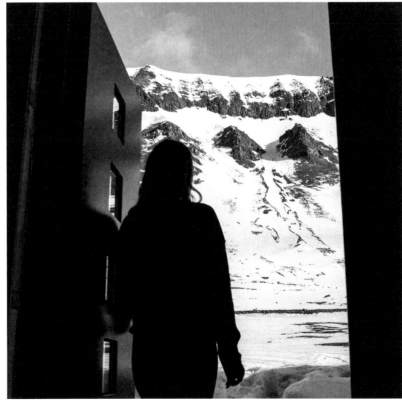

The Coziest Time

There's an undeniable charm to a snowstorm that makes you want to snuggle up inside. The crackling of the wood burning in the fireplace as we watch snow build up outside the window creates a feeling of warmth and comfort in our cabin. I love wrapping myself up in a soft blanket as I cuddle up with a good book and a hot cup of coffee as the snowflakes fall.

This recent polar night has brought endless stormy days, and I believe this might be the snowiest of all my 8 years on the island. I've spent many mornings braving the windy darkness on Grim's daily walks only to come home to huddle up in the cabin for the rest of the day, sitting in front of the fire and working on my laptop as the storm roars outside. When the light started to return, the snowstorms persisted, and at one point, we even experienced winds reaching speeds up to 74 miles per hour (33 meters per second).

The weather here can be quite intimidating, and the forces of nature present on Svalbard should always be respected. At the same time, it is extremely fascinating to watch Mother Nature at work from the comfort of home. It's equally captivating to observe how life continues as usual on our Arctic island, whatever the weather is. Even in the midst of literal chaos outside, adults still walk to work and children still go to school. Once a storm settles, workers are busy clearing the streets, and life continues on as normal.

Every time we come out of polar night, it becomes more apparent to me how much I love the dark season. I think this is because my home becomes my most cherished space (even more than usual) during this part of the year, as polar night offers us a chance to slow down and appreciate the beauty and power of nature in its purest form. There's no rush to be anywhere or do anything, so I can just relax and enjoy the simple pleasures of being in a warm and inviting space.

So when the light returns and our dark nights are suddenly brighter, I almost get a little bit sad. It always feels like the change happens so fast too, and knowing we have 4 months ahead of us without that comforting darkness sometimes feels like a lot. But for now, I'm trying to be sure I take the time to enjoy what is probably one of the last few cozy, dark evenings we'll have in front of our fireplace for quite a while.

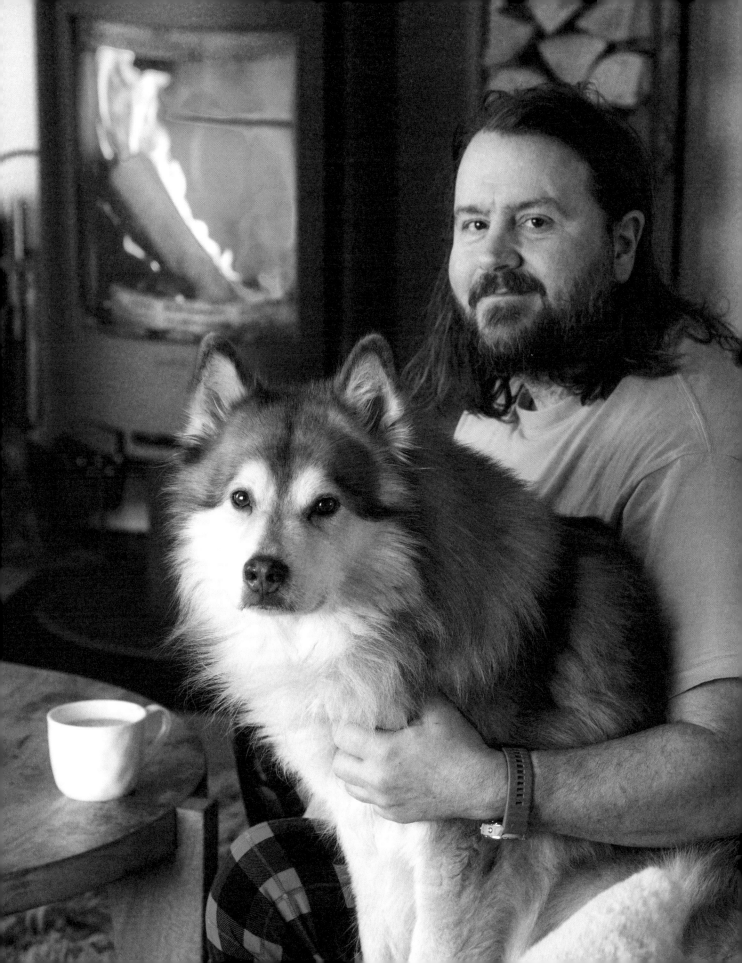

The Sun Returns

It's almost like we have two winters. One where we sleep, and one where everything wakes up. After so many months of darkness, the light starts to fill our lives again, reminding us of our surroundings. The polar night is just a warm-up for our real winter here in the Arctic. We slowly emerge from the sleepy darkness at the same pace as the increasing light.

Polar night officially comes to an end on February 15, when the sun peeks above the horizon for the first time since October. However, it takes a bit longer for the sun to rise high enough to cast its light upon the village. With each passing day, the light on the horizon continues to grow until March 8, which is *Soldagen*, or "Sun Day." Soldagen kicks off a whole week that's dedicated to welcoming the sun back. The entire village is invited to gather at the *sykehustrappa* (the hospital stairs), an old relic located just outside the church building in town. These steps hold historical significance, since they originally belonged to the first hospital that was built here in 1916. The steps happen to be the very spot where the sun's rays first reach Longyearbyen each year. Patients and nurses used to gather on these steps every year on March 8 to welcome the sun after a long polar night, a tradition that became known as Soldagen.

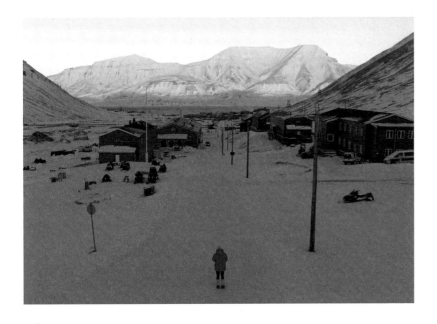

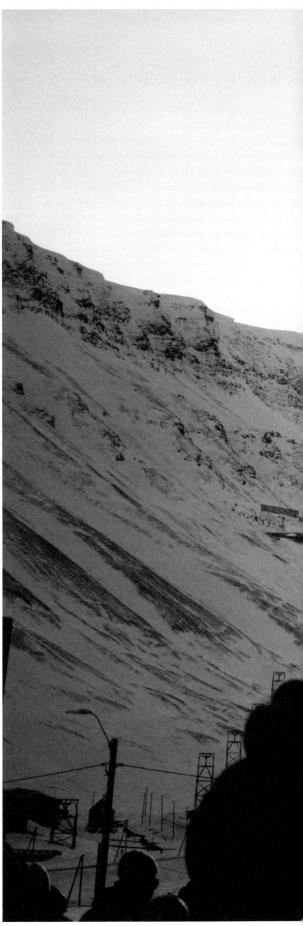

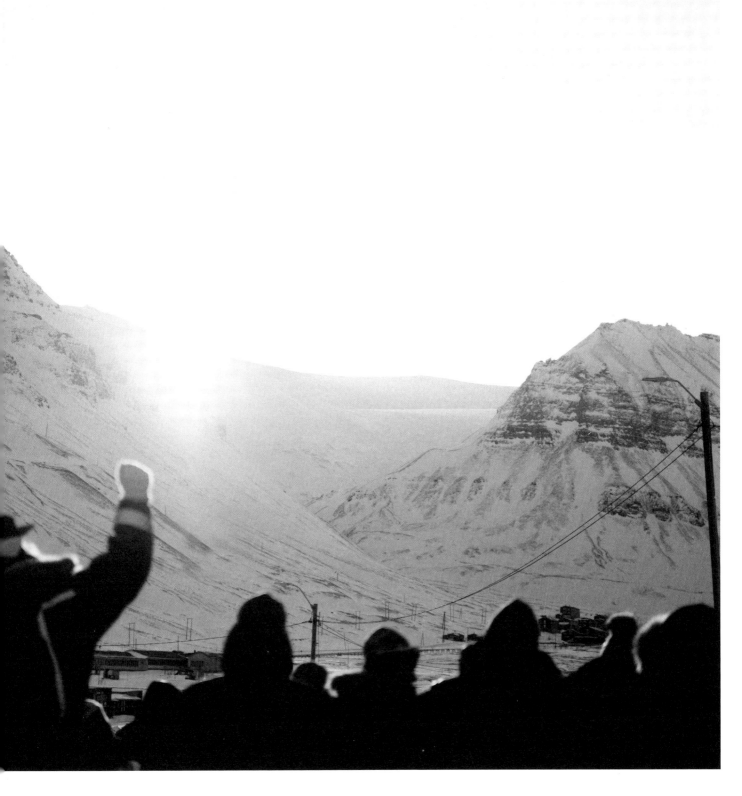

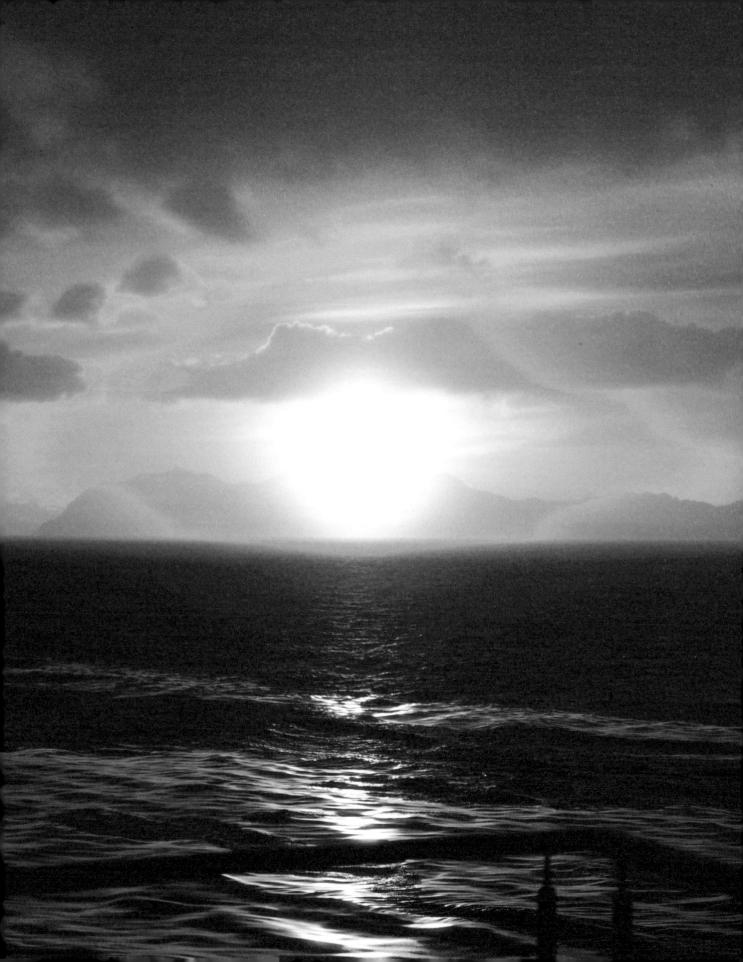

We can feel the warmth of the sun on our cheeks, thawing our frozen skin for the first time in months.

The hospital was moved, and the original building was demolished in the 1970s. In 1993, a decision was made to reconstruct the staircase at its original site in honor of the Sun Festival, thus keeping the tradition alive and commemorating the story. Regardless of the weather, the community gathers here each year, eager to soak up the rays of the first bit of sunshine. The celebration is marked with speeches, songs, and the indulgence of *solboller* (sun buns), a sweet bun with a creamy filling. The event includes a couple of musical segments, and the kids participate enthusiastically, chanting in unison as they await the sun's return, repeating, "*Sol sol kom igjen, sola er vår beste venn*" (Sun sun come back, the sun is our best friend). Together, we watch in anticipation as the sun's rays reach from behind the mountain and make their way into view. When it finally arrives, we can feel the warmth of the sun on our cheeks, thawing our frozen skin for the first time in months. This moment is always met with loud cheers, bringing the event to a celebratory close.

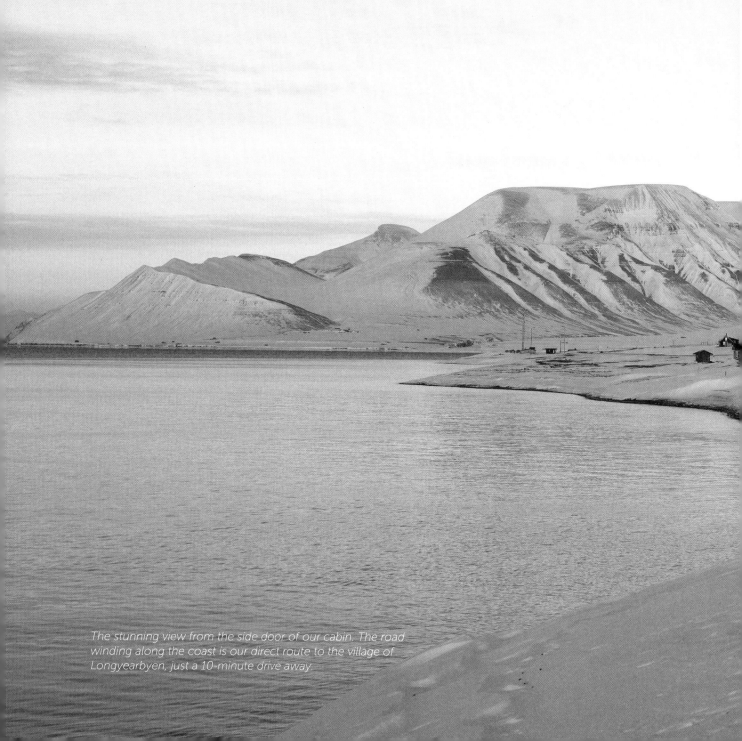

The stunning view from the side door of our cabin. The road winding along the coast is our direct route to the village of Longyearbyen, just a 10-minute drive away.

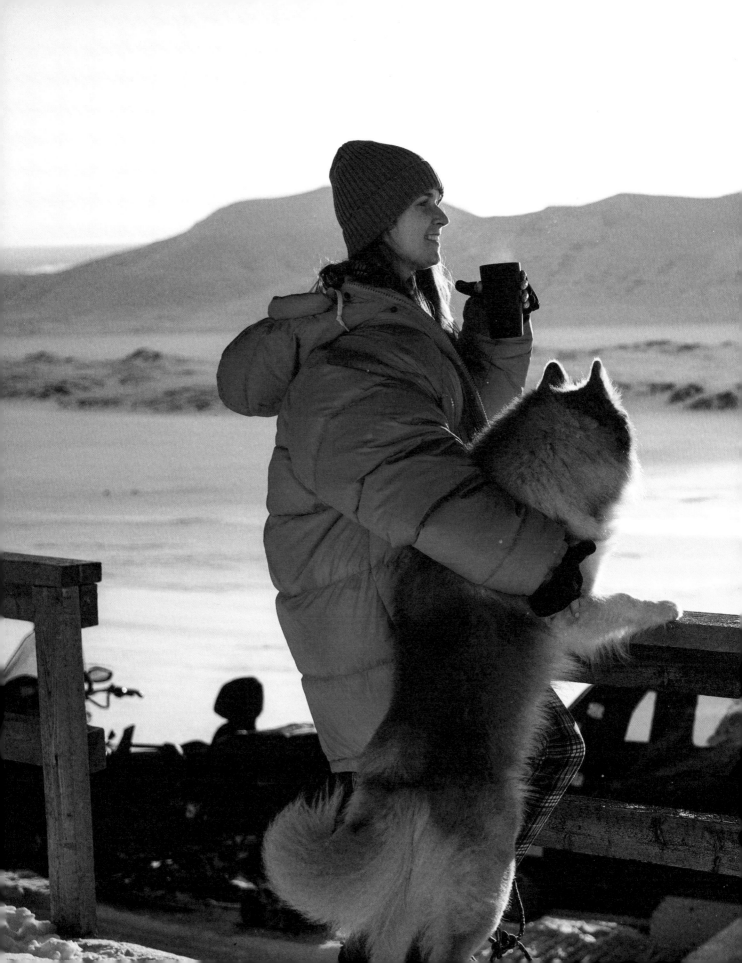

According to our local newspaper, it has only been clear on Sun Day a few times over the past 25 years. It's not unusual to find ourselves standing around the steps even during a snowstorm. Come clear weather or not, the event proceeds as planned. As they commonly say in Norway, there is no such thing as bad weather, only bad clothing.

Not even work can stop people from sharing in the festivities. I recall my days at Huset, when I'd rush from work to join the celebration, leaving a note on my desk that read, "At Sunfest, will be back in 30 minutes." In the middle of the lively festivities, I would take calls, book reservations for the restaurant, and offer explanations about the menu concepts. We were always encouraged to uphold the traditions and support community events, sometimes while working simultaneously.

The rest of the week offers various activities at different locations in town, which include special dinners and musical events, all in celebration of the new season's arrival. It's a time to celebrate making it through the wild winter storms of our long, dark, beautiful polar night all the way to the sunny winter season!

It's a time to celebrate making it through the wild winter storms of our long, dark, beautiful polar night.

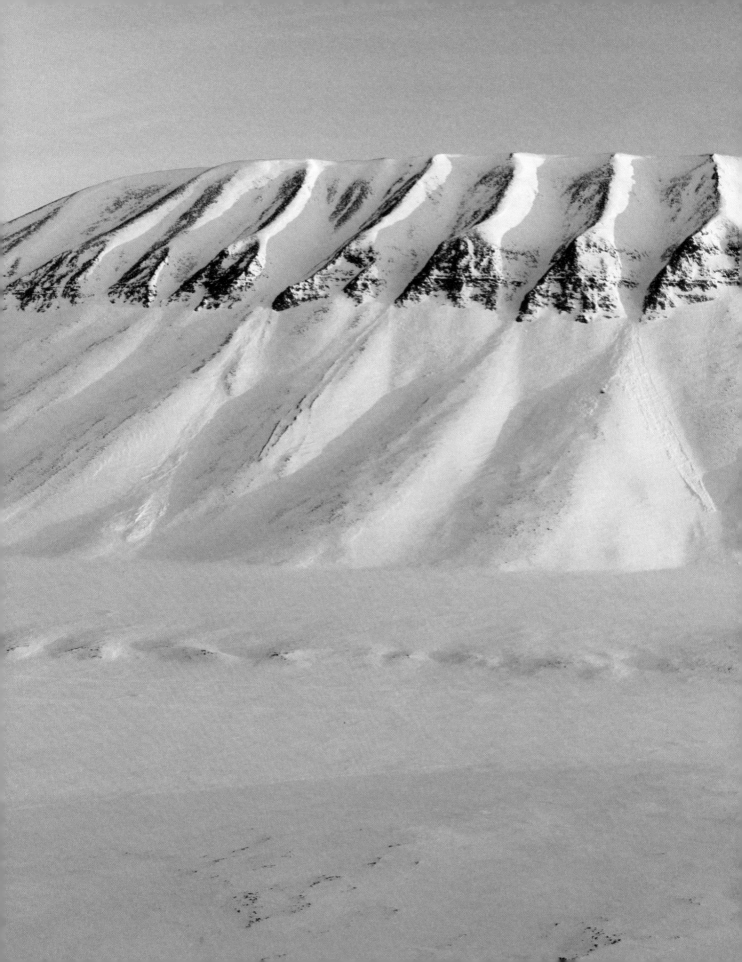

Sunny Winter

As most of the world eagerly anticipates the arrival of spring, we transition into our sunny winter season here in the far north. The beautiful pastel colors of February start to fade with the increasing daylight, and by mid-March, we enjoy about 8 hours of sunlight each day.

For a few months each year, we can venture beyond the village boundaries on our snowmobiles, reaching parts of the island that are otherwise inaccessible. The snowmobile season begins as soon as there is sufficient snow cover, sometimes as early as November, but it reaches its peak during these sunny winter months. The snow-covered landscape coupled with longer daylight hours allow us to experience the untouched, rugged wilderness of Svalbard up close. We drive for hours on end to reach glaciers on the island's far side, spend time in various remote cabins scattered all over Spitsbergen, and bear witness to the thriving wildlife that call this frozen world home. It's an adventurous time that truly shows off the beauty of the Arctic.

The daylight gradually extends with each passing day, and by April 19, the sun shines brightly in the sky around the clock. This time of year provides the ideal setting for all types of snowy adventures!

CALYPSOBYEN

Calypsobyen

On a crisp April day, a week before Easter, Christoffer, our friend Einar, the dogs, and I were busy planning an adventure. On Svalbard, Easter is reserved for long snowmobile expeditions, which are often planned weeks in advance to secure a cabin. The remote cabins that are available for rent are owned by various organizations in the village, and to rent one, you have to be a member of the organization that's responsible for the cabin you're interested in visiting. Applications are distributed a few weeks before the holiday to allow people ample time to prepare.

We weren't fortunate enough to get a cabin this year, so we had to come up with an alternative plan. Fortunately, there are a couple of open cabins available for anyone passing through. We decided to visit one of these, a cabin located in Calypsobyen. This location is a research station situated approximately 87 miles (140 km) from Longyearbyen, and it remains unoccupied during the winter season. To get to this remote, off-grid cabin, we had to prepare for a longer journey. Both Einar and Christoffer had made this trip before, so they were familiar with what to expect. We relied on GPS to navigate, but it never guarantees an entirely trouble-free journey.

The sunny winter season on Svalbard revolves around exploring our breathtaking landscape. Since we have no roads leading out of Longyearbyen and the island is completely covered in snow from late polar night until May, snowmobiles become our primary means of transportation.

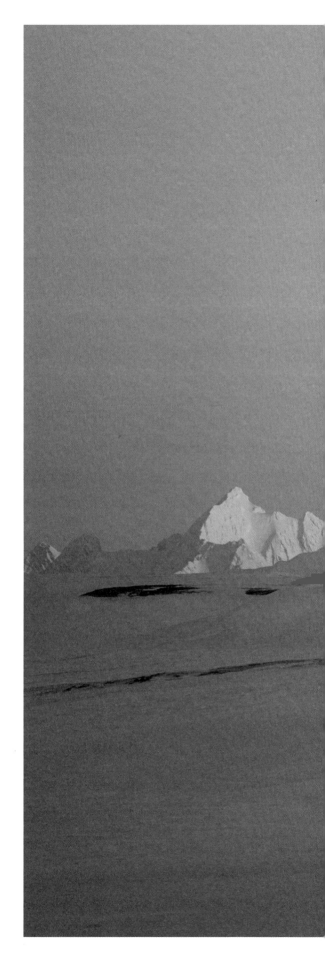

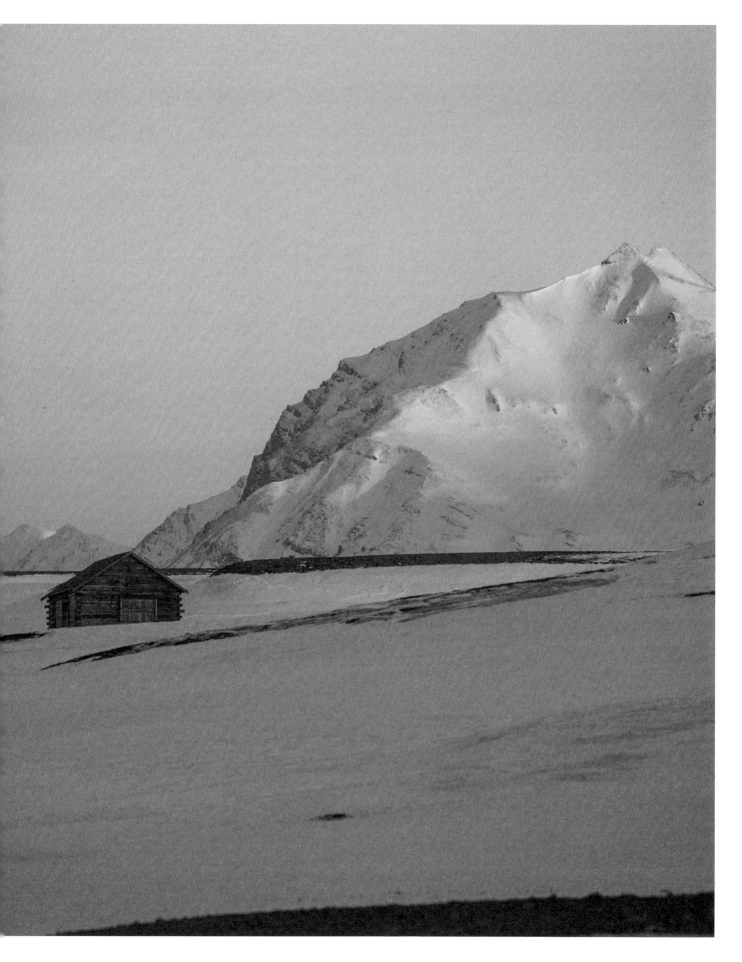

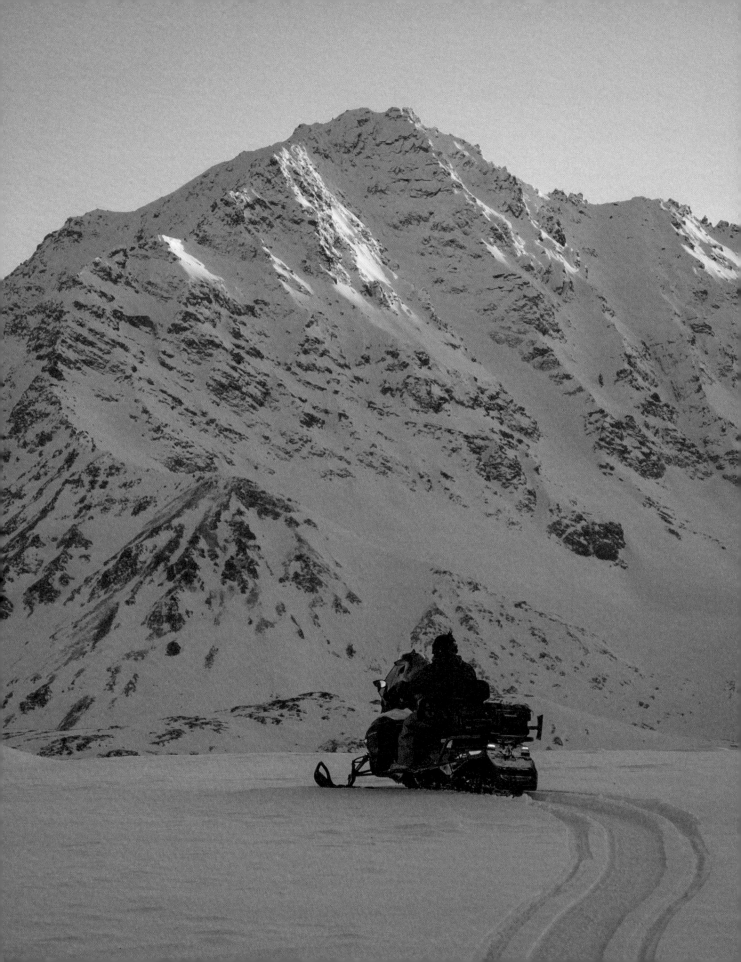

Challenges contribute to the adventure, and overcoming these obstacles brings a sense of reward.

We reached Calypsobyen shortly after midnight, having driven for over 5 hours. The long journey was relatively smooth, except for the last few miles. The wooden sled I towed behind my snowmobile had a total weight of over 882 pounds (400 kg), making it quite challenging for the vehicle to climb steep hills or move through deep snow without getting stuck. There were parts of the route where it took us over an hour to cover a half mile. This wasn't unusual though, as these trips can be a bit difficult at times. I find these challenges contribute to the adventure, and overcoming these obstacles brings a sense of reward.

The reason I had to haul such a heavy load was because Christoffer had the dogs in the "sluffe," the heated sled I purchased for Grim. Grim used to sit on the snowmobile seat in front of the driver, but as he's aged, it's become increasingly uncomfortable for him. Therefore, I opted to purchase a sluffe, a sort of sled that resembles a mini caravan on skis, which attaches to the snowmobile like a trailer. While opting for the sluffe means sacrificing the chance to pack another wooden sled to distribute the heavy load of wood, gasoline, and other necessities, its heated and spacious interior ensures Grim can travel more comfortably. Einar's dog, Fenris, accompanied Grim in his luxurious chariot for this trip.

After 5 hours of continuous driving, we eventually reached the cabin feeling tired but content, only to discover a polar bear had attempted to break in. It had torn the wooden boards covering the windows off the wall and shattered four windows. Despite our tiredness from the long journey, we quickly got to work securing the broken windows, clearing away the shattered glass, and starting a fire to warm up the cabin.

The wild thing was, had we arrived at the cabin and found it already occupied, we would have had to spend the night on the floor before making the long journey back. Fortunately, given the cabin's substantial size with multiple sleeping areas, the likelihood of this happening was quite low. Many people are hesitant to take the chance of traveling this far only to find it occupied and then have to make the long trip back home.

During early April, the sun doesn't set until around 10 p.m., giving us plenty of daylight to make the most of. The early evening was bathed in sunshine as we explored our new surroundings around the cabin, driving our snowmobiles to the nearby glacier and marveling at it glistening in the soft, golden light of the evening sun. This was such a perfect way to make the most of the extended daylight we have in early April. We spent the next few days enjoying the complete isolation of being so far away from civilization. However, the weather became windier and colder after our first day, so I found myself spending more time indoors, engrossed in the books I brought along. I was delving into the series *His Dark Materials* by Philip Pullman for the first time, having discovered it just a few months earlier. Although the books are fictional, many of its settings are based on real locations, including Svalbard! I couldn't envision a more fitting backdrop to immerse myself in these stories of armored polar bears and cities amid the northern lights.

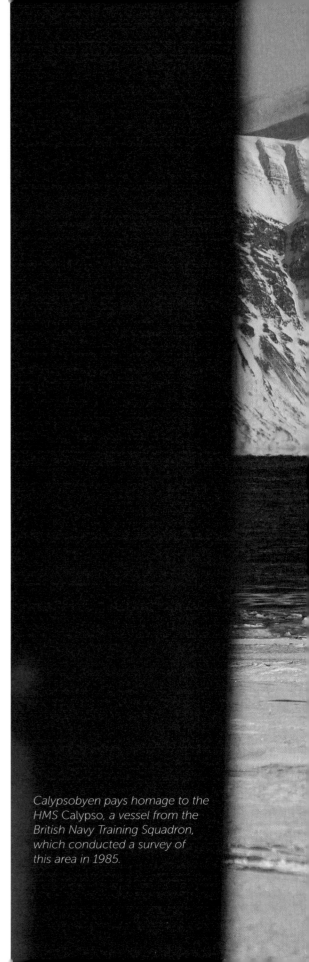

Calypsobyen pays homage to the HMS Calypso, a vessel from the British Navy Training Squadron, which conducted a survey of this area in 1985.

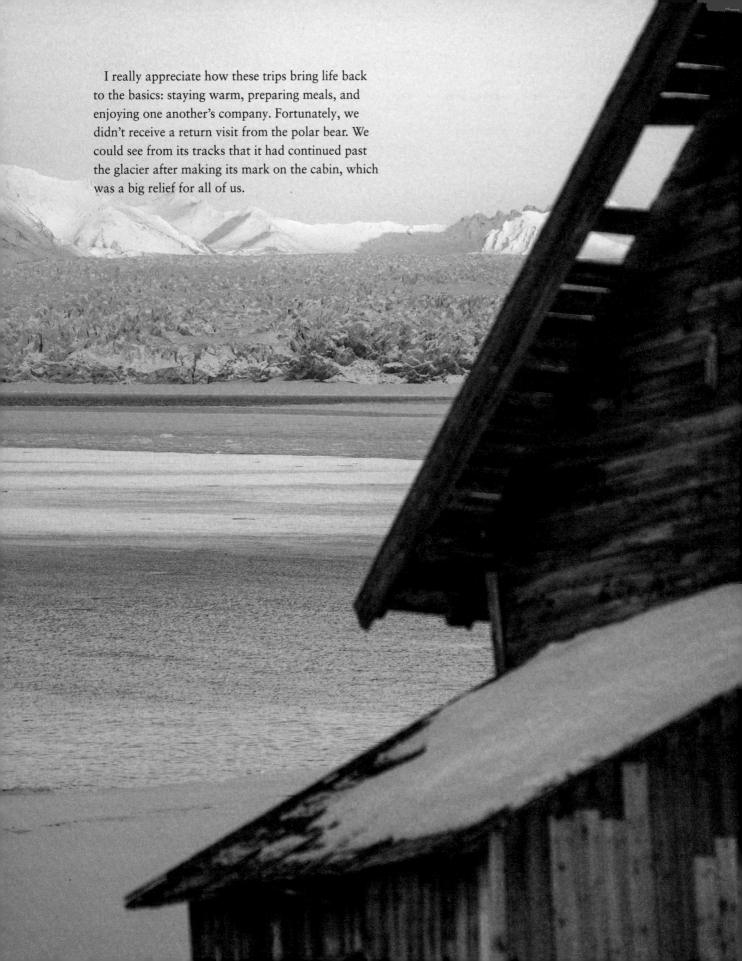

I really appreciate how these trips bring life back to the basics: staying warm, preparing meals, and enjoying one another's company. Fortunately, we didn't receive a return visit from the polar bear. We could see from its tracks that it had continued past the glacier after making its mark on the cabin, which was a big relief for all of us.

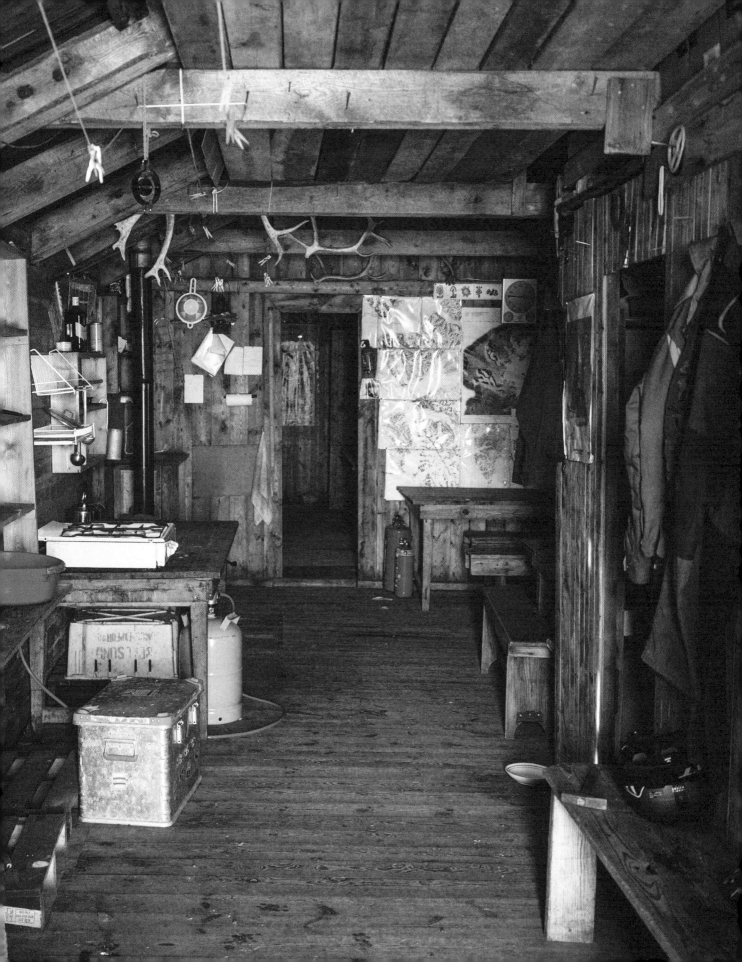

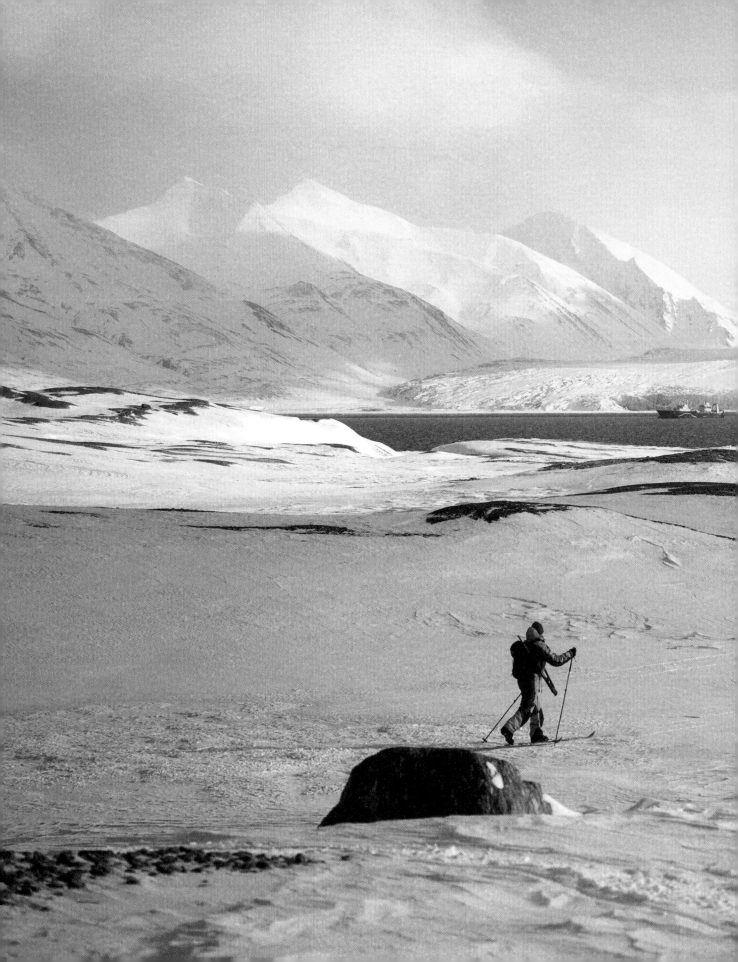

Norwegian Cabin Culture

It didn't take me long after moving to Svalbard to realize how important weekly cabin trips are to those who live here. As the sunny winter season unfolds, Fridays at work become centered on discussions about weekend plans and which cabin everyone intends to visit.

Having never lived in Norway prior to moving to Svalbard, I was unfamiliar with the Norwegian concept of *hyttetur* (cabin trip) and its cultural importance. When I was growing up on the west coast of Sweden, some of my friends would leave for their *sommarstugor* (summer cabins) as soon as school ended, spending their summer months there, but it isn't quite the same thing here.

In Norway, cabin trips are deeply ingrained in society, since they offer an appreciated escape into the country's pristine wilderness. Known as *hyttekultur*, or "cabin culture," this tradition embodies the Norwegian connection to nature and the outdoors. Cabin trips provide an opportunity to unwind, recharge, and reconnect with family and friends amid breathtaking scenery. Whether in the mountains, overlooking tranquil fjords, or hidden within dense forests, cabins serve as havens of tranquility and simplicity. Weekends and holidays are often spent at the family cabin, fostering a lifestyle that appreciates community and the beauty of Norway's landscapes.

Since Svalbard is governed by Norway and about half the population on the archipelago is Norwegian, this tradition is revered here as well. However, due to the availability of private cabins being so scarce, most folks on Svalbard must rely on the cabin lottery system.

With a rich history of trapping on Svalbard, the remote cabins here primarily consist of old 'trappers' huts that were once utilized for overwintering and hunting. Hunters and trappers established these cabins as their base stations, as well as several smaller huts scattered across the island serving as secondary stations. Many of these cabins are now available for us to use.

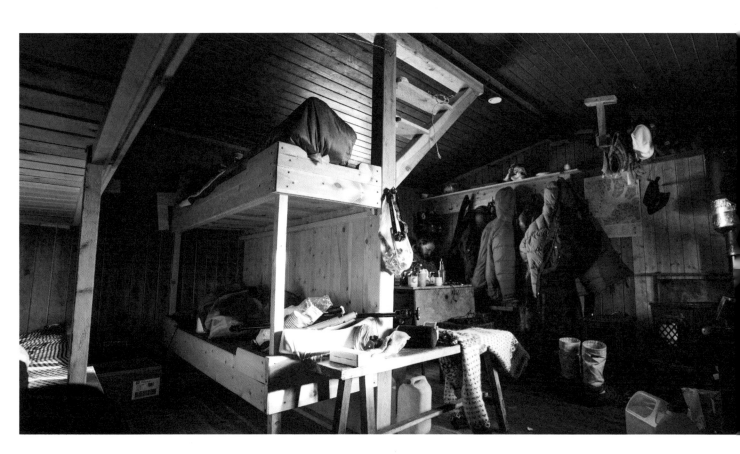

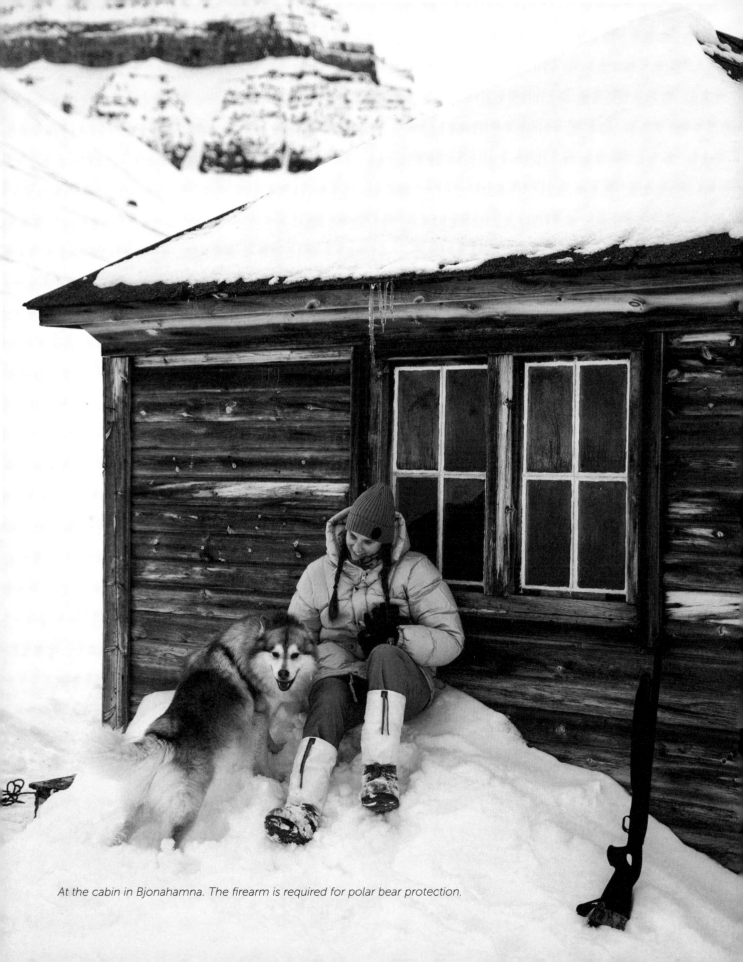

At the cabin in Bjonahamna. The firearm is required for polar bear protection.

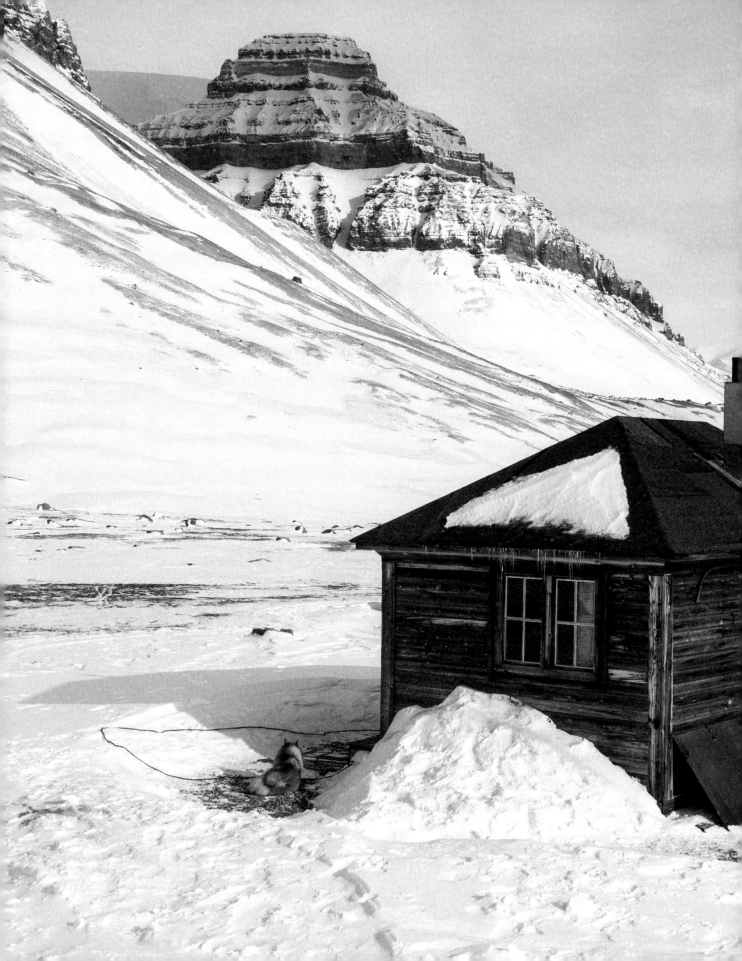

One particular cabin in Bjonahamna has always captivated me; there is an undeniable charm that sets it apart. Situated at the base of a towering mountain, it rests just a stone's throw away from the water's edge in Tempelfjorden. At the fjord's innermost curve, the majestic Tuna Glacier stretches endlessly, meeting the Von Post Glacier by the water's edge. The reverberating sound of the glacier thundering can commonly be heard when staying at the cabin here, a reminder of the majestic surroundings and unique location.

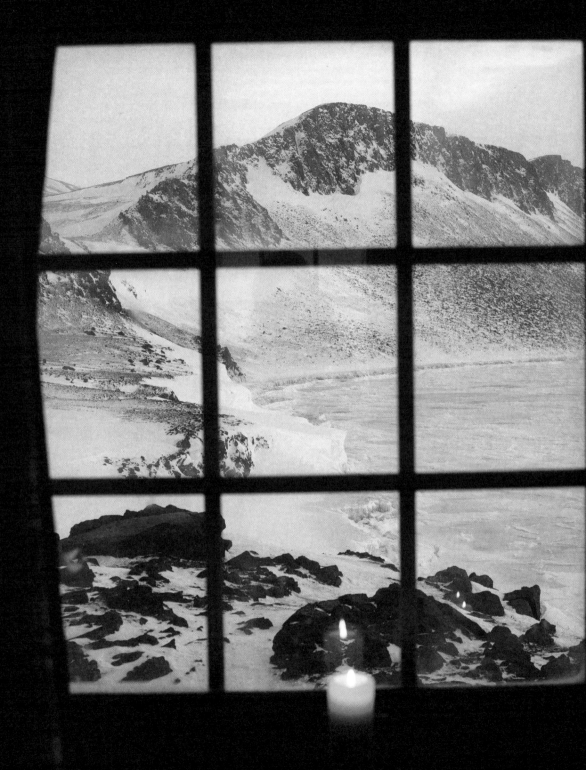

In a world that is constantly speeding up, I often crave the opposite.

Constructed in 1920 by a Swedish coal-mining company, this protected cabin later came under the stewardship of Norwegian trapper Hilmar Nøis in 1923. It served as a secondary station for his trapping activities. In 1955, it was acquired by the Norwegian government and remained in use for trapping. In recent years, it has been made available for rent as part of the cabin lottery system. A weekend spent in this historic cabin feels like stepping into a time machine to the 1920s.

As I sit by candlelight, tending to the woodstove, I can't help but imagine the solitude and isolation experienced by those who spent winters in these same cabins decades ago, miles away from civilization. Out here, the raw beauty of nature is on full display. In a world that is constantly speeding up, I often crave the opposite. Despite living in a cabin in a somewhat remote area, I still feel a desire to seek even greater seclusion that is not solely about detachment from civilization, but rather a yearning for peace and serenity. In these cabins, the primary focus lies in tending to the woodstove, disconnecting from the digital world because internet connection is scarce, and enjoying the silence of the remote location.

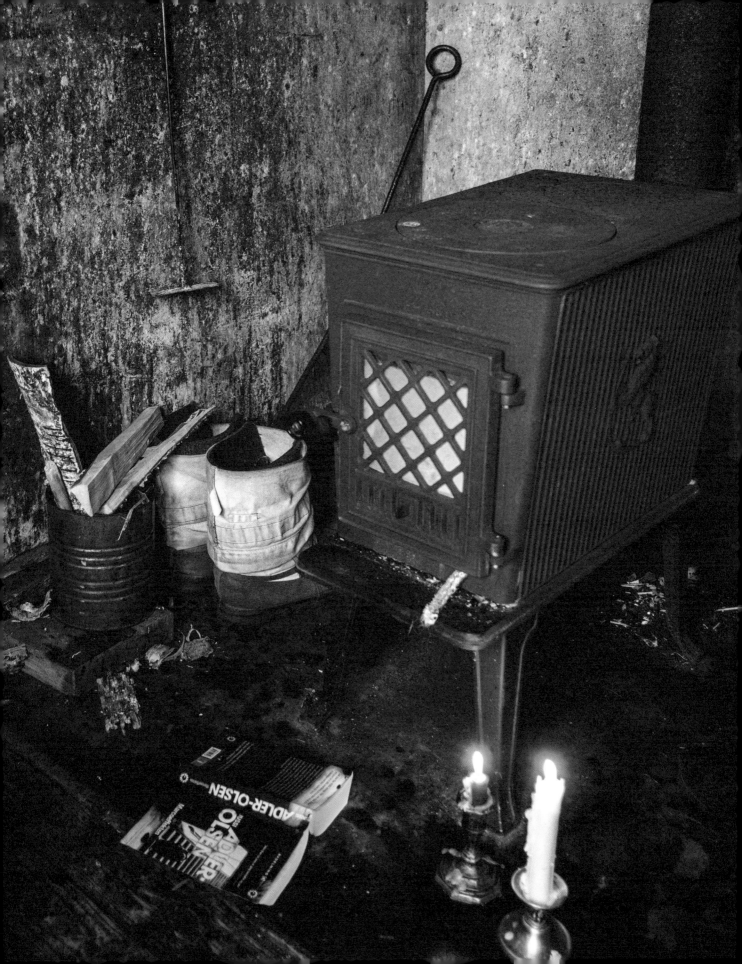

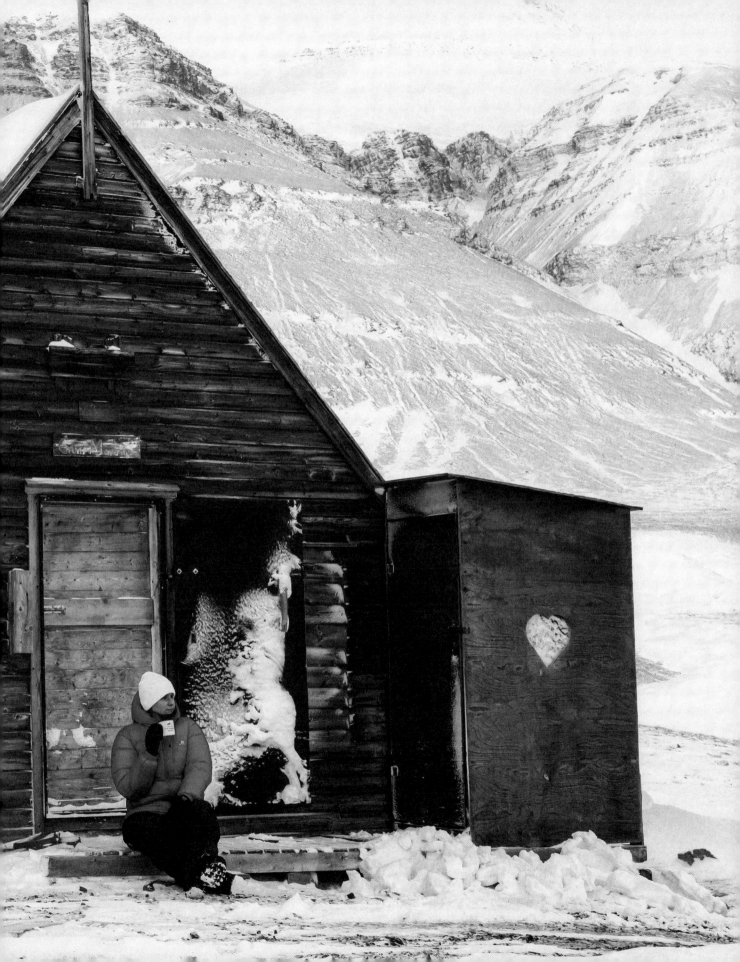

A Frozen World

I find glaciers endlessly fascinating, and they have become one of my favorite parts of nature to document here on Svalbard. Even though I know they *only* consist of thousands-of-years-old ice, they feel like living and breathing things. They move, they make noise, and they constantly change.

It's estimated that about 60 percent of Svalbard is covered by several different types of glaciers.

- **Ice caps:**
 The largest type of glaciers. They are primarily found in the eastern part of our archipelago, where they span vast areas. The largest among them is the Austfonna ice cap, situated on Nordaustlandet, and boasting a total area of 3,012 square miles (7,800 square km). Alongside Iceland's Vatnajökull, the Austfonna ice cap on Svalbard ranks among the world's largest ice caps.

- **Spitsbergen:**
 This type of glacier is one you will see frequently on Spitsbergen, the largest and only permanently populated island of the archipelago. This glacier type is especially prevalent in the southern and northwestern regions of Spitsbergen, with numerous extending into the ocean where they calve or break off into the water.

- **Valley/Cirque:**
 In central Spitsbergen, you will find this glacier type. Longyearbyen and Larsbreen, the two glaciers that lay just behind the town of Longyearbyen, are classified as this kind. They are often on the smaller side, filling only portions of their valleys.

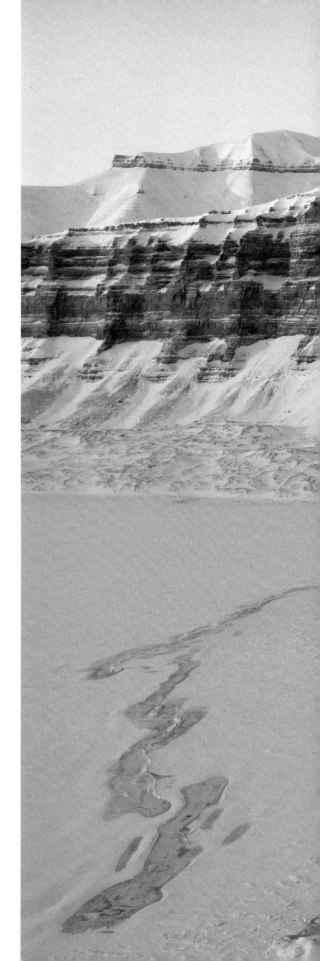

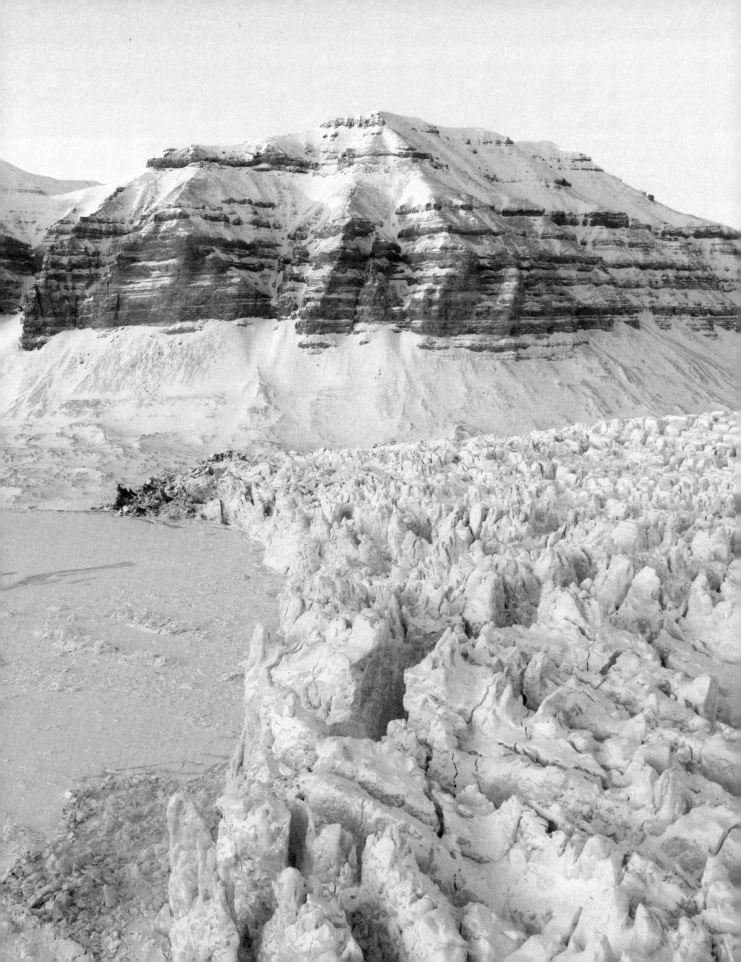

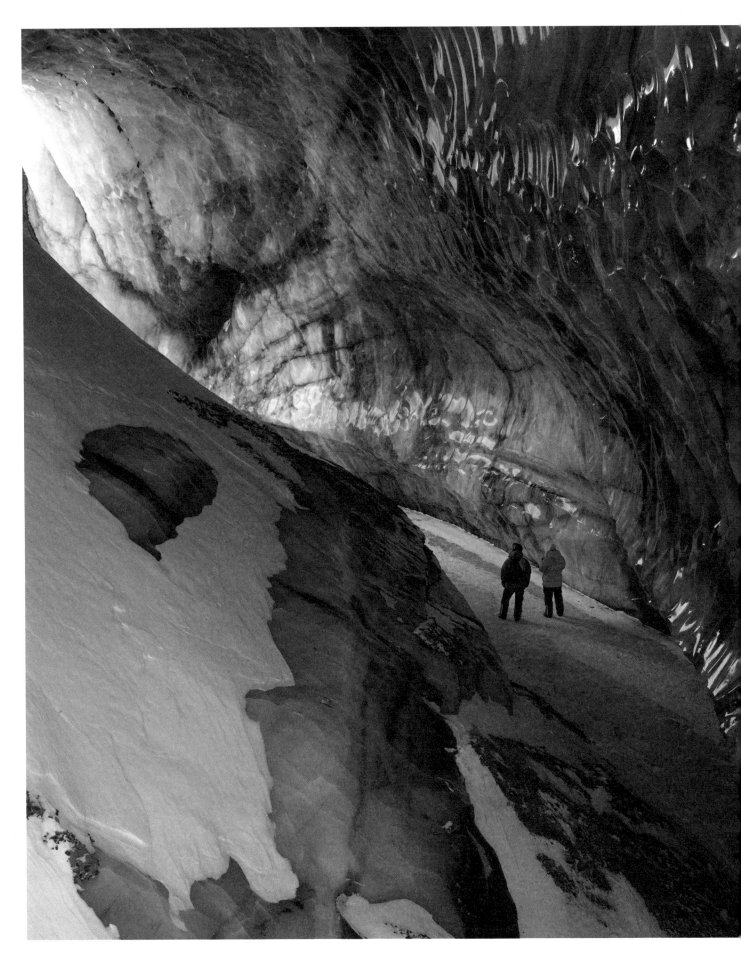

Whether glaciers expand or recede depends on the delicate balance between summer temperatures and winter precipitation. If we go back 5,000 years, Svalbard's average temperature was approximately 7.2°F (4°C) warmer than it is today. At that time, permafrost wasn't found at lower altitudes, and numerous glaciers we can observe today hadn't formed yet. Consequently, many of Svalbard's glaciers are relatively young, dating back less than 4,000 years.

In the winter, we get the opportunity to look at these thousands-of-years-old ice up close by exploring glacier caves. These caves are formed during the warm season when there is milder weather or rain in winter. Meltwater channels are created on the surface of the ice that then subsequently form meltwater caves inside the glacier. During winter, the channels dry up, forming glacier caves. Svalbard's cold climate ensures that the glaciers are frozen solid to the ground, allowing us to somewhat safely explore the world inside a glacier.

Exploring glacier caves typically involves passing through a narrow, human-size opening in the glacier. Although each glacier cave has a unique layout, the opening often leads to a tunnel that guides you deeper into its icy depths. The formations you find inside the glacier give so much insight into its extensive history. Some layers are filled with air bubbles, while others are as transparent as glass. You can observe remnants within the ice that became trapped during the glacier's formation. These remnants include everything from plants to gravel to fossils that offer a glimpse into the past.

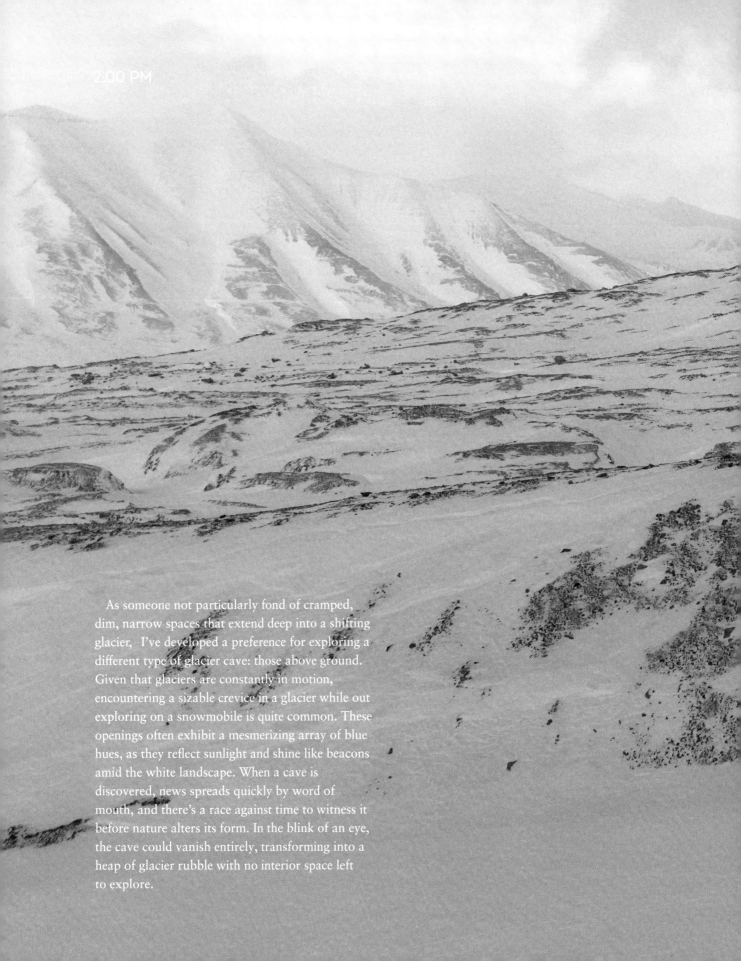

As someone not particularly fond of cramped, dim, narrow spaces that extend deep into a shifting glacier, I've developed a preference for exploring a different type of glacier cave: those above ground. Given that glaciers are constantly in motion, encountering a sizable crevice in a glacier while out exploring on a snowmobile is quite common. These openings often exhibit a mesmerizing array of blue hues, as they reflect sunlight and shine like beacons amid the white landscape. When a cave is discovered, news spreads quickly by word of mouth, and there's a race against time to witness it before nature alters its form. In the blink of an eye, the cave could vanish entirely, transforming into a heap of glacier rubble with no interior space left to explore.

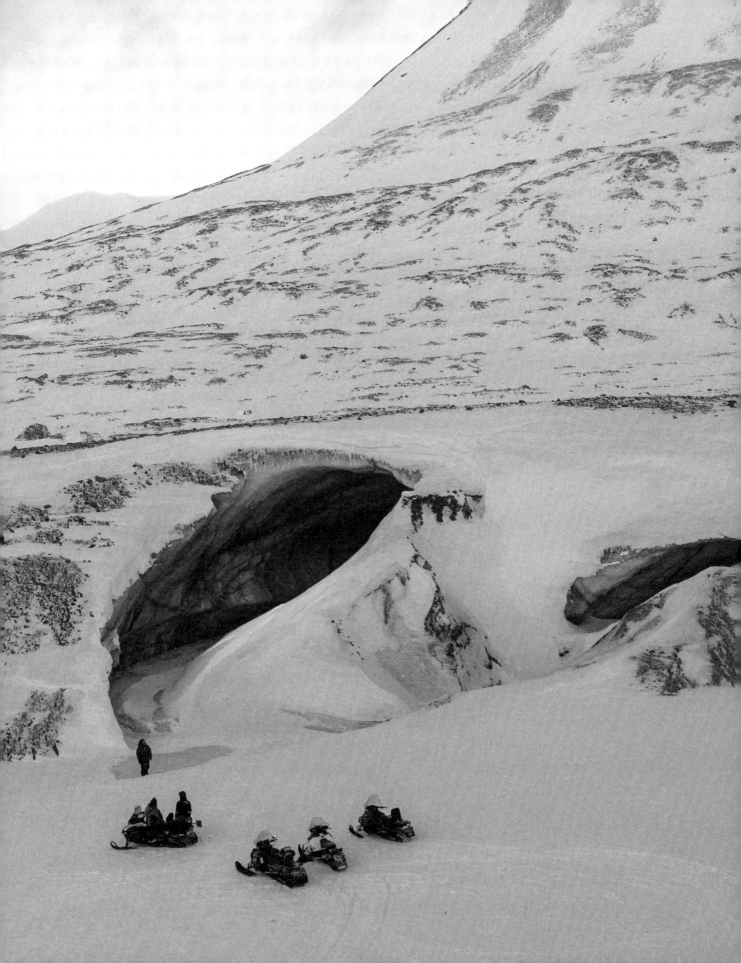

How Are Glaciers Formed?

Glaciers are massive ice formations that develop on land because of the gradual compression of snowfall into solid ice over many centuries.

CONSISTENCY, DENSITY & SHAPE

Snowflakes
90% air

Ice granules
50% air

Firn
30% air

Ice
20% air as bubbles

This graphic illustrates the process of glacial ice formation and equivalent percentages of air in each step.

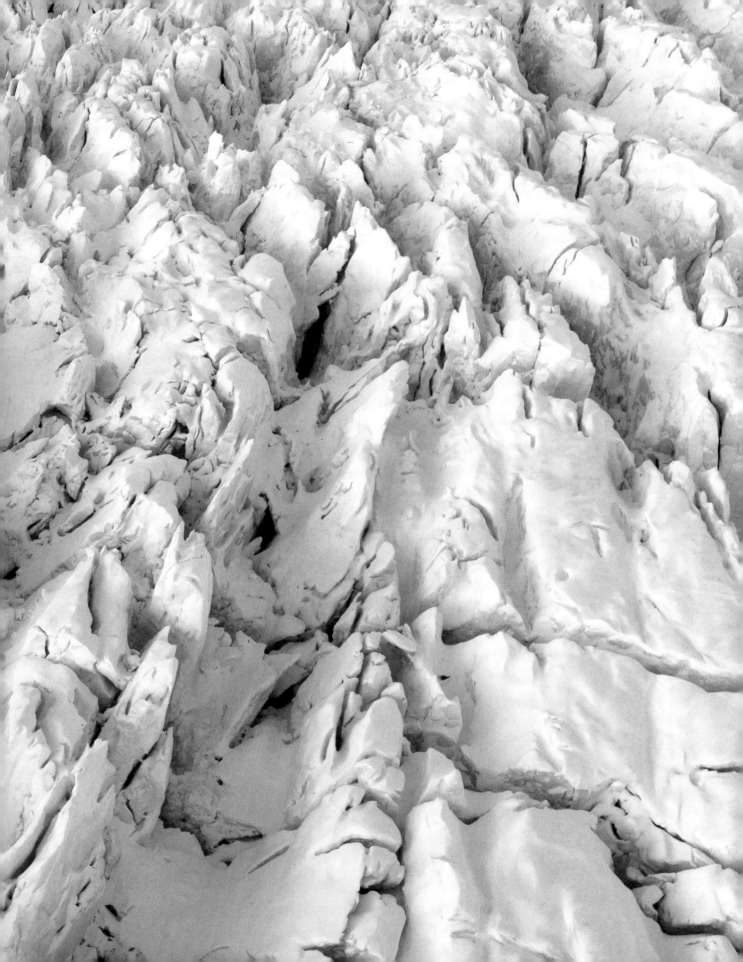

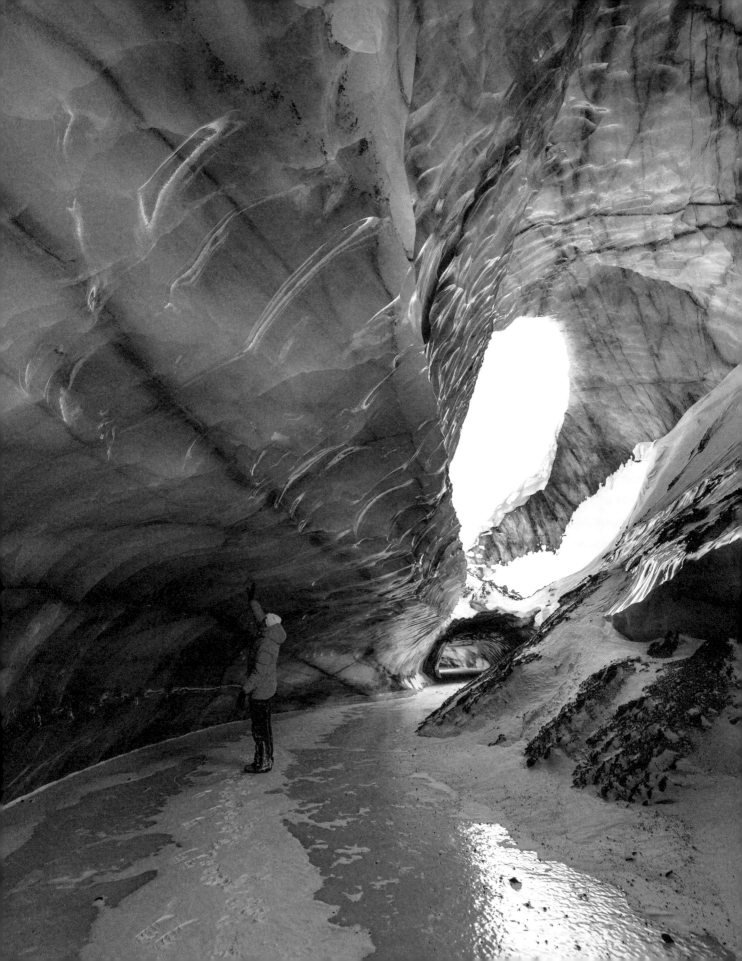

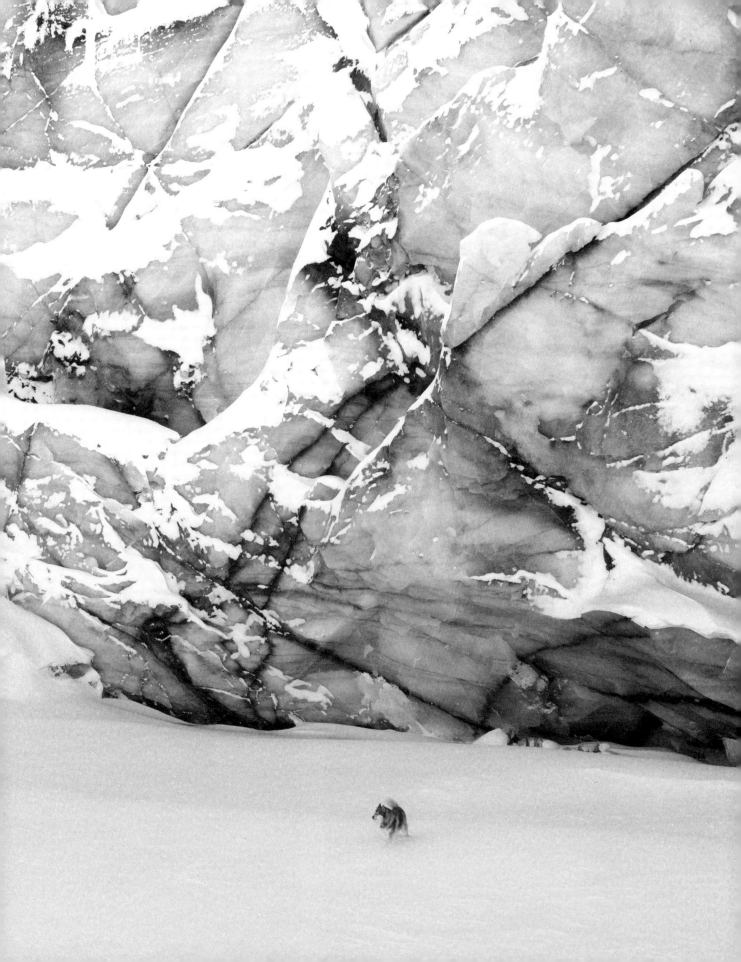

The Last Sunset

As sunny winter comes to an end, I can't help but reflect on how I'll miss the stars, the moon, and the enchanting view of the universe above. However, I've come to appreciate the unique beauty of each season, so once it's time for brighter days to take center stage, I welcome them. Our lives here on Svalbard have taught us to truly value how we are able to adapt across the changing seasons. All these major shifts that take place throughout the year are noticed and celebrated. As one extreme season ends on Svalbard, it paves the way for a new one to begin.

The days leading up to the final sunset are full of the most colorful skies. Each sunset is incredibly vibrant, leaving the entire horizon awash in a golden glow, illuminating the ocean and the mountains that surround us. The sun wants to give us a show before sticking to its constant stream of daylight until August.

Each year, on the day before polar day begins, I stay awake late to witness the last sunset. The sun glows and dips below the horizon a few minutes past midnight, disappearing out of view, only to re-emerge less than 2 hours later. The next sunset we will see won't occur for another 4 months.

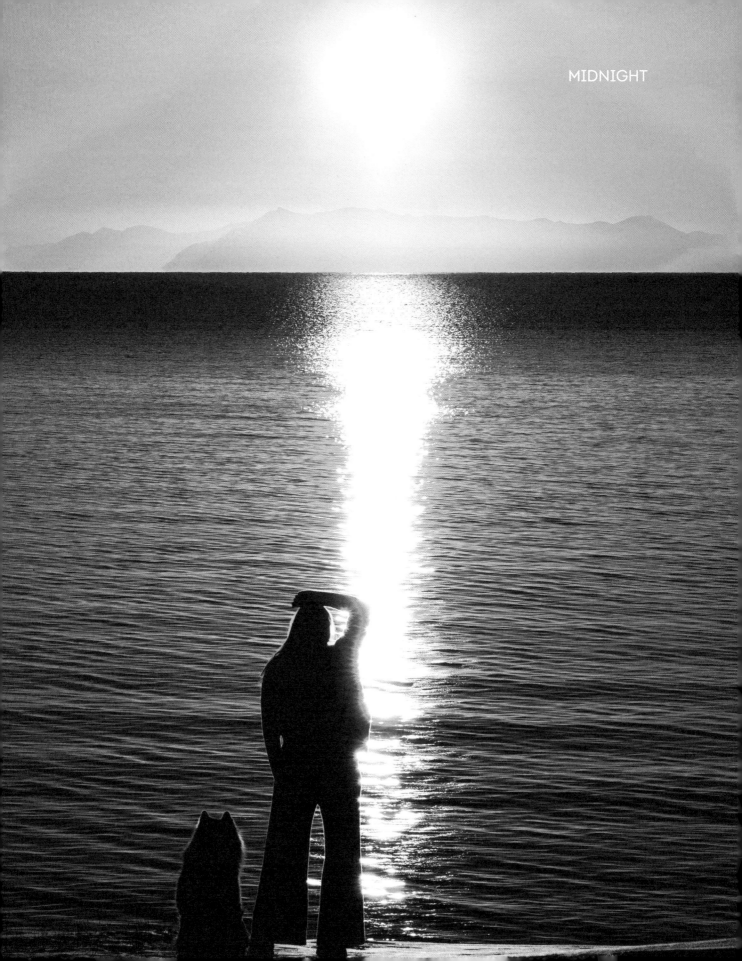

It baffles me each year how fast we transition from polar night to polar day. In February, there's hardly any daylight at all, and our surroundings are mostly dyed with blue hues. On March 8, we say hello to the sun for the first time in the village, and by early April, the dark nights have almost disappeared entirely.

When spring comes, it fills our days with singing birds and whales in the fjords. And while this does sound lovely, I think polar day is more challenging than polar night, which is surprising to many who have not experienced both personally. Endless daylight is quite rough on the body, and once again, it is easy to lose your circadian rhythm. But I take what I've learned from living through many polar nights and ensure I keep a good sleep schedule, which always helps. I tell myself it is a good thing to have a break from the extreme darkness, even if the replacement is extreme light.

Outdoor Enthusiasts

Throughout my various living situations and job placements on Svalbard, one aspect has remained constant: the emphasis on enjoying the outdoors. It's evident that many who choose to live here are drawn by their shared love for nature, which is one of the reasons I adore my life in this place. People here are genuinely enthusiastic about the simple things, like the changing of the seasons and the close encounters with wildlife. I'll never forget the day a polar bear appeared on the other side of the fjord. It was safe to observe it from the shore in Longyearbyen, so that's exactly what everyone did. Walking around town that day, you'd see handwritten notes taped to shop windows saying, "Gone to see the polar bear, back soon."

Late March to mid-May, or high season, mark the peak months for winter adventures on Svalbard. Whether it's for a snowmobile trip, a dog-sledding adventure, or a skiing expedition, the raw wilderness you encounter here on Svalbard is unlike anything found elsewhere, which is why so many travelers make the journey this far north. The roughly 10 hotels in town fill up with people from all over the world, eager to experience our wild Arctic scenery. Longyearbyen serves as an adventure hub, with numerous expeditions departing daily to explore the surrounding landscapes.

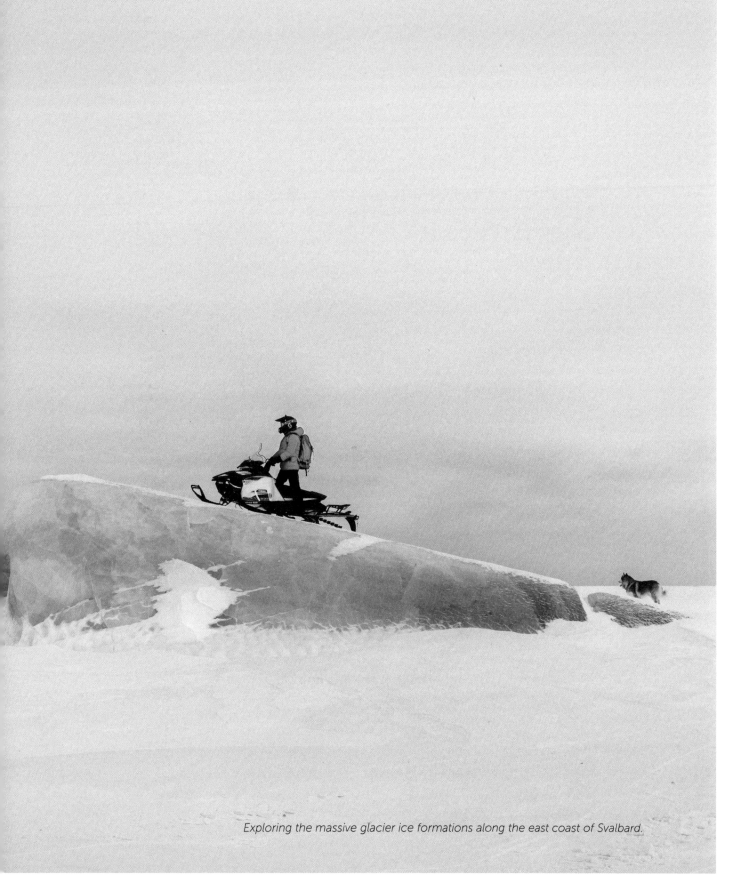

Exploring the massive glacier ice formations along the east coast of Svalbard.

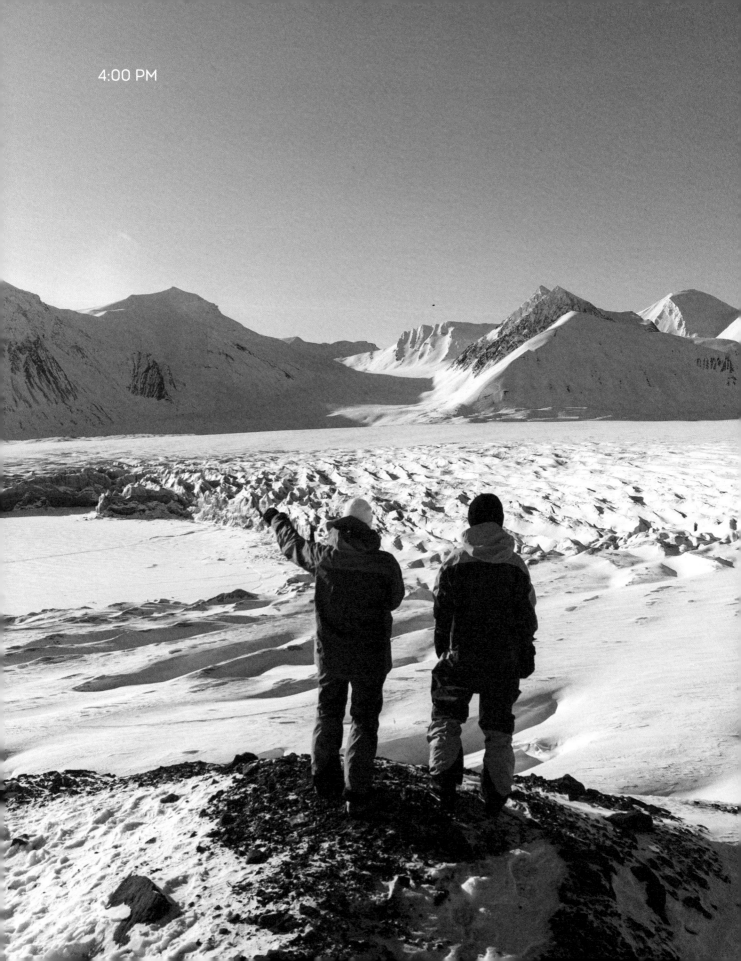

4:00 PM

We frequently meet up for some midnight sun cross-country skiing escapades.

The sun shining around the clock from mid-April onward, together with milder winter temperatures averaging 16°F (-9°C), creates the perfect setting for around-the-clock activities. Getting together with friends almost always means heading outdoors for some excitement. I've had countless memorable outings with my friend Julie and her retired sled dog, Polka. We frequently meet up for some midnight sun cross-country skiing escapades, which is one of our favorite activities to do together.

Having a dog on Svalbard is ideal, as these furry friends serve as perfect companions for activities like hiking. Not only do dogs offer companionship, but they also provide a sense of safety. A dog's natural ability to sense other wildlife is invaluable. I always depend on my dog, Grim, to spot potential dangers before I do, which gives me an extra sense of security while I'm exploring outdoors.

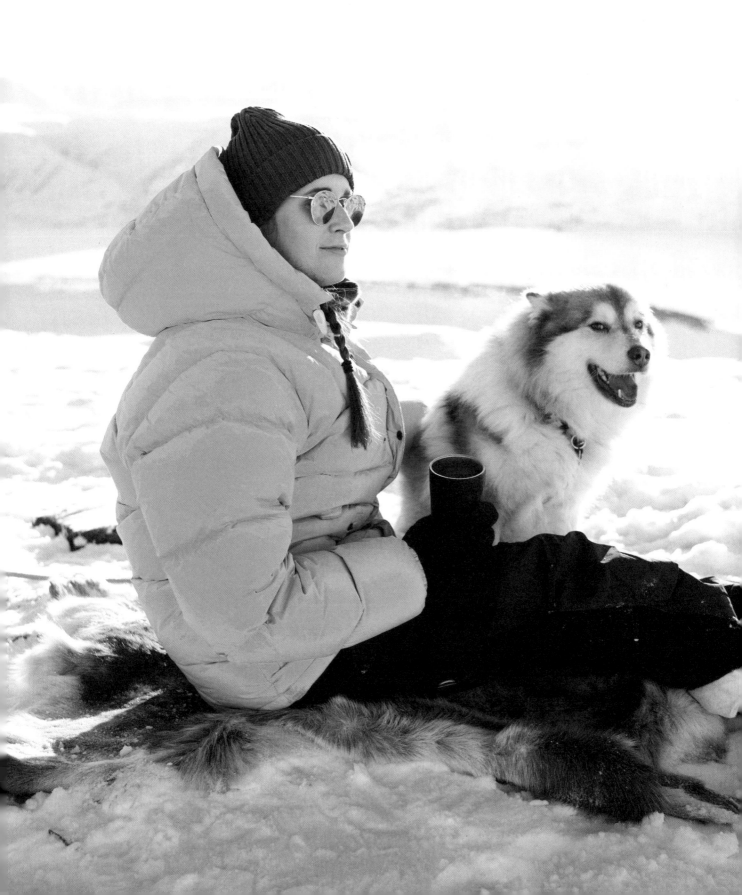

However, I'm still working on honing Grim's cross-country skiing skills; the idea of him pulling me forward doesn't seem to register with him. Grim enjoys skiing because it gives him a chance to bark at reindeer, chase after Polka, and bounce around happily. You wouldn't believe how many times people have stopped me to ask how old my "puppy" is, only for me to tell them he is on the verge of becoming a senior! There is never a dull moment with my fluffy canine companion at my side.

By mid-May, much of the snow has melted, making it impossible to venture out of town any longer. The sunny winter season is over. As the landscape transitions from a snowy winter wonderland to a milder Arctic spring landscape, opportunities for exploration and activities change accordingly.

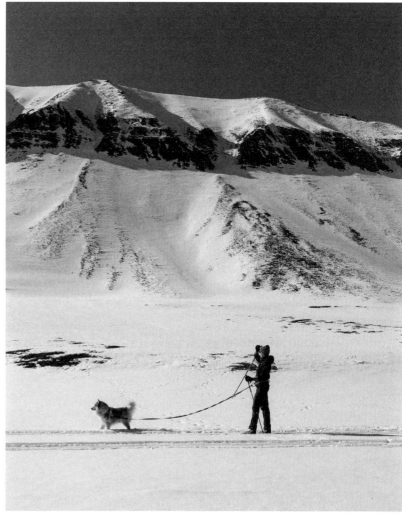

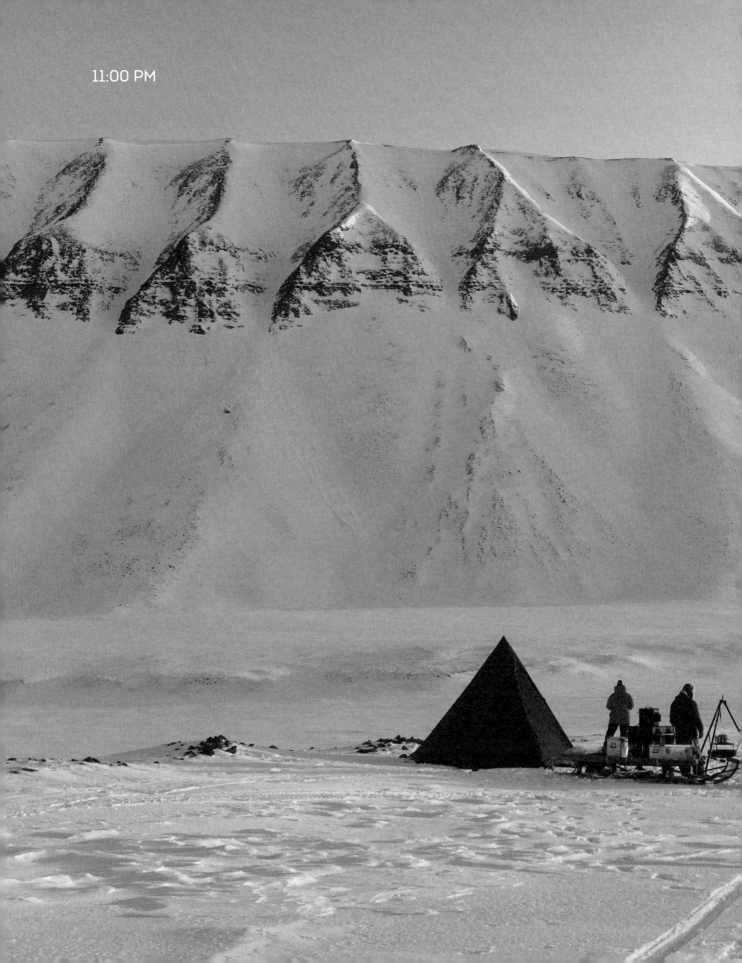

11:00 PM

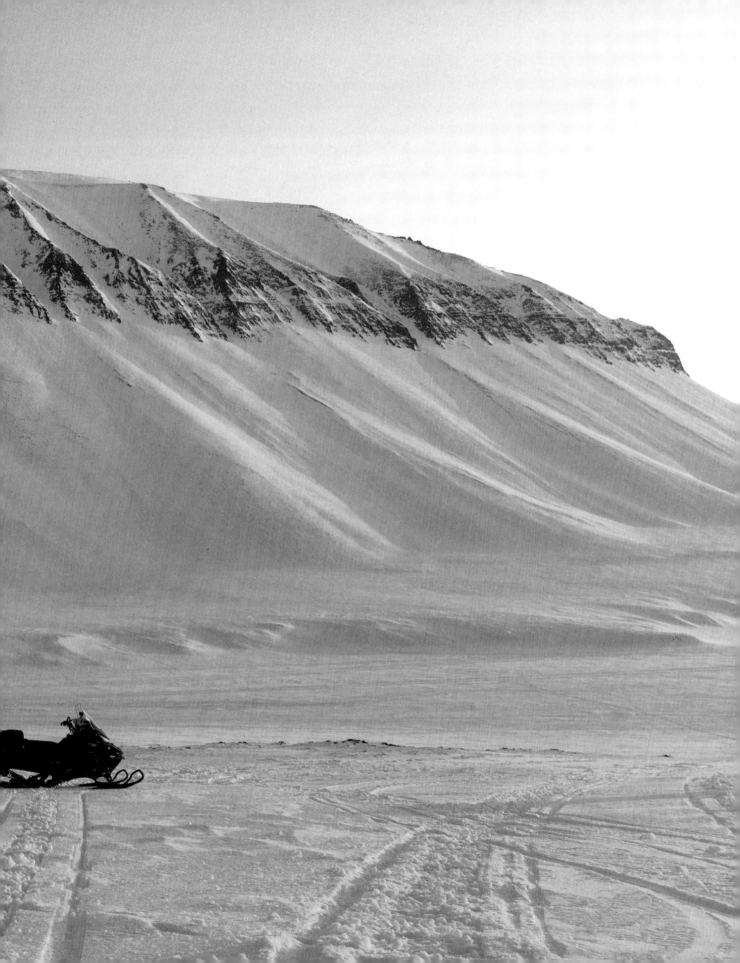

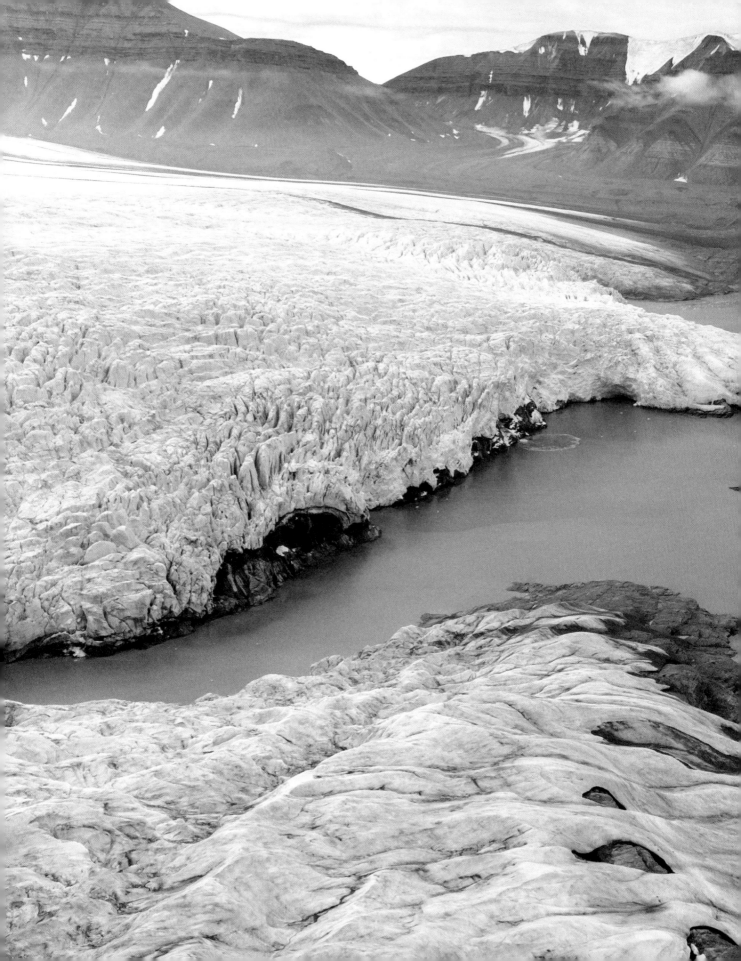

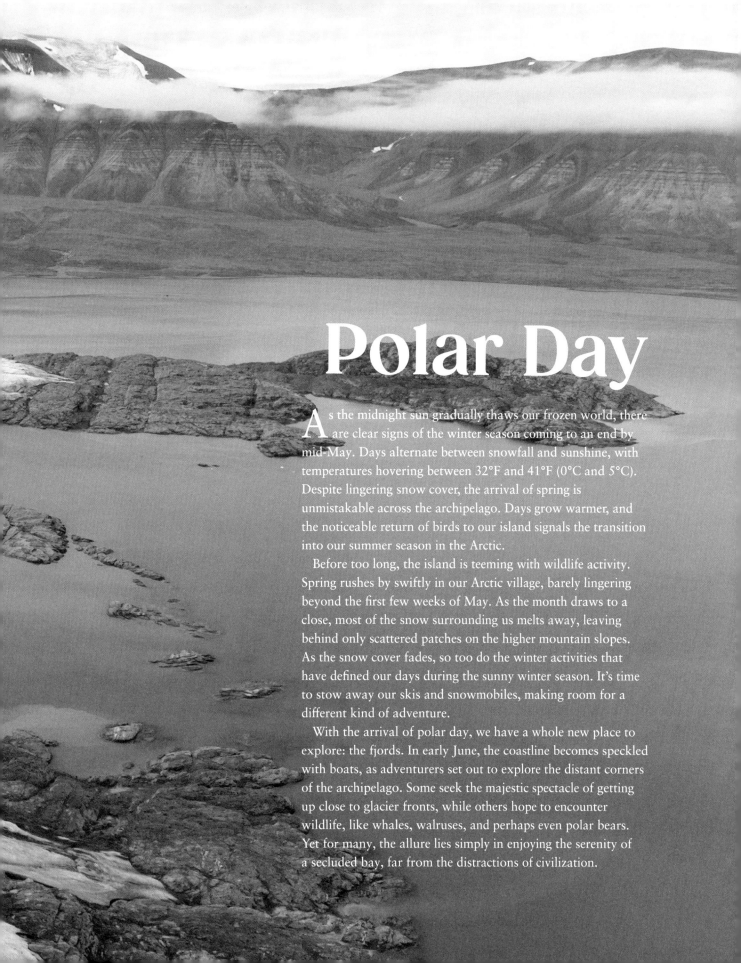

Polar Day

As the midnight sun gradually thaws our frozen world, there are clear signs of the winter season coming to an end by mid-May. Days alternate between snowfall and sunshine, with temperatures hovering between 32°F and 41°F (0°C and 5°C). Despite lingering snow cover, the arrival of spring is unmistakable across the archipelago. Days grow warmer, and the noticeable return of birds to our island signals the transition into our summer season in the Arctic.

Before too long, the island is teeming with wildlife activity. Spring rushes by swiftly in our Arctic village, barely lingering beyond the first few weeks of May. As the month draws to a close, most of the snow surrounding us melts away, leaving behind only scattered patches on the higher mountain slopes. As the snow cover fades, so too do the winter activities that have defined our days during the sunny winter season. It's time to stow away our skis and snowmobiles, making room for a different kind of adventure.

With the arrival of polar day, we have a whole new place to explore: the fjords. In early June, the coastline becomes speckled with boats, as adventurers set out to explore the distant corners of the archipelago. Some seek the majestic spectacle of getting up close to glacier fronts, while others hope to encounter wildlife, like whales, walruses, and perhaps even polar bears. Yet for many, the allure lies simply in enjoying the serenity of a secluded bay, far from the distractions of civilization.

What Is the Midnight Sun?

The midnight sun is a natural phenomenon that occurs when the sun remains above the horizon for 24 hours a day. This phenomenon occurs on Svalbard because the Earth's northern axis tilts toward the sun, constantly keeping us exposed to the sun's powerful light. Thus, the North Pole and our archipelago are fully exposed to the sun for months on end. Because of its extreme northern location, Svalbard experiences some of the longest periods of continuous daylight compared to anywhere else in the world. Here, the midnight sun season, commonly referred to as "polar day," begins on April 19 and lasts for a remarkable 4 months, only concluding on August 24.

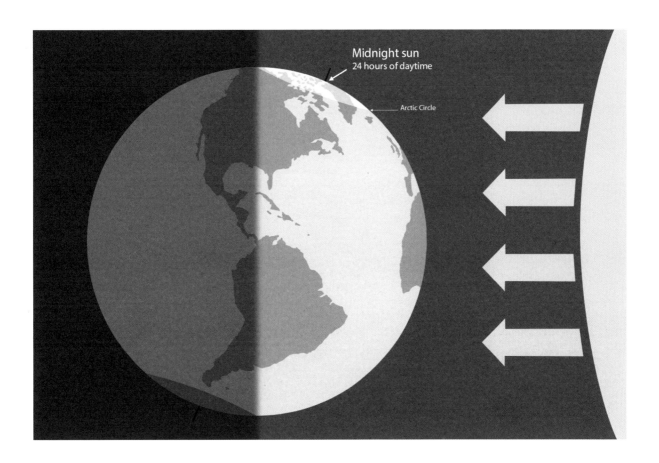

Midnight sun
24 hours of daytime

Arctic Circle

Svalbard experiences some of the longest periods of continuous daylight compared to anywhere else in the world.

BOREBUKTA

Boating to Borebukta

During winter, our boat sits on its trailer outside on land, since there's hardly any indoor boat storage available on Svalbard. While it's hibernating during the darker winter seasons, we remove any weather-sensitive items and bring them home, while the rest remains stored inside the boat. At the end of May, the docks at the small boat harbor, where all the noncommercial boats are moored, are returned to the water after a winter on land. Each year, the boating season wraps up by mid-October, prompting the removal of the docks from the fjord. This is to prevent damage caused by the water freezing over during the cold winter months.

Our vessel is a seasoned Wiking Boat 33, boasting two decades of history and equipped with a relatively new engine. We purchased it a couple of years back from a seller in northern Norway and had it shipped to Svalbard on the shipping boat Norbjørn. The seller had previously spent several years working sporadically on Svalbard and developed a deep fondness for the island. His delight was evident upon learning that the boat's new home port would be Longyearbyen.

From the outside, it looks like any modern boat, painted white with a stylish blue trim and a canopy that keeps the stern deck shaded. Stepping inside, you can see the signs of its years on the light-brown teak and the brass details. But to us, this is all part of the boat's charm. Despite its age, the boat suits us perfectly.

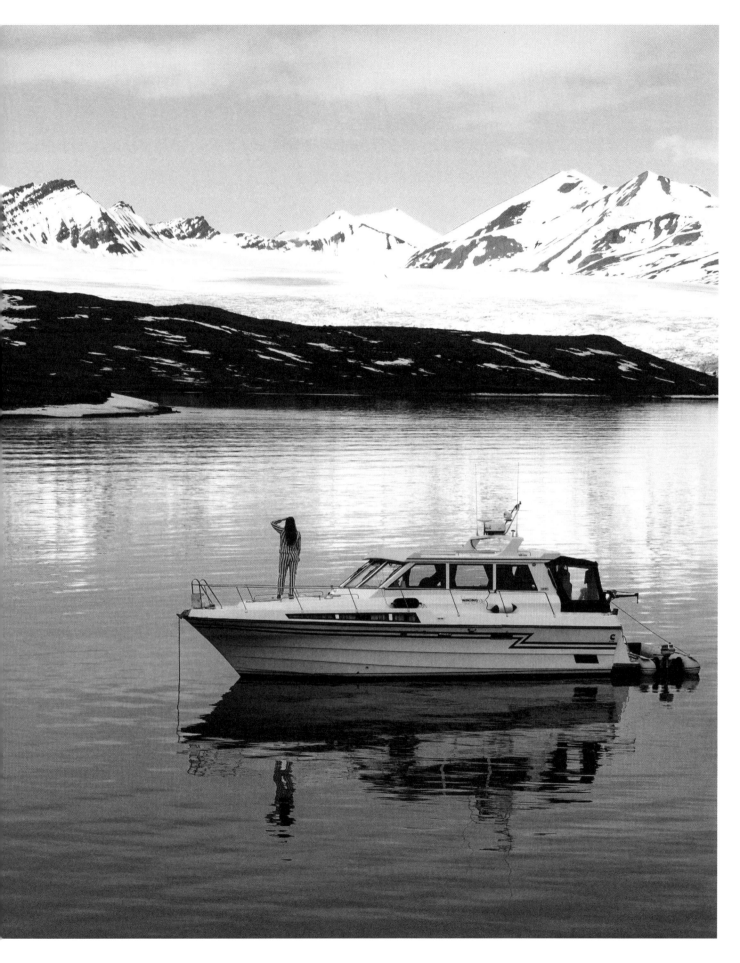

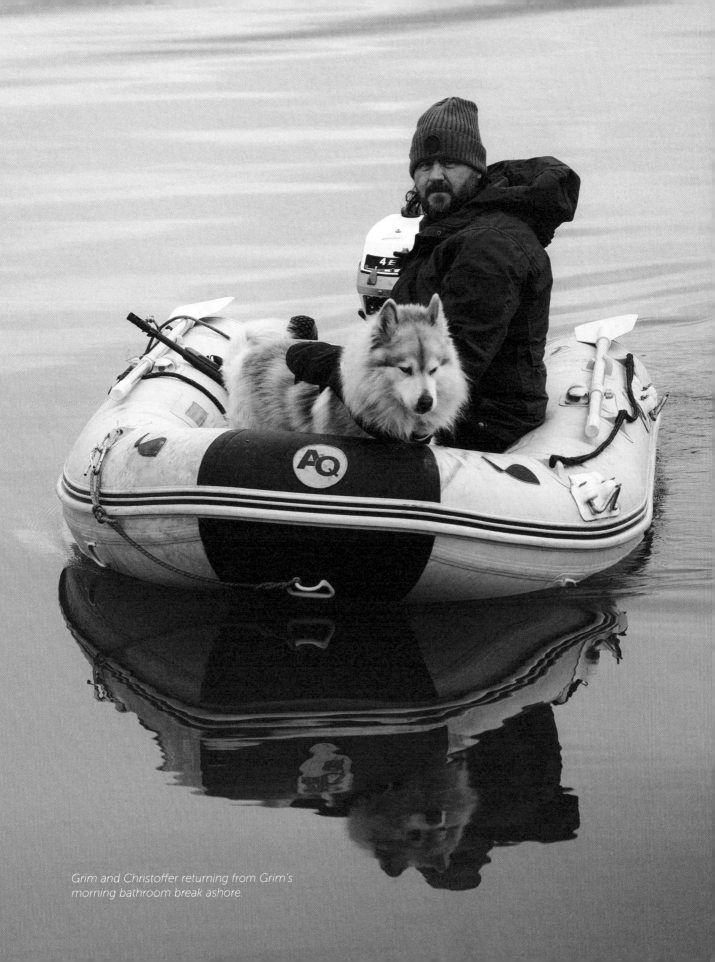

Grim and Christoffer returning from Grim's morning bathroom break ashore.

We're always incredibly excited to kick off the season!

Since this marks our first trip of the season, getting the boat organized is our top priority. The side cabins are cluttered with lines, survival suits, tools, and various other boating essentials. We sift through everything and return every item to its rightful place. Life jackets, including Grim's, are neatly hung outside on the stern deck for easy access when we use the Zodiac, a small inflatable boat (also referred to as a "dinghy") used to transport us between our boat and the shore when we're anchored. Fenders are securely attached to lines and fastened at their cleats, ensuring readiness for docking. Survival suits are strategically placed for quick retrieval in case of an emergency. Everything aboard has its designated place, contributing to our overall safety and preparedness for any situation.

After preparing for a few hours, we're all set to head out. Since it's early in the boating season, many bays are still covered in ice, so the choices are limited. Luckily, our destination is Borebukta, a glacier bay that is a short 3-hour trip across the fjord from our cabin. Here, we'll drop anchor for a few days against the breathtaking backdrop of the Nansen Glacier, a Spitsbergen type that's nearly a mile (1.6 km) wide at its point of contact with the water. It's a great place for the first boat trip of the year, as we're always incredibly excited to kick off the season!

Navigating on Svalbard waters is akin to any other activity in the archipelago: potentially dangerous without the proper expertise or gear. Various factors must be considered, including the presence of drifting ice, unpredictable weather conditions, and wildlife encounters. While polar bears are the animals that most often come to mind when discussing wildlife in Svalbard, during the summer, another intimidating creature appears more regularly: the walrus.

In Borebukta, there's a sand bank that serves as the annual gathering place for walruses to establish their colony. As you enter the bay, it's situated on the right-hand side of the nearly 4.3-miles-wide (7-km) fjord and partially concealed behind a large rock. The walruses blend into the surroundings perfectly, creating what appears to be a bleak, colorless landscape to the untrained eye.

As we approach the bay of Borebukta, we carefully navigate around floating glacier ice in the fjord, steering toward the corner. This spot is ideal for anchorage, as it has a depth of approximately 23 feet (7 m) and a U-shaped coastline that offers some shelter in case of bad weather. Upon anchoring at our designated spot, we notice a walrus swiftly approaching our boat. Walruses are known for their curiosity as well as their occasional destructiveness. They have a knack for damaging dinghies by climbing onto them or using their massive tusks to puncture them. Let's just say it's wise not to get a walrus riled up.

Wide-eyed, Christoffer and I exchange glances before he rushes outside onto our small boat deck to ensure our dinghy is securely stowed out of the water and out of reach of our curious visitor. We then stand back in silence. Even Grim, our dog, senses the tension in the air as we observe the walrus swimming up close to our boat. After completing a lap around us, it disappears into the depths, only to resurface several hundred yards away. Hopefully, this will be the closest encounter with a walrus we'll have during our time here. What an exhilarating start to the boat season!

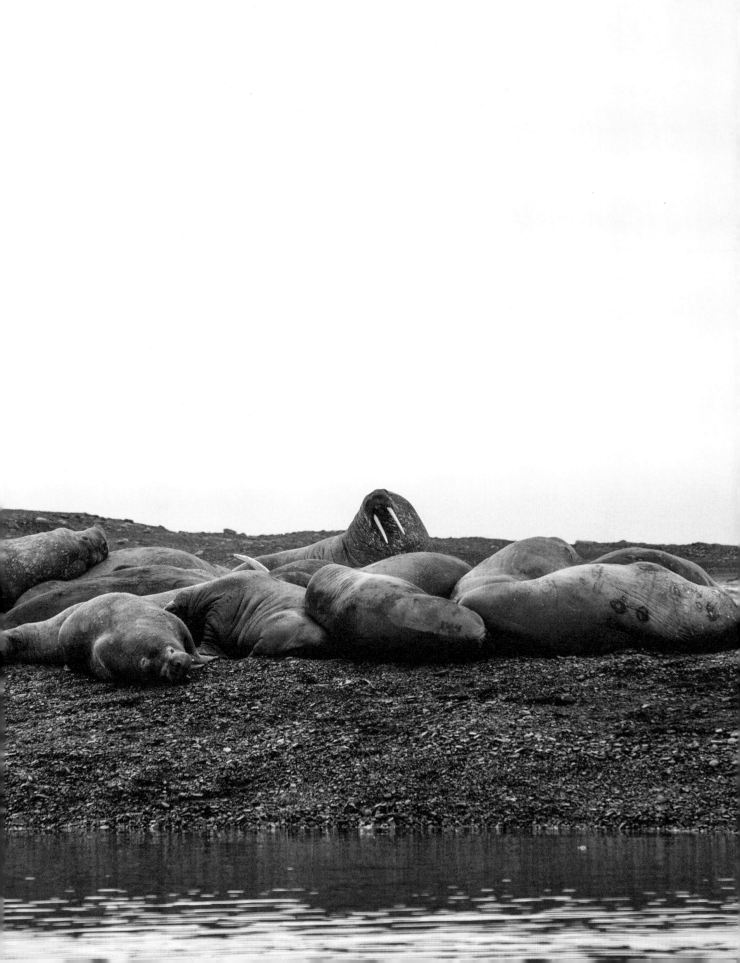

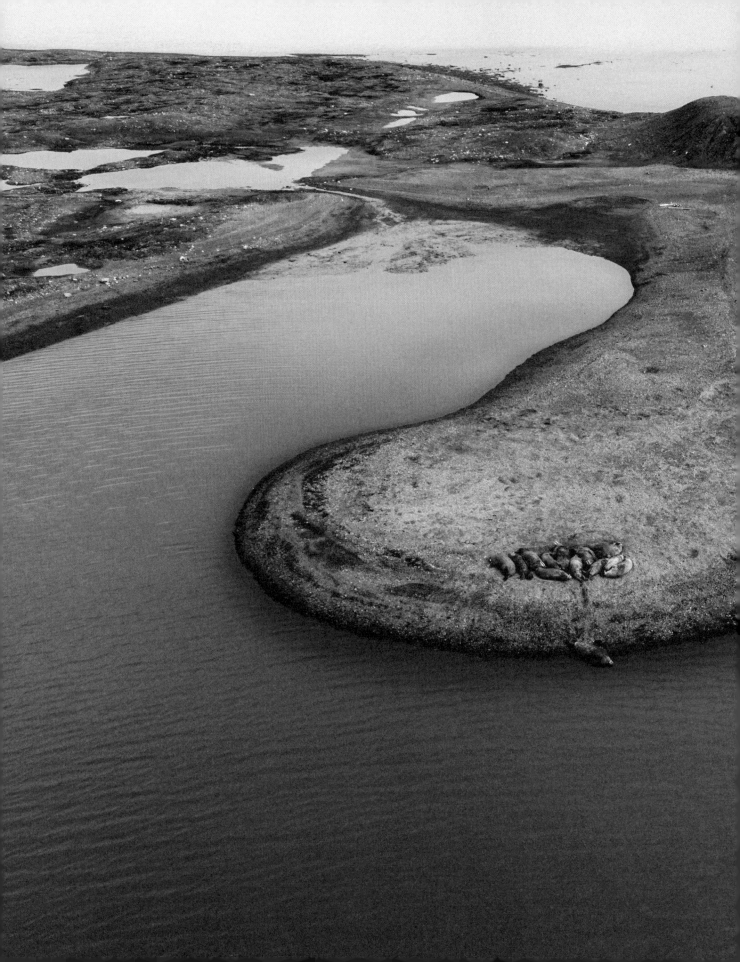

The Walruses of Svalbard

Walruses are found around Svalbard throughout the year, often resting on ice floes. They demonstrate a selective approach to choosing their resting spots, favoring specific areas that provide optimal conditions for accessing food and lounging comfortably. It is common to see large groups of walruses clustered together, reflecting their highly social nature and strong preference for communal living. During the summer and autumn months, they can be spotted lounging in walrus colonies like the one in Borebukta.

There are two subspecies of walruses. Svalbard is home to the Atlantic subspecies, which has an estimated population of around 20,000 to 30,000 worldwide. Approximately 2,000 Atlantic walruses call the Svalbard archipelago home. This contrasts greatly with the Pacific walrus, which has an estimated population of 200,000. Centuries ago, the walrus population on Svalbard faced near extinction due to hunting, leading to its red-listed status and the prohibition of hunting Atlantic walruses since 1952. Despite over 70 years of protection, the walrus population in Svalbard remains relatively small. However, there has been a recent increase in their numbers, with more regular sightings occurring at a frequency not seen in decades. The latest 2018 survey by MOSJ (Environmental Monitoring of Svalbard and Jan Mayen) confirms this upward trend in the walrus population on Svalbard.

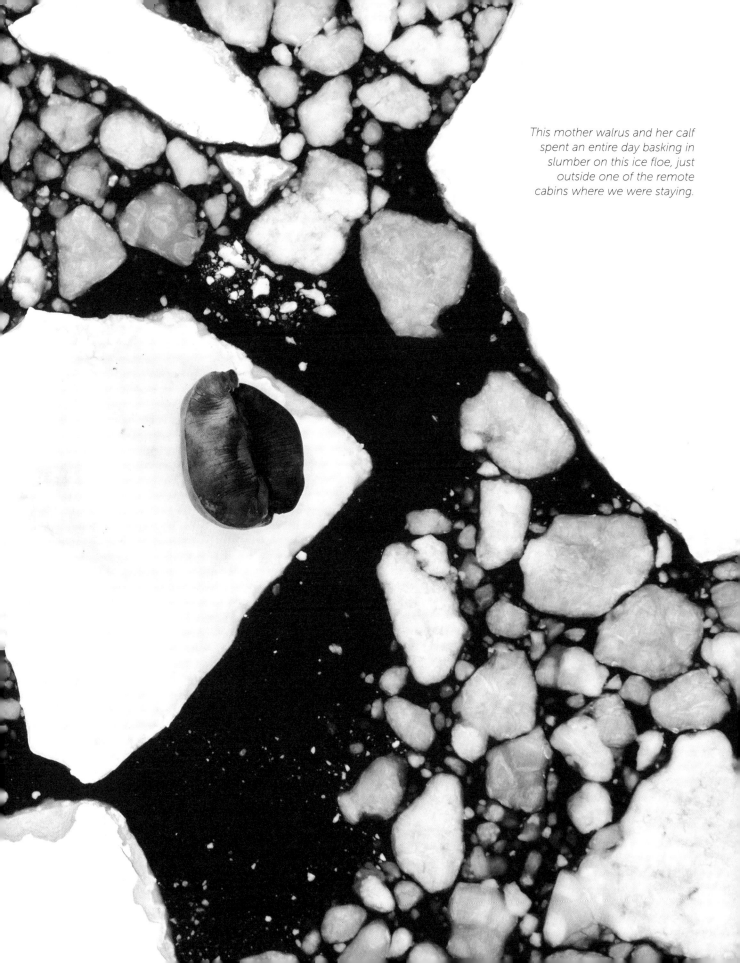

This mother walrus and her calf spent an entire day basking in slumber on this ice floe, just outside one of the remote cabins where we were staying.

Summer Boating Season

I woke up to the sound of water lapping against the boat's hull, rocking us gently. The sun shone brightly through the dark-blue curtains that covered the small cabin windows. Sleeping well during the polar day season can be challenging. I am always on the lookout for a sleeping mask thick enough to block out the endless daylight.

As I got out of bed, the puttering of a motor grew louder. I exited our sleeping quarters, located on the lower deck at the bow of the boat, and climbed the three steps up to the main deck of our little summer home out on the water. While the lower deck of the boat—which houses the main cabin, two small cabins with single berths, and the head (bathroom)—remains cool during summer due to the ocean's chill against the hull, the main deck is the opposite. Its panoramic windows make it into a sunlit greenhouse, soaking up warmth from the never-setting sun.

Looking out through the window, I was met with the sun blazing high in the sky, while Christoffer was navigating our dinghy back from the shore. Being an early riser, Christoffer is always up long before me, taking Grim ashore for his morning bathroom break. Despite our attempts to train Grim to use the boat's swimming platform for his needs, he remained unconvinced, so we took him ashore a few times per day for toilet breaks. Grim stood proudly at the front of the small, rubber boat, resembling a captain eager to guide his crew safely home. Though Grim seemed at home on the sea at this moment, he was only momentarily fearless, as he is actually quite scared of all means of motorized transport. At any second, he can become spooked about something, making him quickly forget about his fearlessness. This is just one of his many quirks.

I walked out of the small aft deck and popped my head out of the canopy that shields the small outer deck from the elements, calling out for Grim. He lit up at the sound of my voice, and as soon as he spotted me, his tail began wagging excitedly. The two of us are inseparable; he is my soul dog, if such a thing exists.

The morning was filled with numerous cups of coffee, enjoyed amid the somewhat summery day. Despite the temperature hovering around 46°F (8°C), the warmth of the sunlight and the clear skies made it feel like summer to us.

I felt a deep sense of happiness that we made it on this trip. Up until the last hour before departing, we were uncertain whether or not we would be able to go. On the day we planned to head out, the weather appeared promising in Longyearbyen but seemed darker toward our destination. Weather can often be an obstacle when adventuring on Svalbard. Whether winter or summer, it's not uncommon to get stuck while out exploring longer than planned.

In the early afternoon, we loaded our dinghy with all the essentials: coffee, snacks, and all our necessary gear, which included a flare gun, radio, firearm, and satellite phone. Eager to embrace the beautiful day and get a closer look at the glacier tucked away in the fjord's innermost corner, we headed toward the shore, setting out on our quest to find the perfect coffee spot. And oh, did we find it!

Here on Svalbard, nature gifts us with countless spectacular moments. Yet, the scenery still always manages to take my breath away. It never gets old. There are so many things I get to experience here firsthand that I'm sure I will remember forever due to the sheer natural beauty of it all. The place we ended up on this boating adventure was one such moment.

We hauled our dinghy up onto the rocky shoreline, which jutted out directly in front of the glacier. Setting up our chairs nearby, we secured an unobstructed view of the colossal Nansen Glacier. There was a stillness that spread out across the bay, interrupted only by the eerie creaks and cracks of the thousand-year-old glacier ice. It stands as one of nature's most breathtaking landscapes. We sat before the truly surreal view in our camping chairs, sipping coffee while Grim slept in the sunshine. It was a moment to relish, as we soaked up the breathtaking scenery.

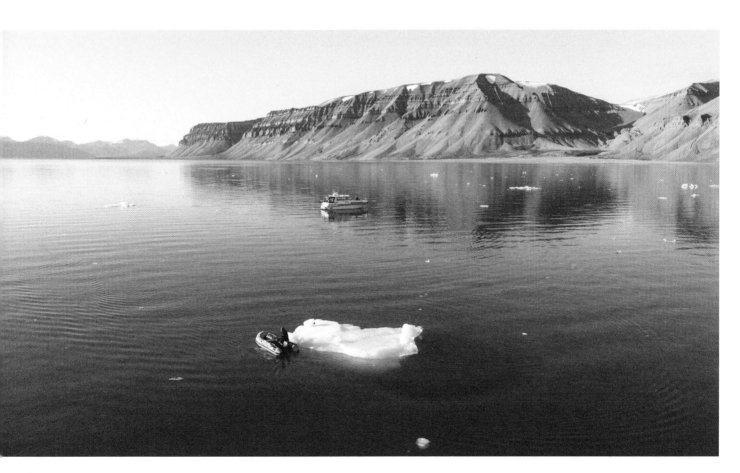

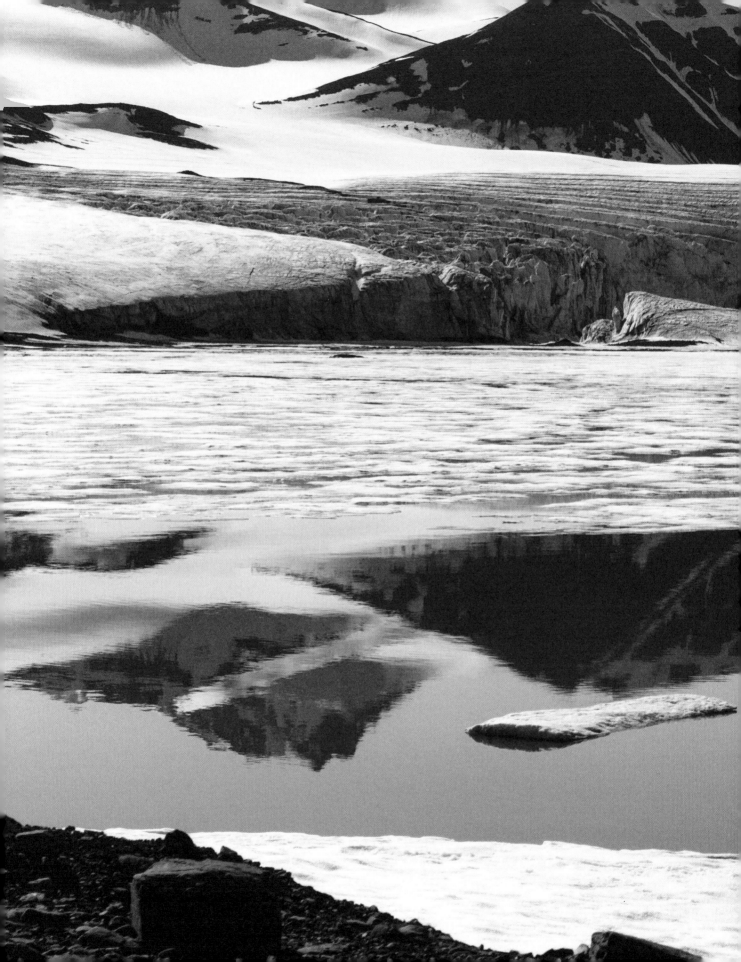

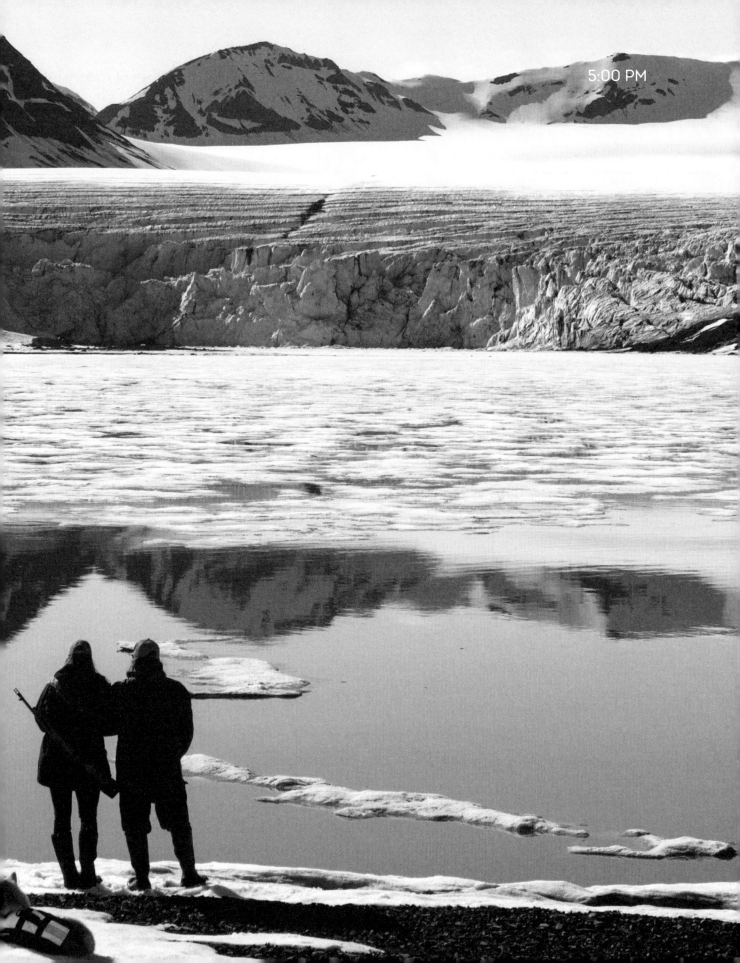

Taking the Polar Plunge

Some of my earliest childhood memories in Sweden that still stand out vividly in my mind are the times when I went winter swimming. I remember my father regularly meeting up with his friends for sauna sessions followed by a polar plunge into the icy ocean waters each winter. Intrigued, I joined them on a couple occasions when I was 6 or 7, eager to experience the thrill of plunging into frigid waters. I still recall the shock of feeling that cold water for the first time. It was like a swarm of pins and needles prickling across my skin. As a youngster, I could only endure the chill for a few brief moments before hastily resurfacing with a shriek of excitement. This fleeting discomfort quickly gave way to an intense rush of energy. Back then, it was a thrilling and daring escapade that I shared with my dad. As an adult, I've come to recognize the benefits of this practice and its transformative effects on both the body and the mind.

Across Scandinavia, using the sauna and going for cold-water plunges are a deeply ingrained and cherished part of our culture. It's not merely a pastime but a way of life, serving as a ritual that offers both physical and mental rejuvenation. Saunas, often nestled in idyllic natural settings, provide communal spaces for relaxation. The tradition of alternating between the intense heat of the sauna and the bracing chill of cold-water immersion is believed to promote health and vitality. Many Scandinavians swear by the therapeutic effects of this practice, claiming it boosts immunity, relieves stress, and invigorates the body. Despite the biting cold of Nordic winters, people flock to icy lakes, fjords, and even the open sea to immerse themselves in the startlingly frigid waters. This practice is just as much about connecting with nature as it is about self-care and resilience.

Despite the biting cold of Nordic winters, people flock to icy lakes, fjords, and even the open sea to immerse themselves in the startlingly frigid waters.

The ocean's temperature around Svalbard hovers between 32°F and 39°F (0°C to 4°C) throughout the year. In Longyearbyen, there's a courageous group of locals known as *Ispinnene*, aka "The Ice Lollies," who have organized a Facebook group that invites anyone in town who is interested to join them on their regular polar plunges. Every Wednesday at 7 a.m., they meet at the town harbor for a brisk dip in the freezing ocean before starting their workday. Despite my 8 years spent living here, I have yet to make it to one of their meetups. Not because the idea of swimming in the icy waters of Longyearbyen harbor doesn't sound appealing to me, but because 7 a.m. feels unbearably early. However, one day, I am determined to join them!

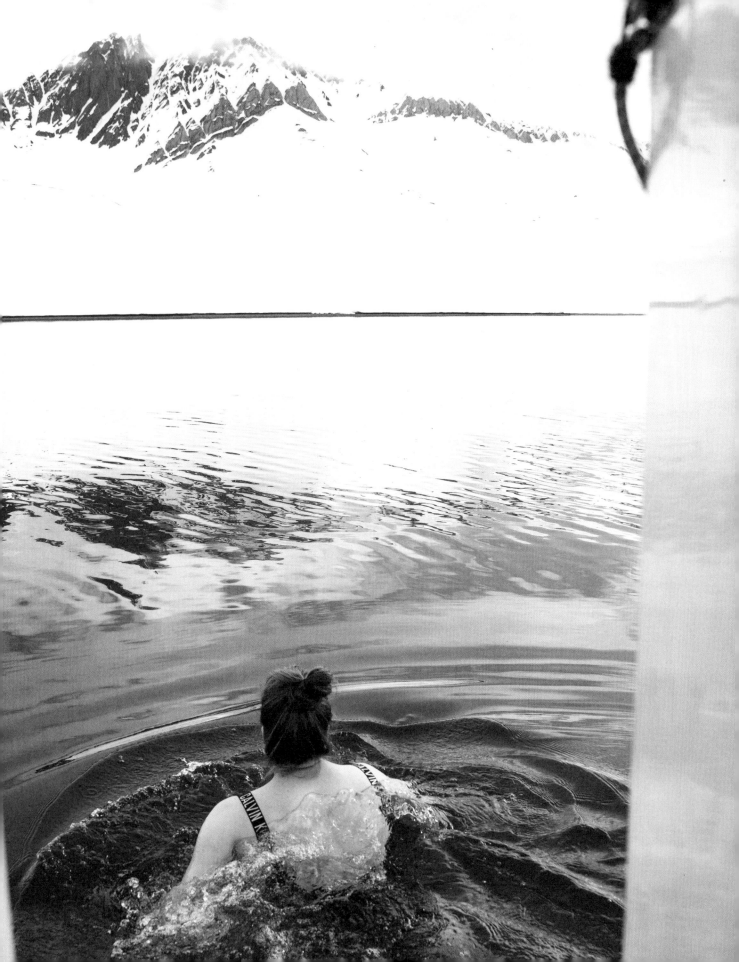

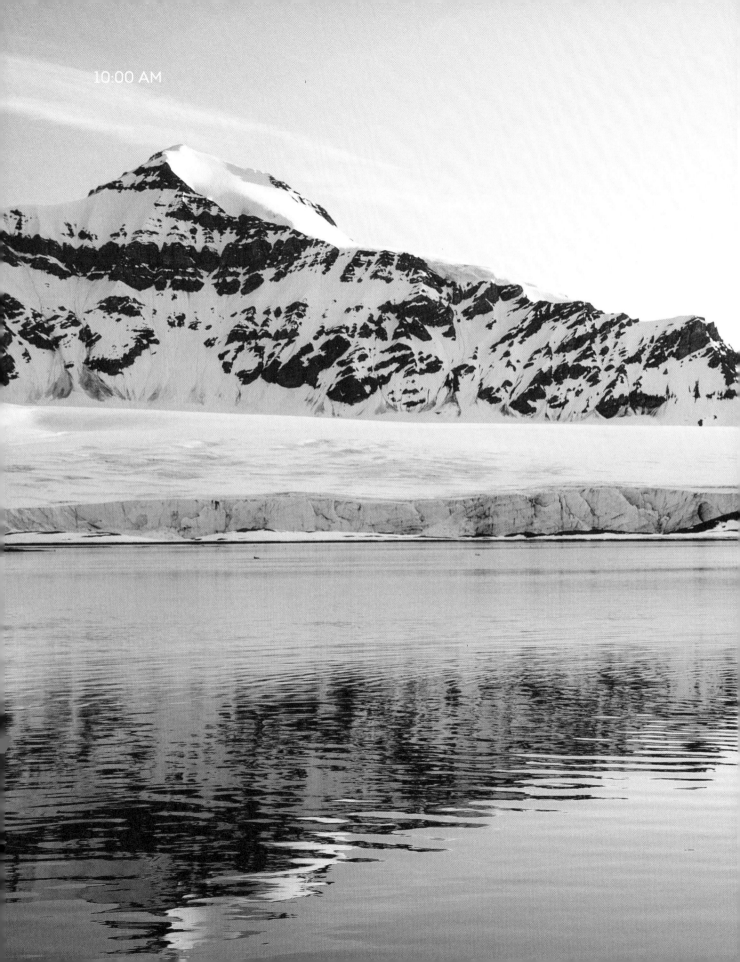

10:00 AM

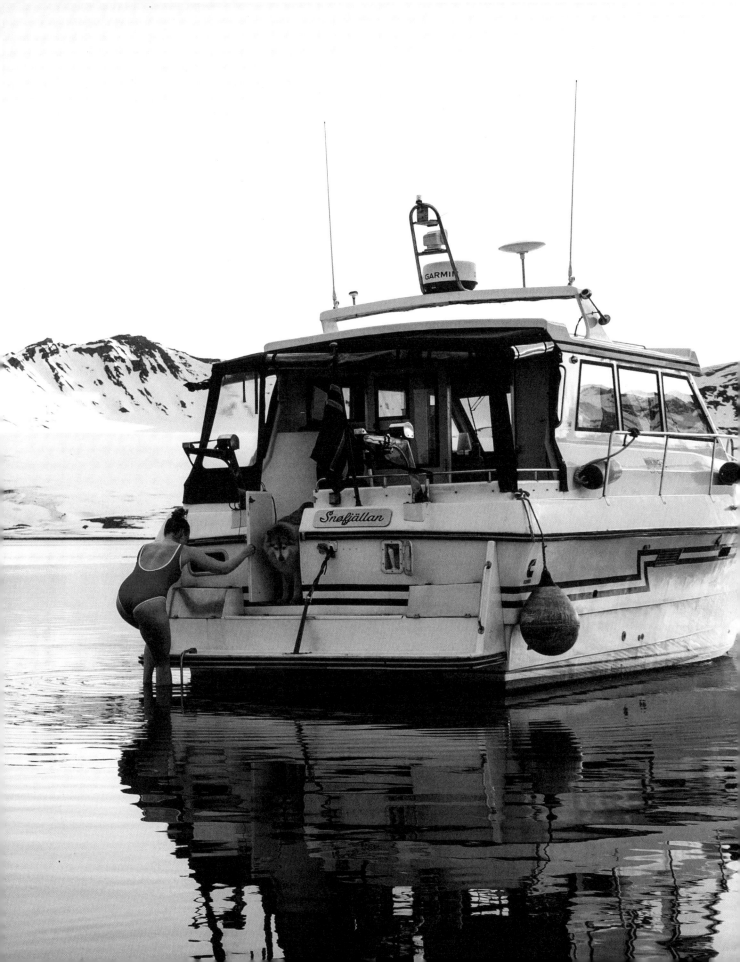

During the summer though, I do indulge in swimming in these chilly waters by myself from the comfort of our boat. It's convenient and serene, set against the backdrop of breathtaking surroundings. Why do I do it? It's as simple as this: it makes me feel alive. As I slowly immerse my body into the water, the cold can still catch me off guard and steal my breath momentarily. Initially, my skin starts to tingle with prickles, and my hands and feet feel as if they're burning. But as the seconds pass, I work to get control of my breath and start to calm myself down. When I can no longer stand it, which can be as long as several minutes or as brief as 20 seconds, I pull myself out and back onto the boat, experiencing a rush of energy that pulsates throughout my body. A euphoric sensation washes over me then, grounding me in the present moment and instilling within me a deep sense of triumph for braving the elements and the cold.

It's safe to say that living on Svalbard has fully reignited my pursuit of the exhilarating feeling that comes with winter swimming, which I first got to experience back in Sweden as a child, and I am so glad for it.

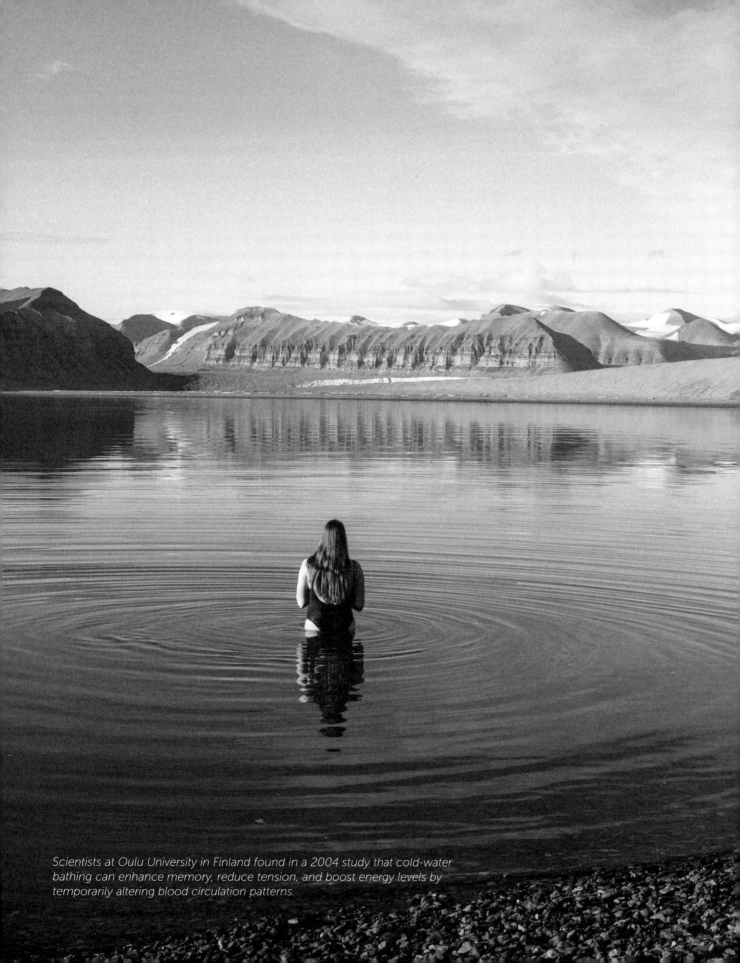

Scientists at Oulu University in Finland found in a 2004 study that cold-water bathing can enhance memory, reduce tension, and boost energy levels by temporarily altering blood circulation patterns.

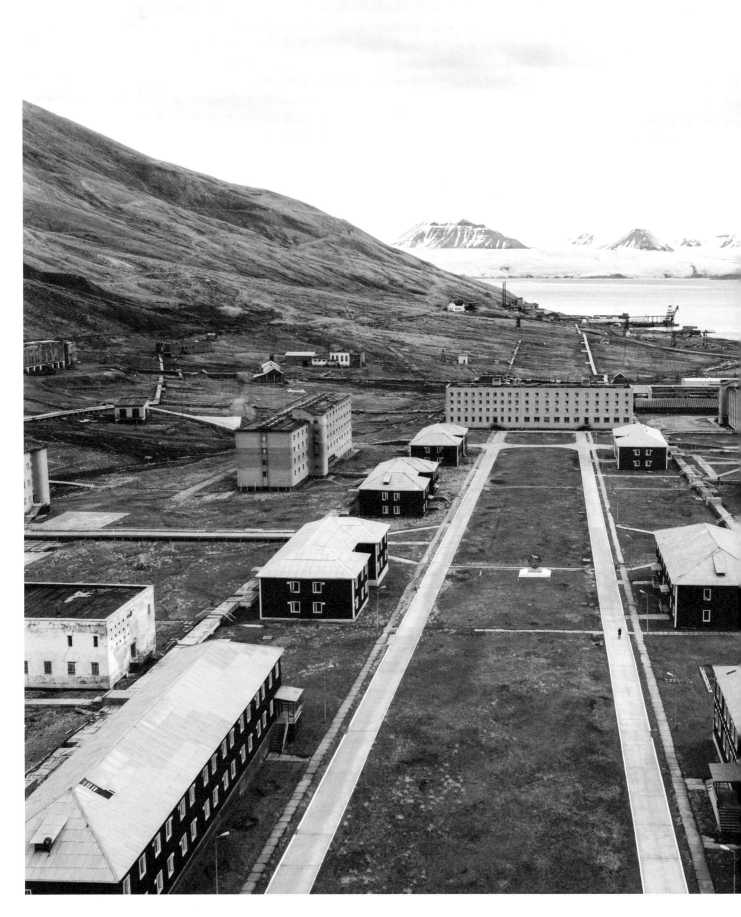

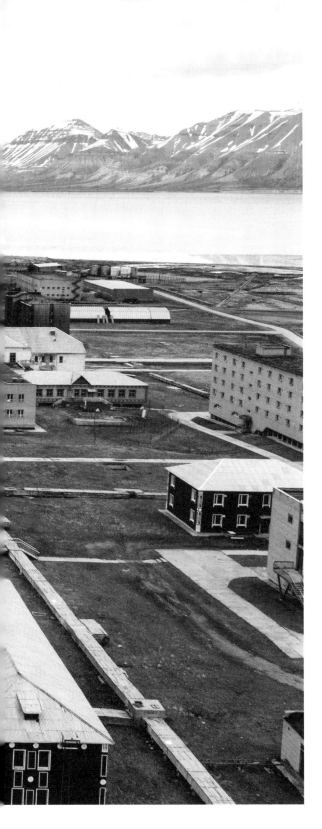

Visiting Svalbard's Ghost Town

Once a thriving Arctic town with a population of approximately 1,500 residents, Pyramiden is now a ghost town. Dominating the town's main street is the world's northernmost statue of Vladimir Lenin, the founding political leader of Soviet Russia, who silently observes the deserted surroundings of the abandoned village.

Pyramiden, referred to as *Piramida* in Russian, takes its name from the pyramid-shaped mountain that's adjacent to the town. Founded in 1910 by Sweden after the discovery of coal deposits in the surrounding mountains, Pyramiden was later sold to the Soviet Union in 1927. By the 1980s, Pyramiden was thriving as a bustling coal-mining community, boasting a population that exceeded a thousand residents, most of whom were Ukrainian.

Throughout the 1960s, '70s and '80s, employment in the Pyramiden mines was highly coveted. Workers enjoyed 2-year contracts with respectable wages, making positions in this Soviet settlement highly sought after with numerous applicants vying for each job available. The town featured an array of local amenities, including a cultural center complete with a theater, library, art and music studios, and a sports complex. Unlike Longyearbyen, which was still predominantly male dominated at the time, Pyramiden stood out by catering to families with their respected primary school and kindergarten.

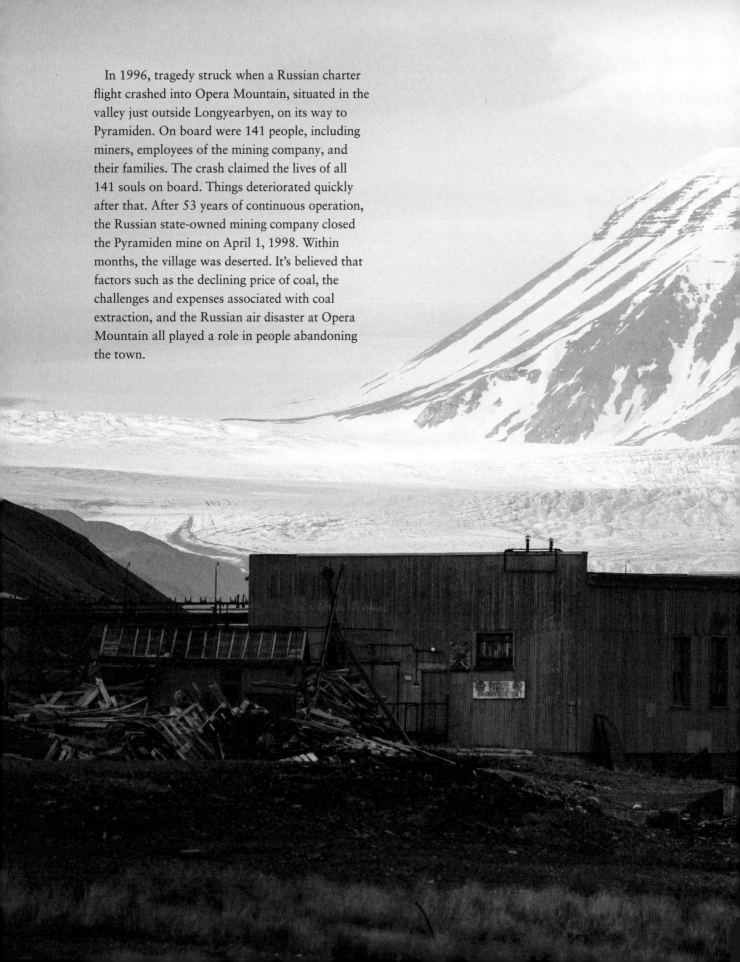

In 1996, tragedy struck when a Russian charter flight crashed into Opera Mountain, situated in the valley just outside Longyearbyen, on its way to Pyramiden. On board were 141 people, including miners, employees of the mining company, and their families. The crash claimed the lives of all 141 souls on board. Things deteriorated quickly after that. After 53 years of continuous operation, the Russian state-owned mining company closed the Pyramiden mine on April 1, 1998. Within months, the village was deserted. It's believed that factors such as the declining price of coal, the challenges and expenses associated with coal extraction, and the Russian air disaster at Opera Mountain all played a role in people abandoning the town.

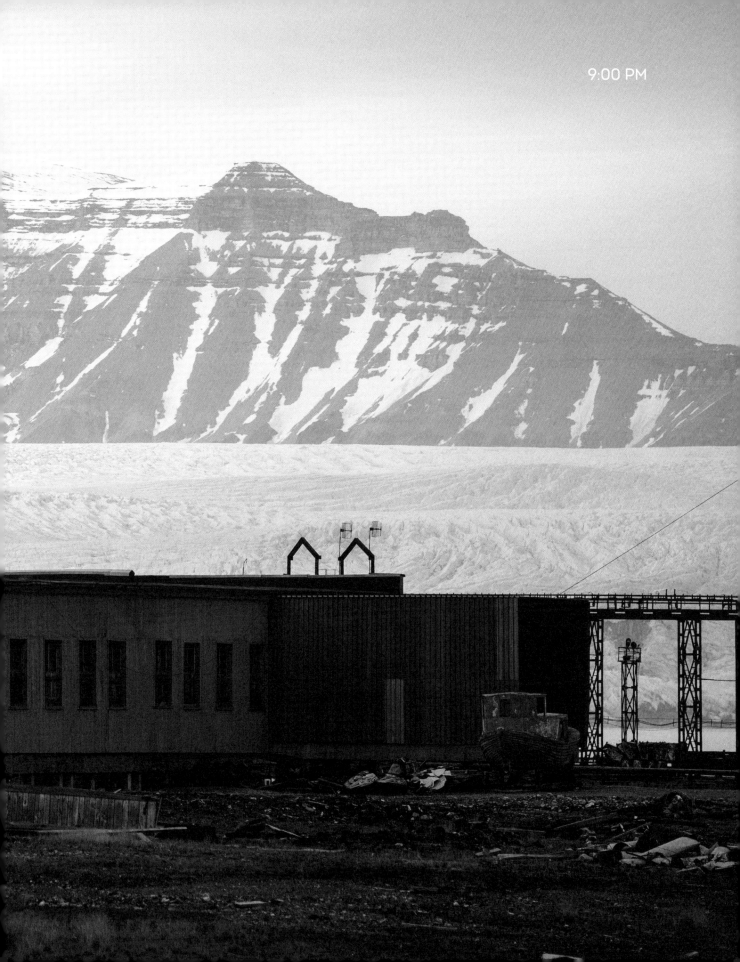

In 2013, the Pyramiden Hotel reopened its doors, welcoming guests for overnight stays. The hotel is also home to the Pyramiden Museum, a post office, and a souvenir shop. Positioned 31.1 miles (50 km) north of Longyearbyen, the town sits toward the innermost corner of Billefjorden, drawing visitors from far and wide. With its captivating history and fascinating surroundings, it serves as a popular destination for both locals and tourists alike. During winter, the only way to get here is by snowmobile, resulting in a lengthy but incredibly scenic journey. Once the fjord freezes over by February, adventurers can travel the 7.5-miles (12-km) route through valleys and across the ice-covered waters, passing seals basking in the sun before the colossal glacier fronts. In the summer, Pyramiden is accessed exclusively by boat, a trip that ranges from 2 to 6 hours depending on your boat's speed and the weather conditions. Upon arrival, you can choose to delve into the captivating history with a guided tour of the buildings or simply indulge in a meal at the hotel, which offers a menu showcasing traditional Russian dishes, before making the return journey.

The last time Christoffer and I visited the town was several summers ago. We arrived on our boat to an empty and quiet harbor. After anchoring, we took our dinghy ashore and made the 15-minute walk to the town center. Along the aged wooden walkway, remnants of the past surrounded us. Exploring Pyramiden felt akin to stepping inside a time capsule. It still looked as if the residents departed abruptly, leaving everything frozen in time. Most of the town's buildings remained desolate, since they had been abandoned for decades, serving as silent echoes, remnants of the town's past.

While certain buildings remained remarkably preserved, others had been reclaimed by nature. Arctic foxes darting among the derelict buildings took a special interest in Grim. Approaching the heart of the town, the calls of seabirds grew louder, and a pungent stench began to tickle the inside of my nose. It soon became evident as to why. The tall, angular buildings teemed with life, every available perch occupied by nesting birds and their droppings.

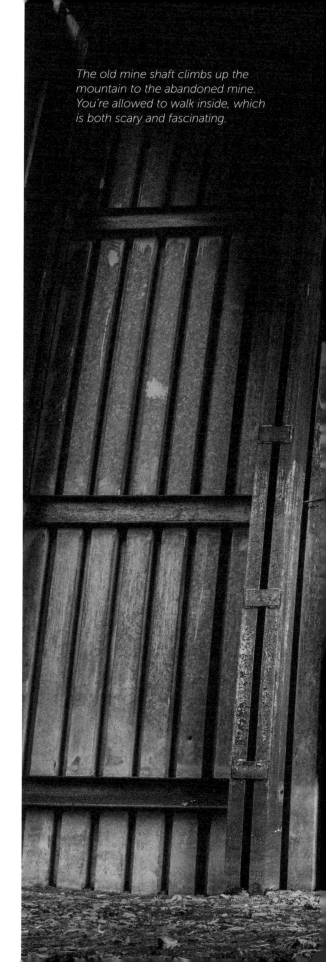

The old mine shaft climbs up the mountain to the abandoned mine. You're allowed to walk inside, which is both scary and fascinating.

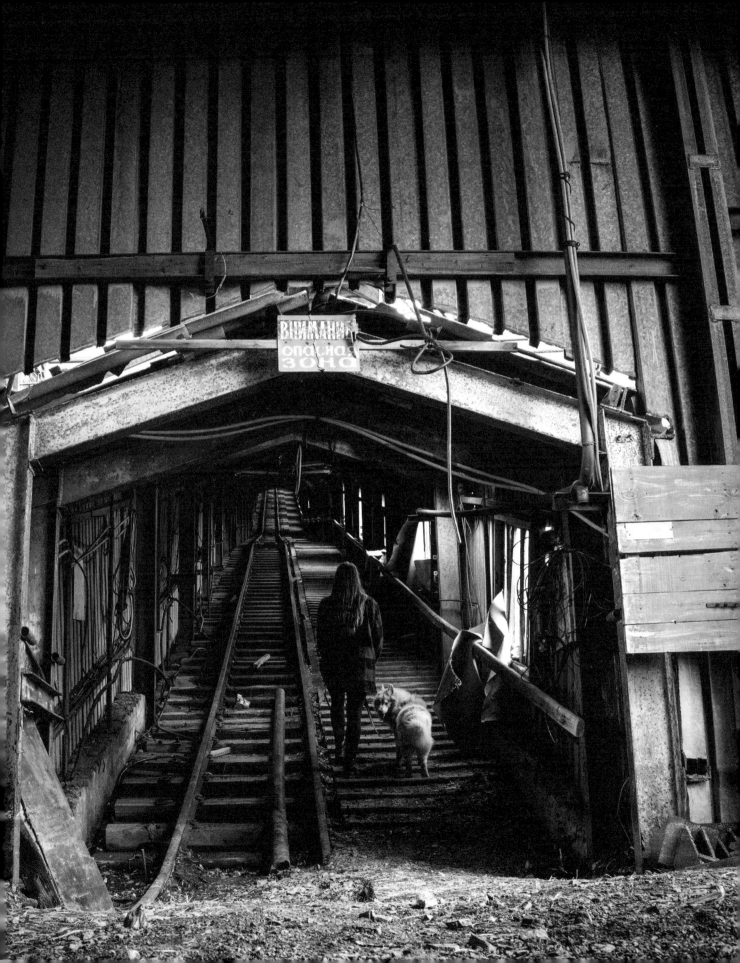

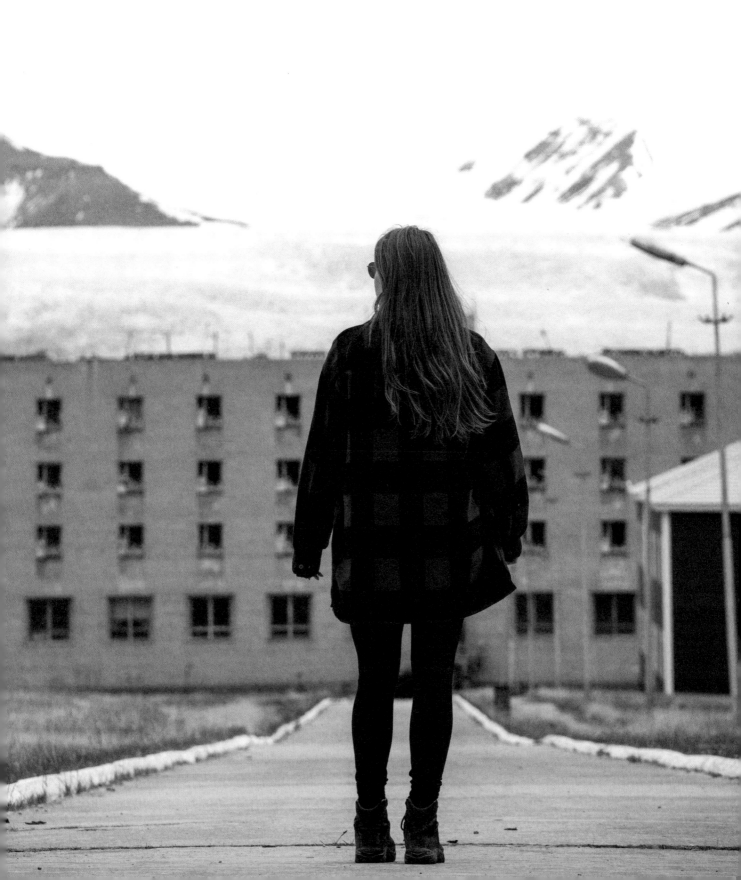

The majestic Nordenskiöld Glacier stands as a radiant backdrop to the village, showcasing the breathtaking beauty that serves as the defining natural landmark of this once heavily populated area. Pyramiden now only has a handful of residents who live here for a few months each year to run the hotel and welcome guests who want to check out the ghost town. The main inhabitants are the Arctic animals that call this place home. Arctic foxes and Svalbard reindeer roam the town's streets, sharing the land with the occasional polar bear that finds itself here, on the prowl for food.

An eerie yet enchanting atmosphere surrounds this place. Wandering around the meticulously paved streets, the allure of Pyramiden as a sought-after destination becomes apparent. While some buildings still appear outwardly pristine, their interiors have been reclaimed by birds or are cloaked in layers of dust, lending the town the ambience of a grand museum. As you stroll through Pyramiden's streets, vivid imaginations conjure visions of life here decades ago.

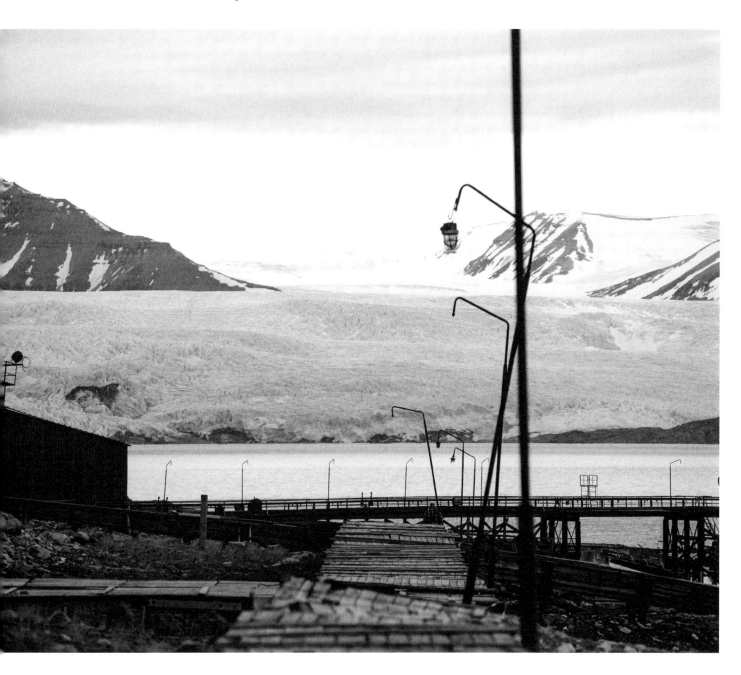

Fun Facts

Alcohol is rationed:

Alcohol sales on Svalbard are regulated by quotas, an ordinance that dates back to earlier days. Residents listed on the Population Register of Svalbard who are 18 or older are eligible for an alcohol quota card. However, individuals must be at least 20 years old to purchase products that contain over 22 percent alcohol. Contrary to common misconceptions, this rule isn't aimed at combating seasonal depression but rather stems from the island's coal-mining history. Longyearbyen was initially a company town and enforced a ration system to mitigate excessive alcohol consumption among the miners who lived here. Interestingly, liquor and beer were more strictly regulated, since these were the kinds of drinks the miners preferred, while wine sales were notably unrestricted, since officials in power were known to prefer wine instead, as the local version of the story goes. Despite decades passing since the rule was enacted in the 1950s, it persists, mandating that locals possess a card for alcohol purchases. The ration is not applicable to alcohol purchased at a bar or a restaurant; it is solely for use at the government-owned store, which is the only authorized reseller of beverages that exceed 4.75-percent alcohol content in Norway and Svalbard.

Cats are banned on the entire archipelago:

In 1992, legislation was implemented that forbids cats from living on the Svalbard archipelago. Given the abundance of breeding colonies of seabirds and other avian species here, the presence of even a few cats could wreak havoc on our local bird populations. Moreover, cats pose a risk of introducing diseases into the delicate ecosystem of these Arctic islands.

Jan	Feb	Mar	Apr	Mai	Jun
ØIØIØ	ØIØIØI	ØIØIØI	ØIØIØI	ØIØIØI	ØIØIØI
1	2	3	4	5	6
Jul	Aug	Sep	Okt	Nov	Des
ØIØIØ	ØIØIØI	ØIØIØI	ØIØIØI	ØIØIØI	ØIØIØI
7	8	9	10	11	12

Sysselmesteren på Svalbard

Jan	Mar	Mai	Jul	Sept	Nov
Sterkvin	Sterkvin	Sterkvin	Sterkvin	Sterkvin	Sterkvin
1 Feb	2 Apr	3 Jun	4 Aug	5 Okt	6 Des

ALKOHOLKORT 2024

Kortnr: 182

Navn: BLOMDAHL, CECILIA ERI

Født:

Jan	Jan	Feb	Feb	Mar	Mar
Brennevin	Brennevin	Brennevin	Brennevin	Brennevin	Brennevin
1	2	3	4	5	6
Apr	Apr	Mai	Mai	Jun	Jun
Brennevin	Brennevin	Brennevin	Brennevin	Brennevin	Brennevin
7	8	9	10	11	12
Jul	Jul	Aug	Aug	Sep	Sep
Brennevin	Brennevin	Brennevin	Brennevin	Brennevin	Brennevin
13	14	15	16	17	18
Okt	Okt	Nov	Nov	Des	Des
Brennevin	Brennevin	Brennevin	Brennevin	Brennevin	Brennevin
19	20	21	22	23	24

Longyearbyen was initially a company town and enforced a ration system to mitigate excessive alcohol consumption among the miners who lived here.

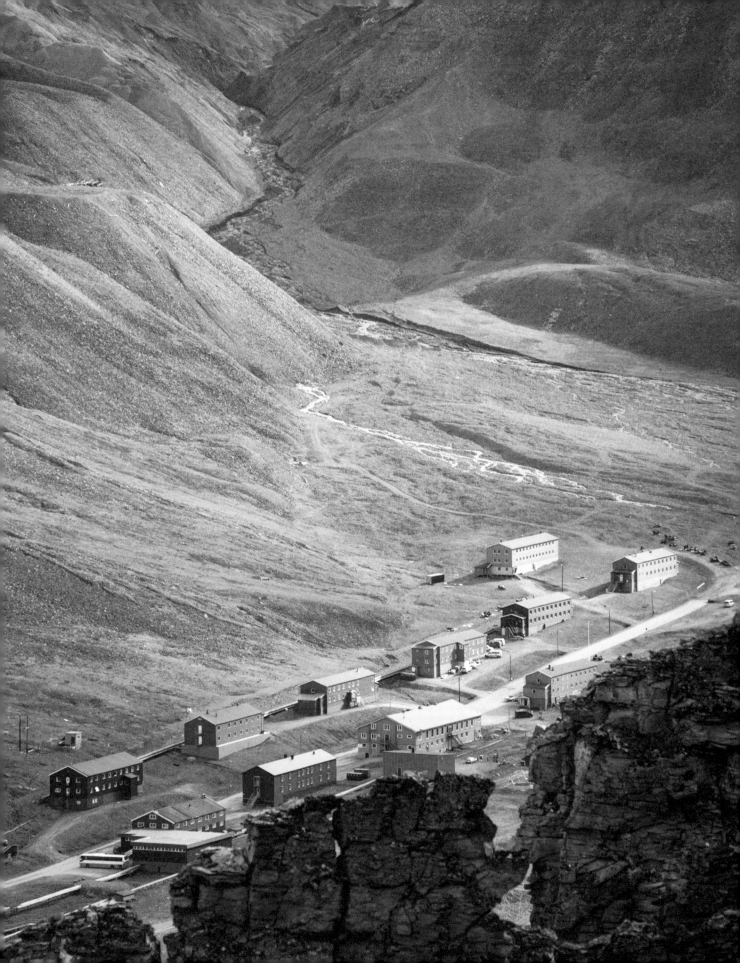

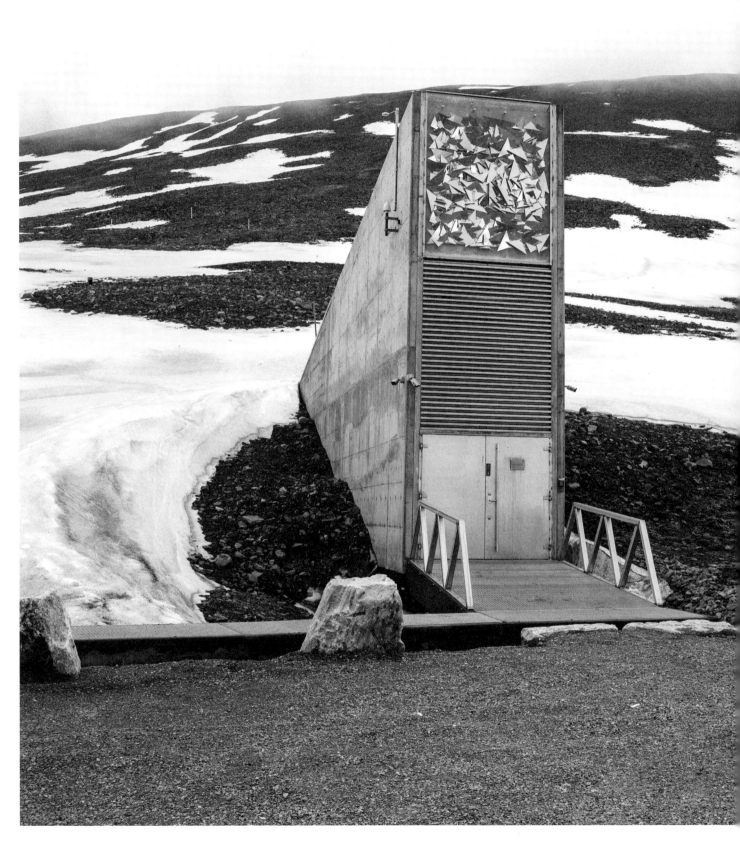

The Svalbard Global Seed Vault protects duplicates of more than 1 million seed samples from nearly every corner on Earth. The vault is situated in a mountain right behind the airport.

The Global Seed Vault:

Spitsbergen proudly hosts the Svalbard Global Seed Vault, a crucial facility dedicated to safeguarding the genetic diversity of plant species for future generations. Opened in 2008 and situated within the mountainous terrain just behind Svalbard's airport, this vault currently houses an impressive 1.2 million seed samples that represent nearly every corner of the globe. Its primary mission is to serve as a fail-safe, housing collections of vital food crops to mitigate the risks posed by natural disaster, conflicts, or other catastrophic events. The vault is maintained at a frigid -0.4°F (-18°C), but even in the case of power failure, the permafrost on Svalbard coupled with the vault's strategic location approximately 500 feet (152 m) deep into the mountain ensures the preservation of these invaluable reservoirs.

Take off your shoes:

A common practice in town involves removing your shoes before entering certain buildings, like hotels or communal spaces. This tradition dates back to when coal mining was the primary industry in Longyearbyen. The custom originated as a preventive measure against tracking coal dust and dirt indoors, which helped to maintain the cleanliness and hygiene of shared spaces. Even today, this tradition serves as a respectful nod to the town's historical roots.

You are not allowed to give birth here:

Due to the limited facilities available at the hospital in Longyearbyen, pregnant mothers are asked to travel to the mainland several weeks before their due dates. The town hospital serves both primary and specialist health needs for Svalbard's residents, offering outpatient services during the day for examinations, treatments, and minor surgical procedures. Universal healthcare coverage is available to all employed individuals paying taxes on Svalbard, which includes coverage for childbirth expenses and accommodations on the mainland for expectant mothers who must leave the archipelago when the time comes to give birth.

Foraging, Fishing, and Finding Sustenance

Living at the top of the world on a remote Arctic island, our primary source of sustenance arrives by shipping boat or air freight. Frozen meat and vegetables, along with items like canned and dried goods, are transported by the shipping boat. However, perishable items, such as salad, vegetables, dairy products, and other fresh produce, arrives by air freight. Should these shipments cease for any reason, the question arises: What alternatives do we have for sourcing food? With the ground permanently frozen and the region situated well above the Arctic tree line, traditional crop cultivation is not achievable. While there are edible mushrooms and mountain sorrel available for foraging on the tundra, relying solely on these would prove insufficient. Additionally, collecting mountain sorrel requires approval from the government office because our Arctic flora is protected by law, which can make even the simple act of picking a flower prohibited.

In Longyearbyen, we don't have any livestock. This results in Svalbard reindeer being our sole meat source, a resource we happen to have in abundance. Locals with a hunting license are entitled to one reindeer annually provided they apply and pass the yearly shooting test. Upon approval, hunters are assigned a specific type of reindeer based on the reindeer's age and gender within a designated hunting area that can span miles. Since the tundra is only accessible on foot due to our laws that protect the flora, hunters must carry their catches back home themselves. While a single reindeer can provide enough meat for a hunter's dinner for a few months, it can also serve as valuable, locally sourced protein that can be shared with other residents.

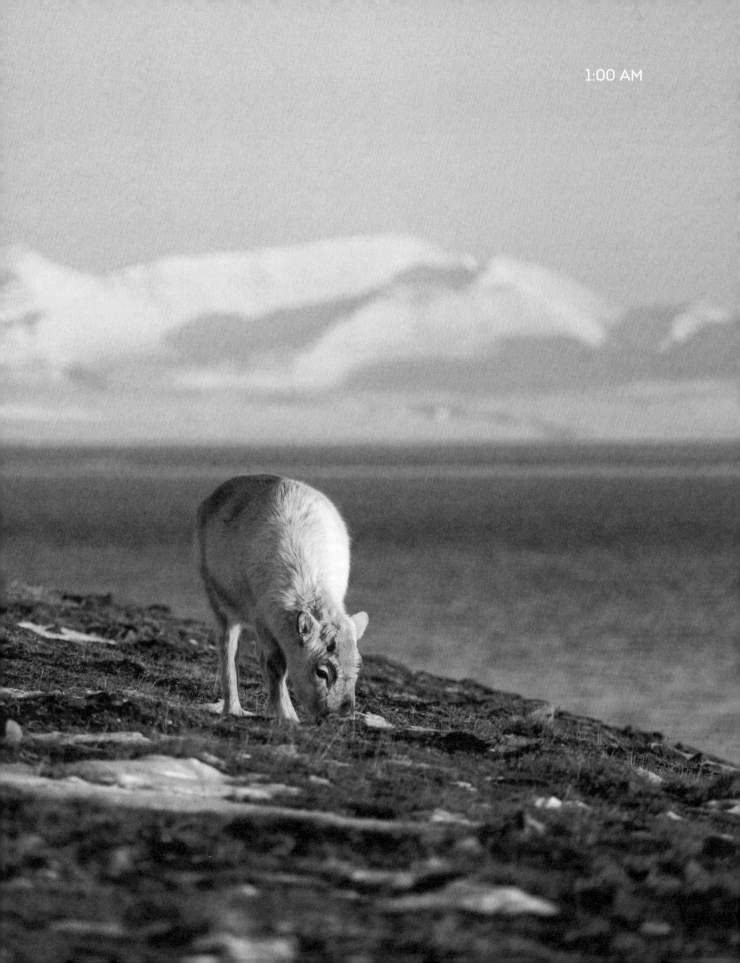

While fishing is permitted year-round, the peak months are typically from July through September.

The vast ocean that surrounds us has plenty of fjords, which brim with an array of fish species. These fish include Arctic cod, haddock, Atlantic wolffish, Arctic char, and salmon. Christoffer previously spent many summers fishing for Arctic cod, supplying the local restaurants with fresh catches. While fishing is permitted year-round, the peak months are typically from July through September. During this period, the ice fjord outside Longyearbyen becomes abundant with haddock and Arctic cod, two very sought-after catches. Commercial fishing is prohibited on Svalbard due to laws and regulations, but locals are permitted to catch up to 4,409 pounds (2,000 kg) of fish per boat per year, for personal use or to sell. Therefore, if it ever becomes necessary, we can likely sustain ourselves on the fish we can catch from the fjords.

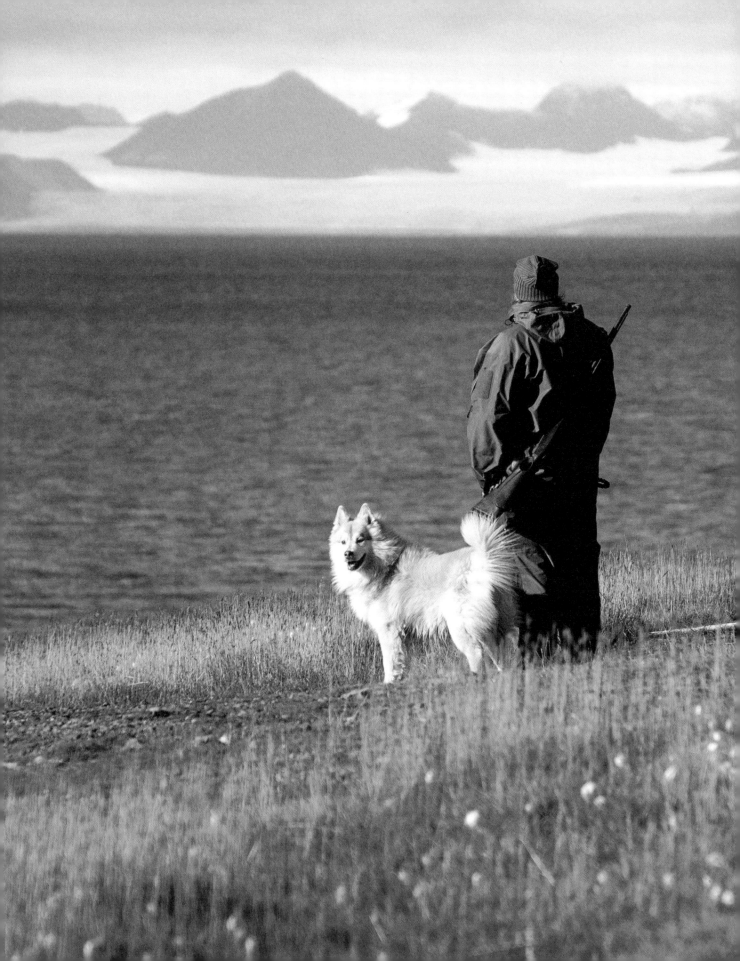

Fishing has become a genuine passion of mine. As I got to know Christoffer, I frequently joined him on his fishing trips. It was always more convenient for him to have another person on board—that way someone could steer the boat while the other could fish. Eager to learn more about him, as well as wanting to get out there on the fjords, I readily volunteered for the task. There's a unique joy in navigating the picturesque fjords and providing for ourselves by catching our own food. Sharing a meal made from something you've caught yourself holds a special kind of significance. I also find the act of fishing itself to be incredibly calming. It requires patience above all else. While some trips result in a catch almost instantly, others require hours of waiting between bites. We're careful to always release smaller fish and keep only those that meet our size standards.

On an island where foraging options are limited, every summer we make it a priority to stock our freezer with self-caught fish. It's a fantastic way to access local food and reduce our reliance on imported protein.

Our favorite spot to fish is located just 328 feet (100 m) or so from our cabin. We primarily fish for Arctic cod, though haddock is also plentiful here. The ultimate fishing prize to catch on Svalbard is the Atlantic wolffish, which happens to be a pretty rare fish to catch, but it's definitely worth the effort, since it's so incredibly tasty! I've only managed to hook three in all my years fishing with Christoffer. Every summer, I make it my mission to land at least one Atlantic wolffish. If the end of the boat season arrives in October and I still haven't accomplished this feat, I simply transfer my goal to the next summer!

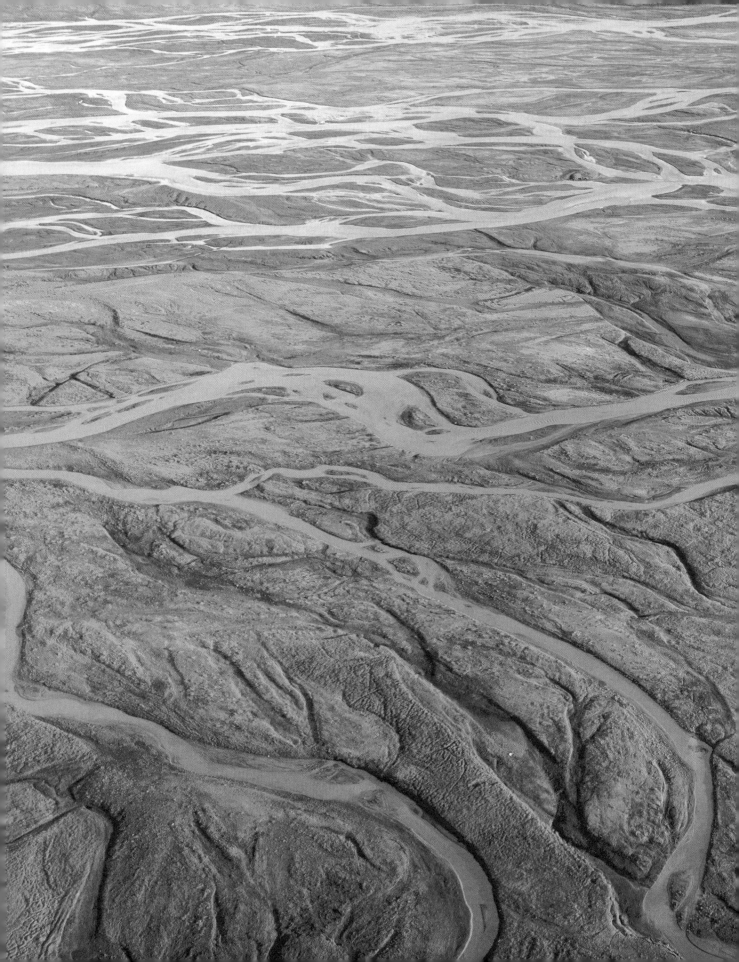

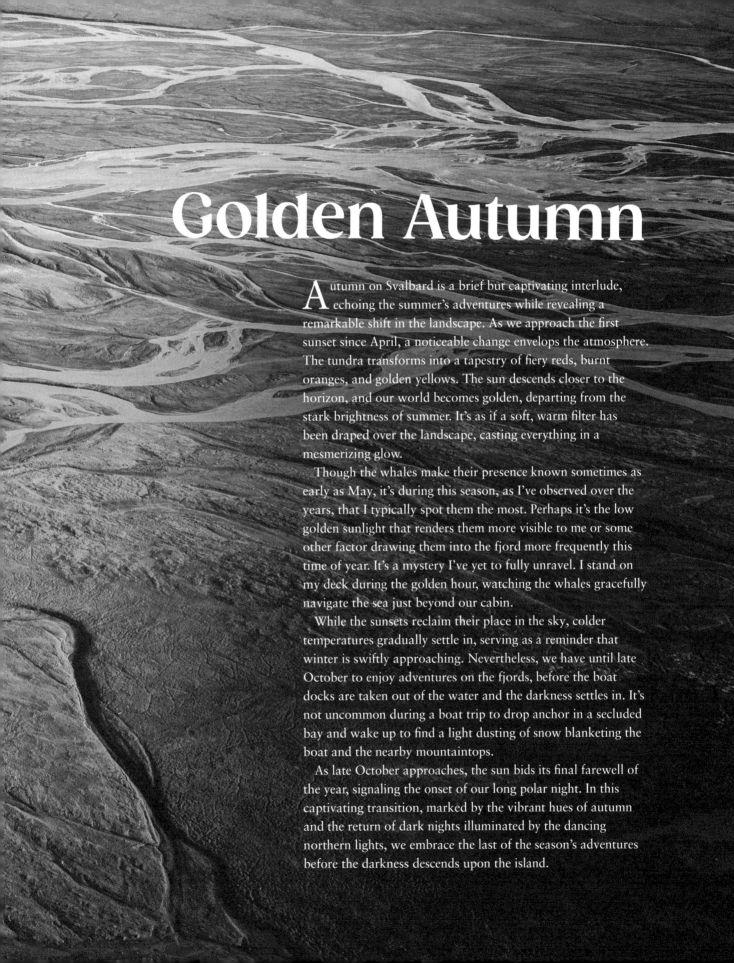

Golden Autumn

Autumn on Svalbard is a brief but captivating interlude, echoing the summer's adventures while revealing a remarkable shift in the landscape. As we approach the first sunset since April, a noticeable change envelops the atmosphere. The tundra transforms into a tapestry of fiery reds, burnt oranges, and golden yellows. The sun descends closer to the horizon, and our world becomes golden, departing from the stark brightness of summer. It's as if a soft, warm filter has been draped over the landscape, casting everything in a mesmerizing glow.

Though the whales make their presence known sometimes as early as May, it's during this season, as I've observed over the years, that I typically spot them the most. Perhaps it's the low golden sunlight that renders them more visible to me or some other factor drawing them into the fjord more frequently this time of year. It's a mystery I've yet to fully unravel. I stand on my deck during the golden hour, watching the whales gracefully navigate the sea just beyond our cabin.

While the sunsets reclaim their place in the sky, colder temperatures gradually settle in, serving as a reminder that winter is swiftly approaching. Nevertheless, we have until late October to enjoy adventures on the fjords, before the boat docks are taken out of the water and the darkness settles in. It's not uncommon during a boat trip to drop anchor in a secluded bay and wake up to find a light dusting of snow blanketing the boat and the nearby mountaintops.

As late October approaches, the sun bids its final farewell of the year, signaling the onset of our long polar night. In this captivating transition, marked by the vibrant hues of autumn and the return of dark nights illuminated by the dancing northern lights, we embrace the last of the season's adventures before the darkness descends upon the island.

Turning Golden

The transition from summer to autumn on Svalbard is unmistakable and swift when it unfolds just a few days after the first sunset in August. Despite the temperature remaining relatively constant, the change is palpable in the air. The wind takes on a chillier edge, the atmosphere becomes more crisp, and the tundra starts to transform, adopting hues of orange. Fresh snow also begins to crown the mountain peaks. All these shifts signal the arrival of what we fondly refer to as "golden autumn," a brief yet captivating season. This is the time of year when migratory birds gear up for their journey south and flora brace themselves for the long winter ahead. Though our autumn may be fleeting, lasting just over a month, its presence is deeply felt. The scenery becomes a canvas painted with the most dazzling array of autumnal colors, as if someone has delicately sprinkled cinnamon across the landscape.

Svalbard's seasons are exceptionally intense and all-encompassing. After basking in 4 months of uninterrupted daylight, we welcome our first sunset on August 25. Since the start of the polar day season on April 19, we've lived through 128 days without a single glimpse of the night sky. While I always rejoice at the return of the sun in February, I also find solace in its departure. The endless daylight, though stunning, can be taxing on both body and soul. In Sweden, we use the word *lagom* to describe something akin to having "just enough." Svalbard however, embodies the antithesis of lagom, as it often can feel like we have too much of one kind of thing. It is a land of extremes. From months of relentless sunshine straight to the unforgiving darkness of polar night, Svalbard knows no moderation.

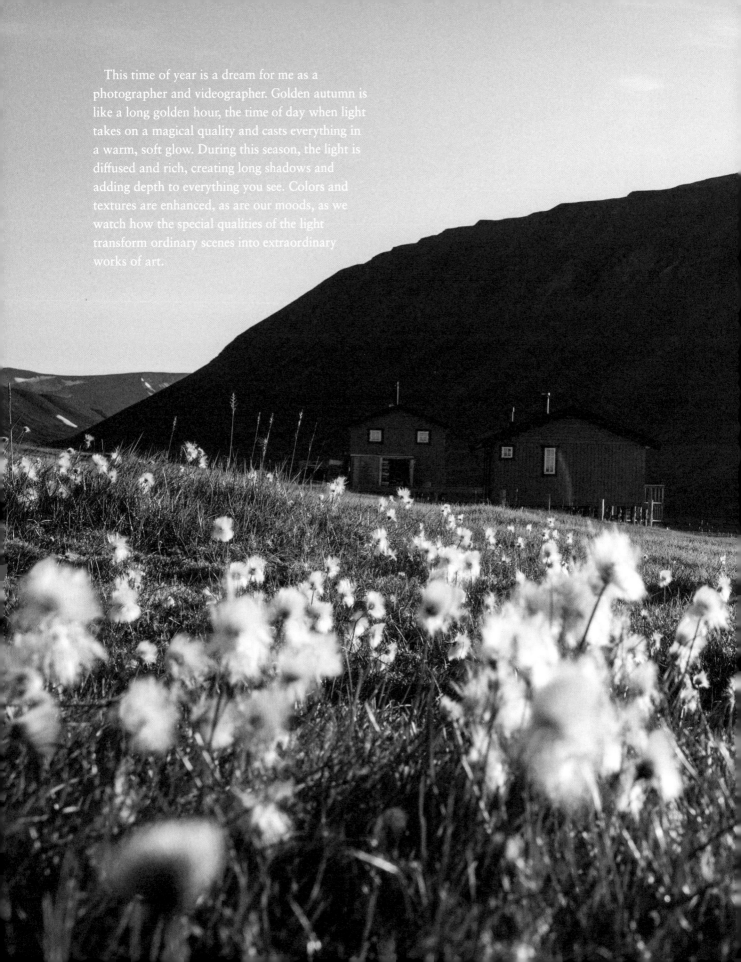

This time of year is a dream for me as a photographer and videographer. Golden autumn is like a long golden hour, the time of day when light takes on a magical quality and casts everything in a warm, soft glow. During this season, the light is diffused and rich, creating long shadows and adding depth to everything you see. Colors and textures are enhanced, as are our moods, as we watch how the special qualities of the light transform ordinary scenes into extraordinary works of art.

Fenris standing among the cotton grass in Bjørndalen near our cabin.

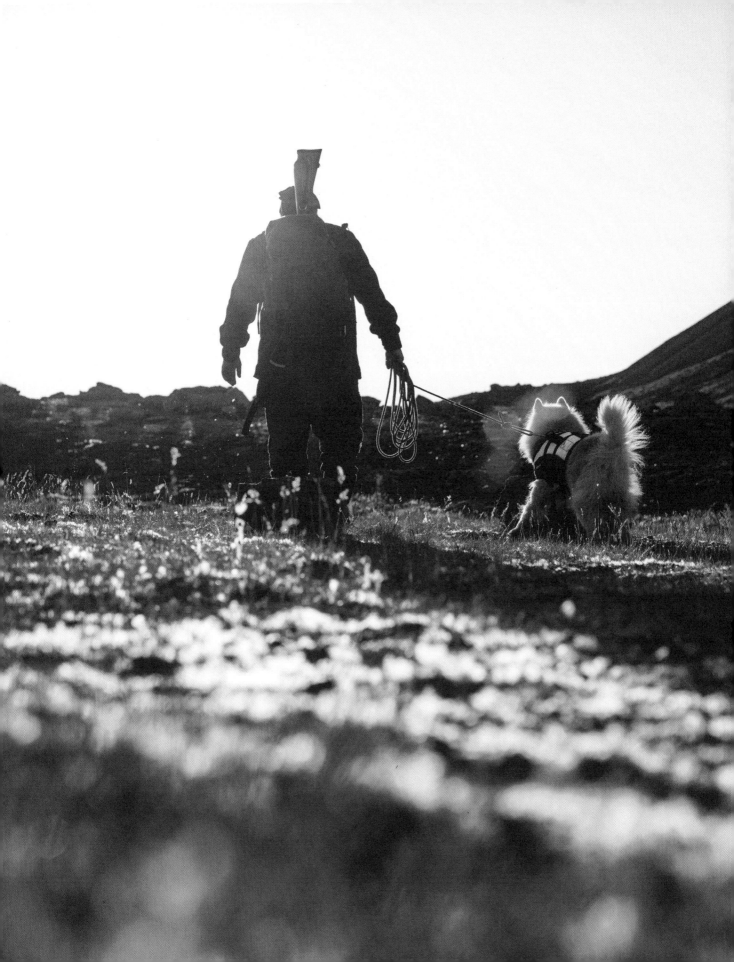

I love the feeling of heading out with Grim for a hiking adventure.

For me, there is no better way to embrace the beauty of golden autumn than by venturing out on a hike. Earlier in the summer when the sun returns, the tundra is damp from all the melting snow, but it steadily dries up over time. By late summer and early autumn, the landscape turns into the ideal terrain for hiking adventures.

I love the feeling of heading out with Grim for a hiking adventure. We typically set our sights on conquering a nearby mountain peak. With each step taken, I uncover new angles and perspectives waiting to be captured by my camera lens, every moment presenting an opportunity to freeze time in a photograph.

From a distance, the landscape may appear desolate since it totally lacks trees and bushes. The absence of trees on Svalbard is due to our position well above the Arctic tree line, which marks the southernmost latitude where trees can grow in the Arctic region. North of this boundary, the challenging environmental conditions, such as Svalbard's permafrost, pose significant difficulties to tree survival and growth. Yet upon closer inspection, you can uncover a multitude of hardy plants that are resilient enough to endure our rugged climate.

On Svalbard, the tundra ecosystem is incredibly fragile due to the limited areas where conditions are less harsh and plants can thrive. Only about 10 percent of our land is suitable for plant growth, and various challenges like a lack of nutrients, temperature changes, and short growing seasons hinder plant development. During the summer, the top layer of the permafrost thaws up to 59 inches (150 cm), allowing plants to grow in this unfrozen top layer of soil. However because of their slow growth rate, damaged plants take a considerable amount of time to regrow, and sometimes they may not recover at all.

To reduce potential harm to these plants, strict regulations have been implemented. Activities on the tundra are limited to walking, and snowmobile travel is only permitted when the ground is fully snow covered. Additionally, picking flowers is completely forbidden. These measures are essential to safeguard our delicate ecosystem, which ensures its long-term viability and allows it to withstand environmental stressors as much as possible.

Each summer and autumn, as I witness vibrant wildflowers resurfacing, I contemplate their resilience. Their ability to grow in this harsh environment against all odds always brings a smile to my face. I love to see the cotton grass blanketing the valleys, its tufts swaying gently in the Arctic breeze, creating a whimsical scene that reminds me of the illustrations in a Dr. Seuss book.

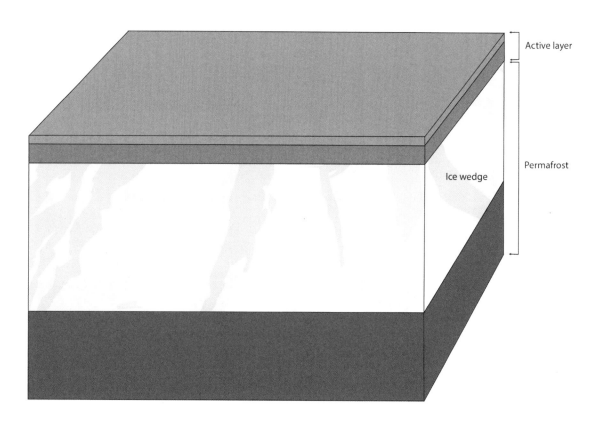

Permafrost refers to any ground, whether soil, sediment, or rock, that has remained continuously frozen for at least 2 years. Permafrost can stretch beneath the earth's surface anywhere from just a few feet to over a mile deep, encompassing vast areas across the Arctic tundra or existing in isolated spots like on mountaintops in alpine zones.

Whale Watching

Standing on the deck outside our cabin, I scan the fjord, trying to pinpoint the source of the sound. On quiet days with little wind, you often hear them before you see them; from miles away, the sound of water spraying into the chilly autumn air reaches my ears. Shielding my eyes from the low evening sunlight reflecting off the water, I look across the fjord. I hear another breath of a whale, then another, until I finally spot them. The fins of five whales break the surface as they leisurely swim through the fjord. These appear to be fin whales, massive creatures that can reach up to 82 feet (25 m) in length and weigh as much as 8 tons.

While whaling activity once thrived in the seventeenth and eighteenth centuries, it has thankfully been forbidden since 1986, when the International Whaling Commission implemented a global ban on commercial whaling due to the near extinction of certain whale species. The whales are now allowed to roam peacefully around the fjords of Svalbard, where they migrate during the summer to capitalize on the abundant fish and plankton resources. We're blessed with a variety of whales, including blue whales, humpbacks, and belugas.

11:00 PM

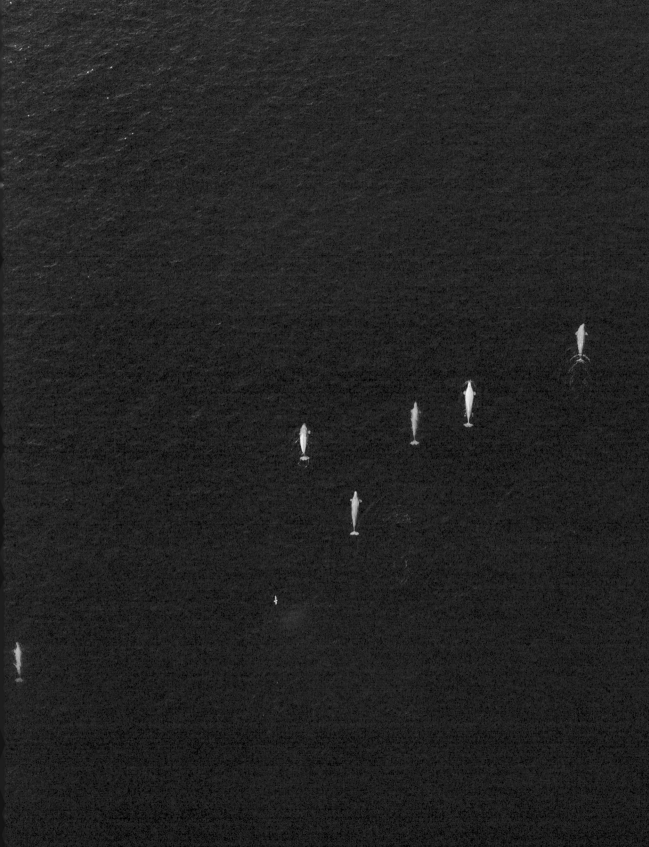

Just outside our cabin in the calm fjord,
a pod of beluga whales swims by gracefully.

From May all the way until September, it seems there's a pod of whales gracing the waters wherever you look. One unforgettable experience witnessing these giant, magical creatures happened the night we spent in a secluded cabin nestled at the base of the massive Nordenskiöld Glacier in Billefjorden. Unlike most of Svalbard's cabins, which are accessible only to locals, this particular cabin welcomes visitors from across the globe. As we awoke to a moody morning, a glance through the cabin window revealed a pod of beluga whales gracefully swimming around in front of the deep-blue glacier. Hurriedly, Christoffer and I took our coffees outside and scrambled up the rocks behind the cabin to enjoy our morning brew while overlooking the fjord. The Nordenskiöld Glacier provided a breathtaking backdrop to the white whales swimming around peacefully in the serene waters. Beluga whales typically travel in pods ranging from 10 to 25 whales and are renowned for their highly social nature.

But you don't always need to travel far for a front-row seat to witness whales on Svalbard. I can recall countless times standing in our kitchen, only to glance out of the window and be greeted by the sight of a large pod of beluga whales swimming just a few feet from the shore. There's an indescribable magic to whales; spotting one in the fjord outside our cabin feels like uncovering a hidden treasure. Although I've seen them many times, I always feel compelled to rush outside and soak in the moment, as if it's something I can't afford to miss. I don't always succeed in persuading Christoffer to join me, but Grim is a sure bet. He joins me on the deck without knowing what we're up to, but he's always eager to be involved. As the sun casts a golden hue over everything, Grim and I stand amid the golden hour, savoring the moment shared with our giant neighbors. It's an experience I never imagined for my future: to have the privilege of watching whales thriving in their natural habitat from the deck of my own home.

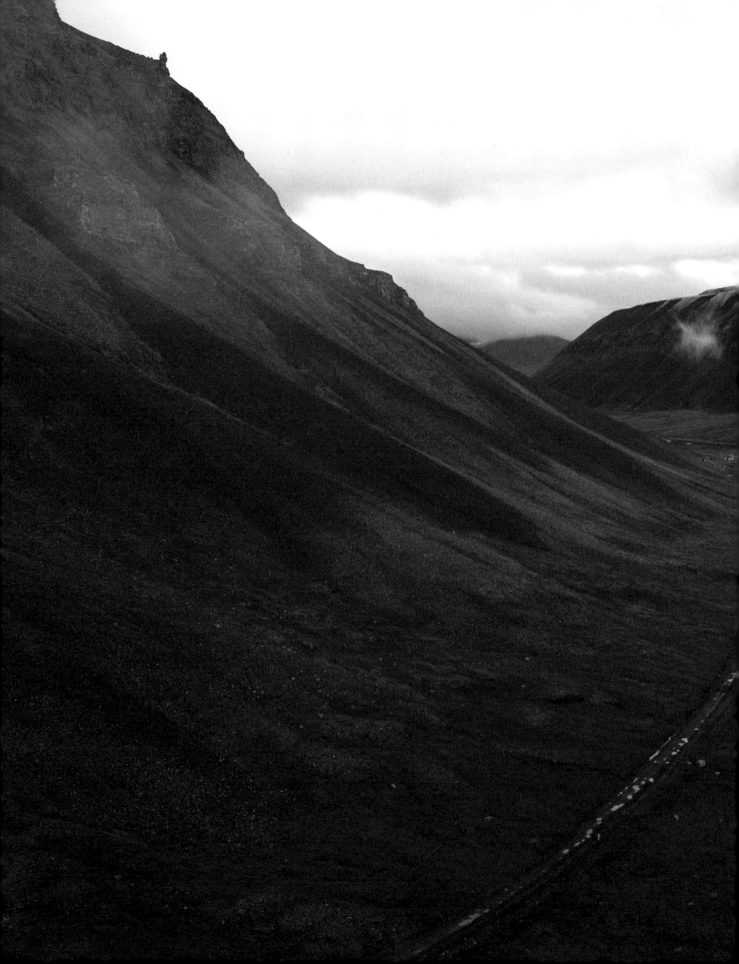

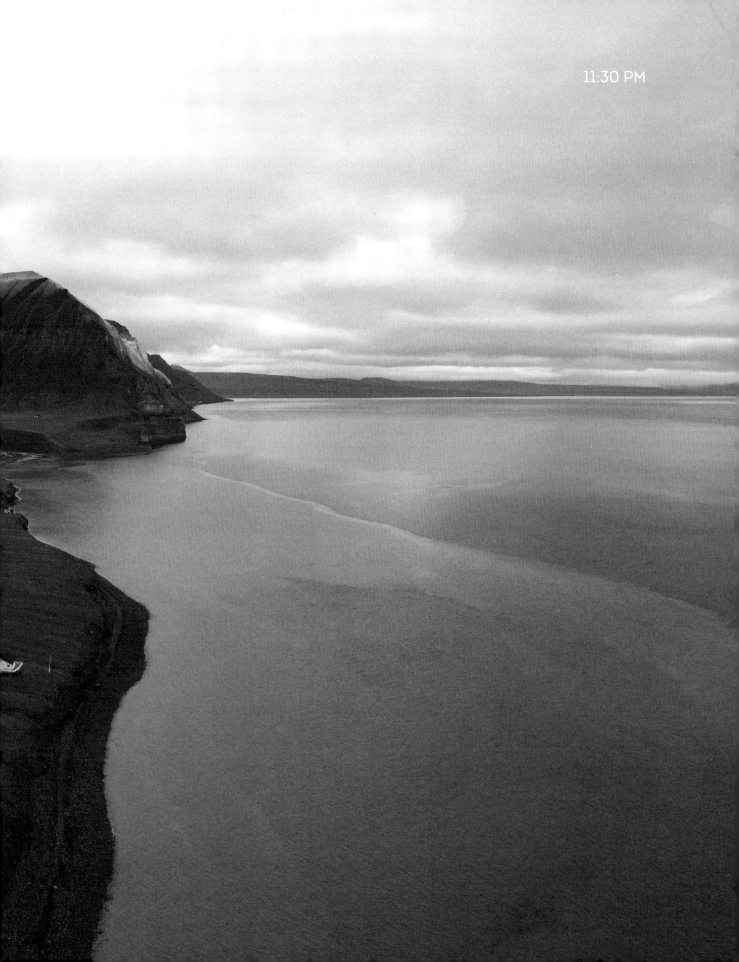

11:30 PM

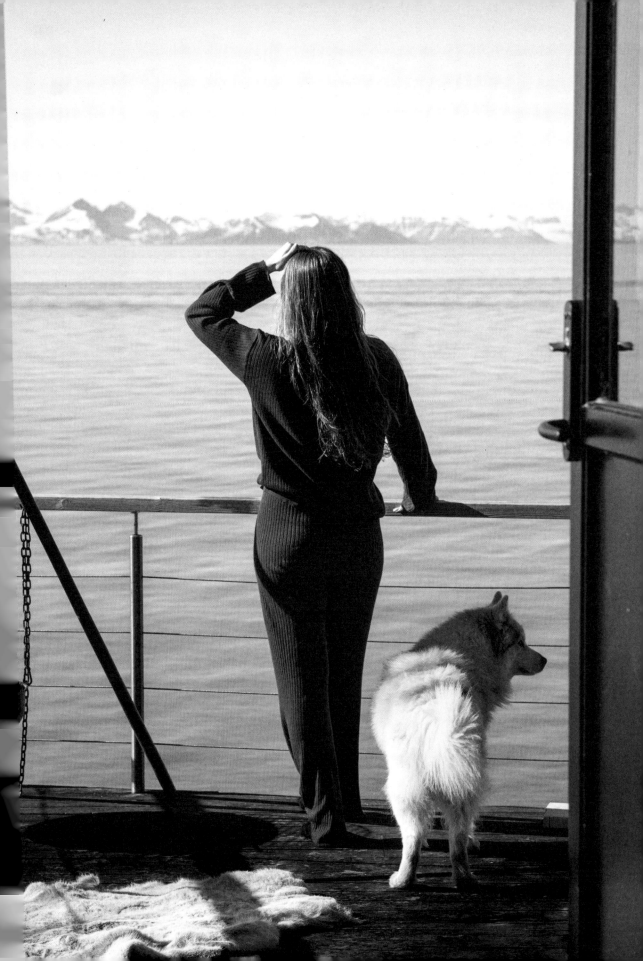

DIARY ENTRY
SEPTEMBER 10

Life in the Arctic

This morning was like a scene straight out of an episode from an Animal Planet show. Reindeer casually wandering around, a walrus chilling in the shallows, Arctic foxes making a ruckus up in the mountains, and to top it off, a polar bear passing by, all at the same time. It's moments like these that make living here so exhilarating, with nature putting on a show right past our doorstep. People often wonder how Grim handles run-ins with polar bears, but he hasn't had any close encounters before now. When the bear strolled by today, he surprisingly played it cool, trotting up to the door to give us a classic "let me in" whine with a hint of urgency, but not a single bark. It seemed like he'd gotten a good grasp of the memo to not mess with the polar bears.

Shortly after the polar bear passed by our cabin, it decided to take a swim across the fjord. At that moment, the government helicopter arrived, alerted by our neighbor of the bear's presence. The helicopter then tracked the bear's swim, ensuring it didn't head toward town. It's worth noting that polar bears are excellent swimmers, which is impressive for such big, fluffy creatures.

After the helicopter wrapped up its polar bear patrol, our morning settled back into its usual calm. I grabbed my coffee and stepped outside to the serene sounds of the ocean and the distant calls of birds. The mountain behind our cabin grows quieter with each passing day, a clear indication that the colder season is approaching. Soon, the birds will leave us for warmer climates. I drank my coffee quickly, knowing it wouldn't stay warm for long in the 39°F (4°C) weather. (I could have used a Thermos cup, but I like the feel of a regular cup better.) You might find my love for coffee a bit excessive, but it's not the caffeine I'm after—it's the vibes. I'm all about that cozy feeling you get from the smell, taste, and sensation of sipping on a nicely made latte, especially as the days get chillier.

I've always been a winter enthusiast—or a "winter girl," as I like to call myself—and this feeling becomes especially strong this time of year. As the days grow darker and the air colder, I feel a sense of awakening within me. While many view the arrival of autumn as the bittersweet end of summer, I welcome it with celebration. There's nothing I love more than the sound of frost crunching beneath my boots or the scent of snow in the air.

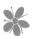

The return of our sunsets and darker nights have been so eagerly welcomed that when they arrive, it almost feels surreal. The other evening, I swung open our cabin door to reveal a deep-blue evening sky. As I spotted a faint cluster of stars twinkling above, I couldn't help but let out a shriek of joy. Oh, how I'd missed them! You'd think the long period of daylight would help me in my quest to become a morning person, but surprisingly, it's quite the opposite. For 4 months straight, day and night alike, I had been greeted by the relentless brightness of the sun, telling my body that it was time to be awake. I must admit, the polar day tends to throw my internal clock for a loop, more so than polar night. In our bedroom, we've got three layers of blackout curtains, and I resort to wearing a sleeping mask to try to convince my body that it's nighttime. It works reasonably well at first, but by the time August comes around, I start feeling like a walking zombie from the disrupted sleep routine. Now that the nights are growing darker, sleeping has finally become a bit easier.

While enjoying my morning coffee on our deck is a daily ritual, having a polar bear casually stroll by our cabin is certainly not—but hey, that's life in the Arctic for you! Living in this remote corner of the world means you never quite know what to expect. It was definitely not the kind of morning I ever imagined having 8 years ago while I was sipping coffee at my hotel desk job in Gothenburg, but these are the stories I'll be sharing for years to come!

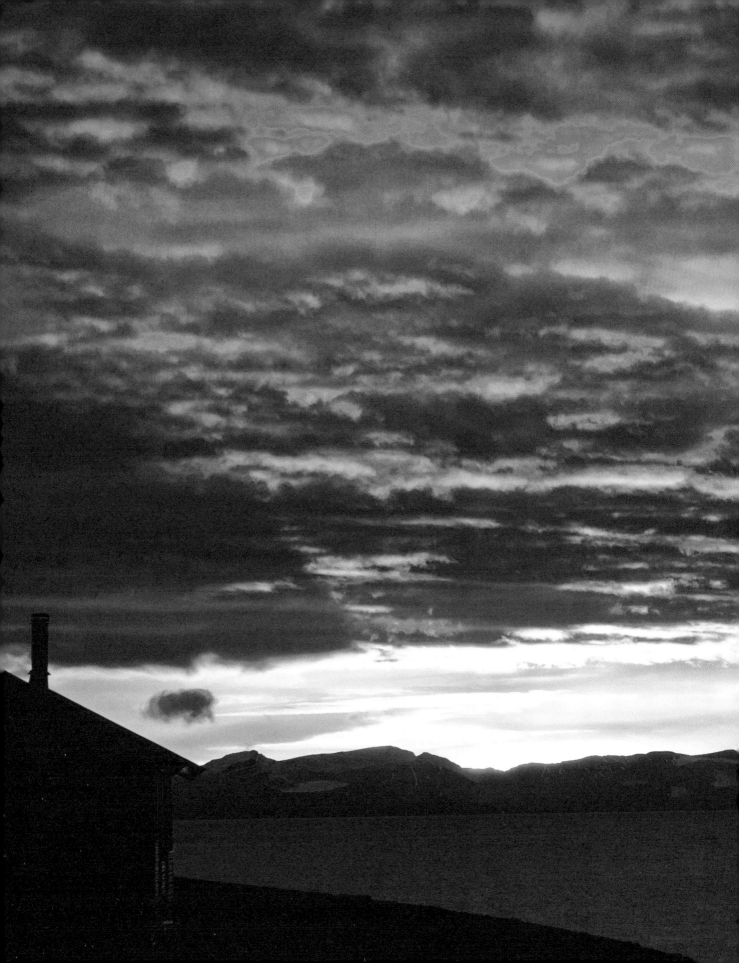

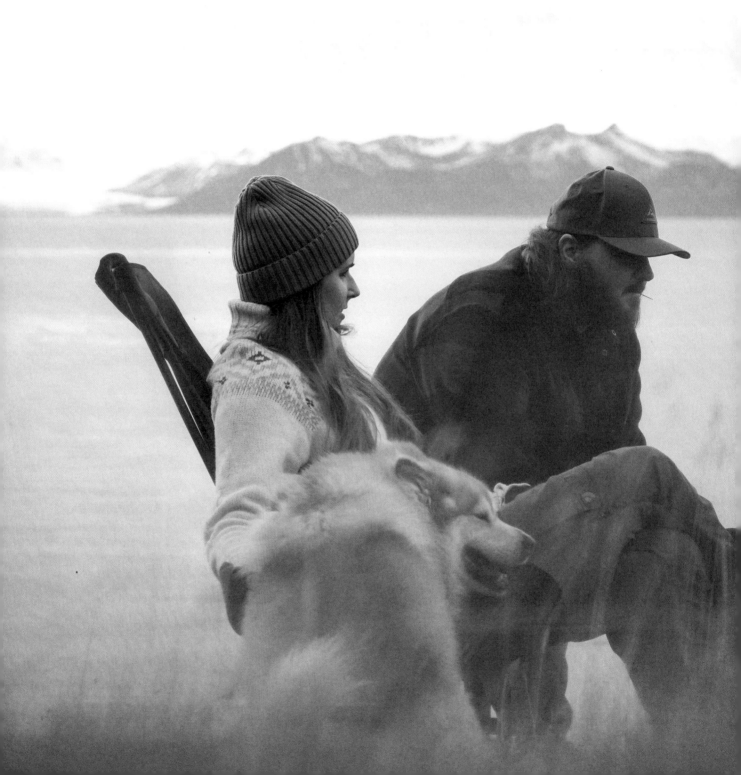

80 Degrees North

It was a gray Thursday afternoon when we departed from Longyearbyen, embarking on a journey that would take us around the rugged west coast of the island. Our route would lead us from the familiar 78 degrees north of Longyearbyen all the way up to the remote 80 degrees north of the pinnacle of Spitsbergen. This expedition would take me to latitudes on Svalbard I had yet to explore.

This time of year is best spent on the fjords, but our boat's range is limited due to the absence of fuel beyond Longyearbyen's port. Nonetheless, within Isfjorden alone—the fjord just outside our cabin that serves as a gateway to nearby adventures—there is an abundance of other connected fjords to explore. In our pursuit of reaching latitudes even farther north, we decided to join one of the expedition ships that frequently ventures into the remote corners of Svalbard.

Svalbard boasts a diverse and storied history, and one of the things it is known for is serving as the starting point for the legendary race among explorers to reach the North Pole. The renowned Norwegian explorer Roald Amundsen selected Ny-Ålesund, then a coal-mining settlement nestled in the northwestern reaches of Spitsbergen, as the base for his historic 1926 voyage to the North Pole aboard the airship *Norge* (Norway).

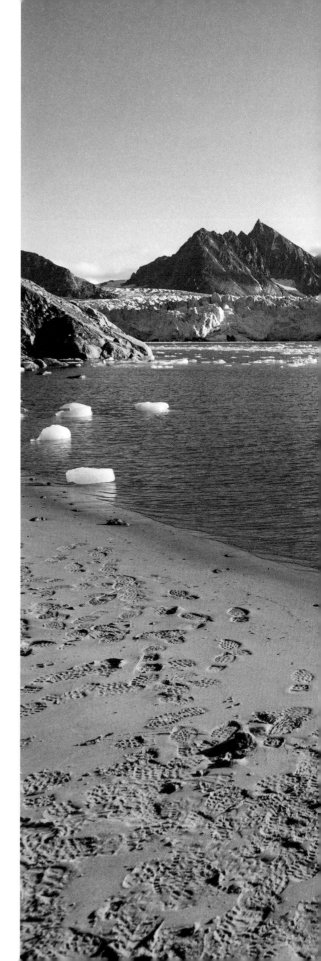

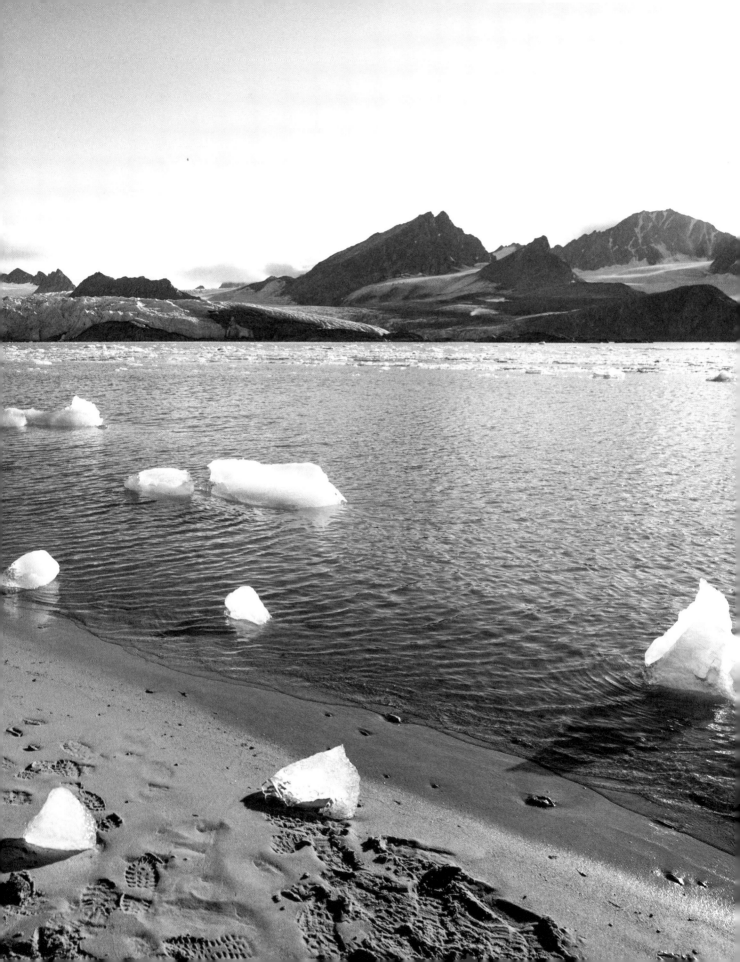

The ship's charming original features and intricate brass details made capturing it a photographer's delight.

Christoffer and I were eager to venture farther than our usual routes, so we opted for a 4-day trip aboard a midsize expedition ship to explore new fjords, encounter wildlife, and simply unwind. Given the ship's age, dating back to 1956, it displayed multiple signs of its advanced years. The ship's charming original features and intricate brass details made capturing it a photographer's delight, offering picturesque scenes at every turn. However, when it came to sleeping arrangements, the vessel revealed its shortcomings. Since there was an extensive distance to cover to get to 80 degrees north, there was no pause to drop anchor for the night, resulting in the boat remaining in transit even during sleeping hours, presenting an unexpected challenge. One might liken it to sleeping inside a spinning laundry dryer. However, what were a couple of nights of disrupted sleep compared to the awe-inspiring views that awaited us in the remote corners of Svalbard?

Fortunately, stepping onto the aft deck in the morning sunlight with a stunning glacier stretching before us provided the ideal cure for any lingering restlessness from the night before. Weather permitting, we enjoyed two landings each day, one in the morning and one in the afternoon. These landings provided a rare opportunity to explore locations typically inaccessible, such as historical remnants of trappers' cabins and mining sites. Additionally, participants could opt for extended walks to immerse themselves in Svalbard's diverse flora and fauna.

The journey to and from 80 degrees north spanned a vast distance, providing a wonderful opportunity to explore the remarkable nature and wildlife across our region along the way. While my primary aim was to reach 80 degrees north, I was also excited to revisit the charming research settlement of Ny-Ålesund. The last time I visited was years earlier when I was employed by a travel agency and tasked with scouting locations for an upcoming TV production. Unfortunately, I didn't have much time to explore during that visit, so I was thrilled to be returning.

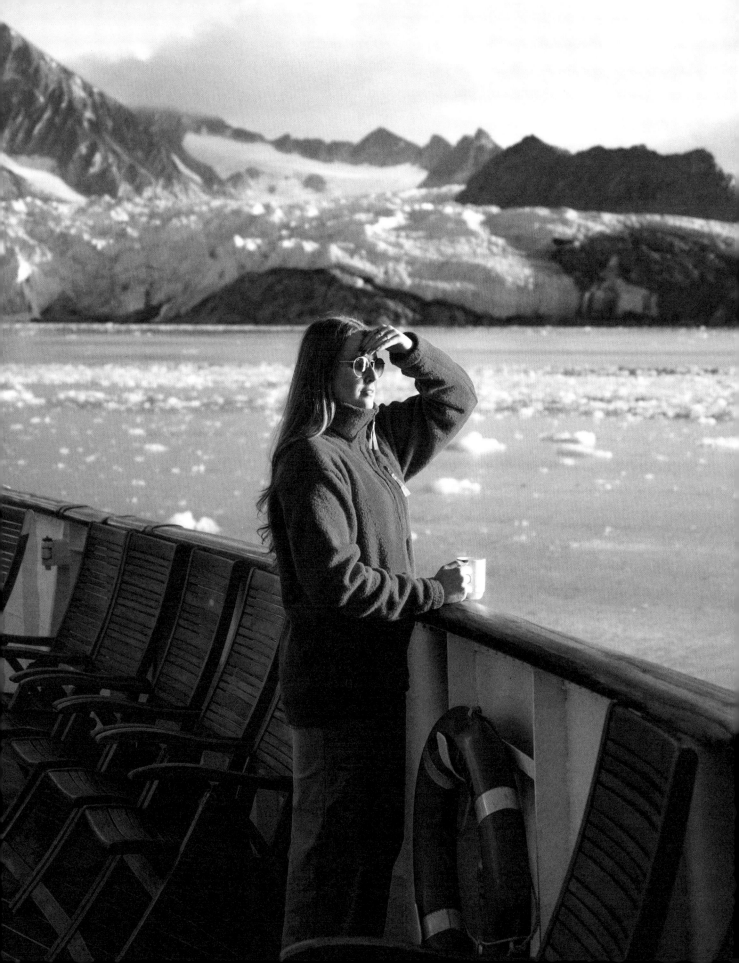

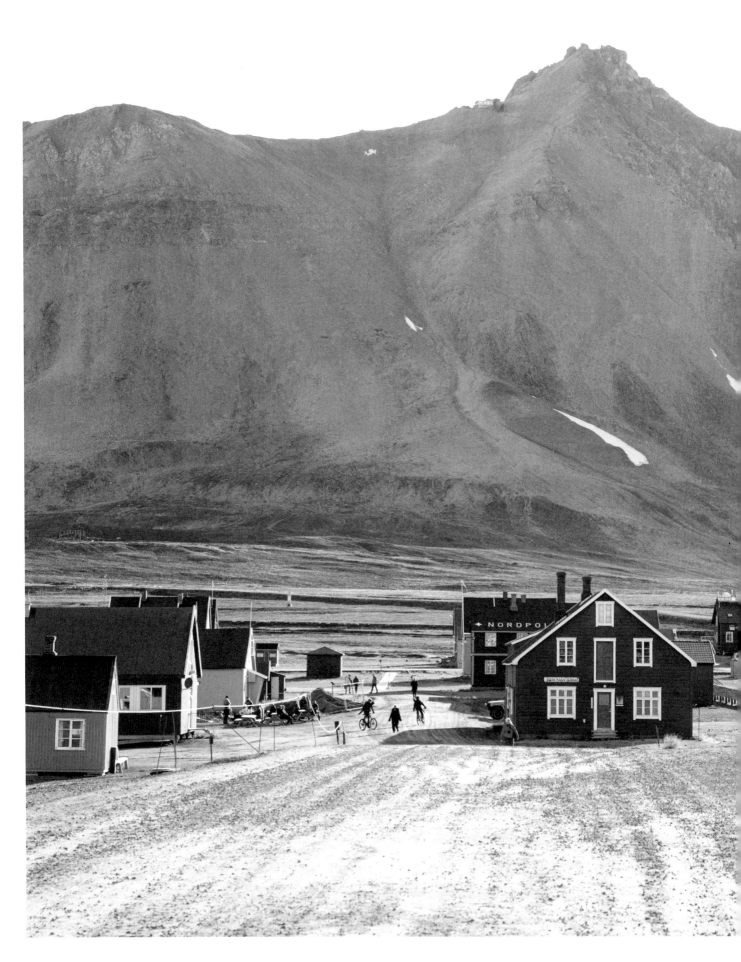

Ny-Ålesund holds the title of being the world's northernmost research station that operates year-round. Throughout the year, Ny-Ålesund's population fluctuates between 40 and 150, depending on the season.

Situated at 79 degrees north, Ny-Ålesund lies in the northwest region of Spitsbergen. Before Norway's sovereignty over our archipelago took effect in 1925, Svalbard was known as Spitsbergen, a term coined by the Dutch navigator William Barentsz in 1956. The name means "pointed mountains" in Dutch, which accurately describes the landscape, since it is characterized by sharp peaks. Following Norway's governance, the name "Svalbard" was formally adopted for the entire archipelago, while Spitsbergen remained associated solely with the main island where we reside.

Ny-Ålesund is one of Svalbard's four permanent research stations and plays a pivotal role as a hub for scientific exploration and discovery. Established in 1916 as a mining community by Kings Bay AS, Ny-Ålesund had 300 residents by 1918. Ny-Ålesund was known as the premier spot for polar expeditions not only for Roald Amundsen's historic expeditions in 1926, but also for the dramatic North Pole venture led by the Italian explorer Umberto Nobile in 1928. Unfortunately, tragedy struck on this journey when their airship crashed, resulting in the loss of half the crew. Remarkably, Nobile survived the crash and was eventually rescued.

Strolling through this very quiet, quaint village, one wouldn't suspect it to have such a dynamic and vibrant past. While the other passengers from the boat enjoyed a guided tour of Ny-Ålesund, Christoffer and I headed to the gift shop to grab a souvenir, since we'd visited before. In Ny-Ålesund, residency is exclusive to those employed here. Accommodations for tourists are not available within the settlement, and access to the guest house is reserved for those invited by the residents who work in Ny-Ålesund.

Presently, Ny-Ålesund operates as a research station with approximately 40 residents year-round. However, during the summer months, the population can occasionally rise to around 150 individuals. Over the years, 11 institutions representing 10 countries have established permanent research stations, conducting studies across various fields, including atmospheric physics, biology, geology, glaciology, and oceanography.

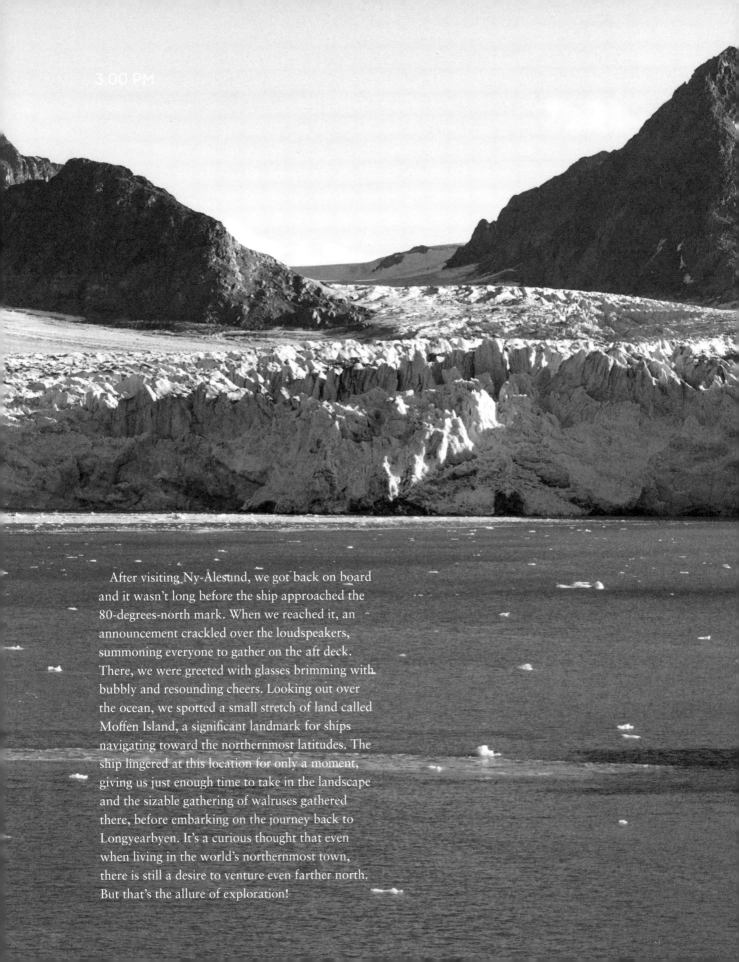

3:00 PM

After visiting Ny-Ålesund, we got back on board and it wasn't long before the ship approached the 80-degrees-north mark. When we reached it, an announcement crackled over the loudspeakers, summoning everyone to gather on the aft deck. There, we were greeted with glasses brimming with bubbly and resounding cheers. Looking out over the ocean, we spotted a small stretch of land called Moffen Island, a significant landmark for ships navigating toward the northernmost latitudes. The ship lingered at this location for only a moment, giving us just enough time to take in the landscape and the sizable gathering of walruses gathered there, before embarking on the journey back to Longyearbyen. It's a curious thought that even when living in the world's northernmost town, there is still a desire to venture even farther north. But that's the allure of exploration!

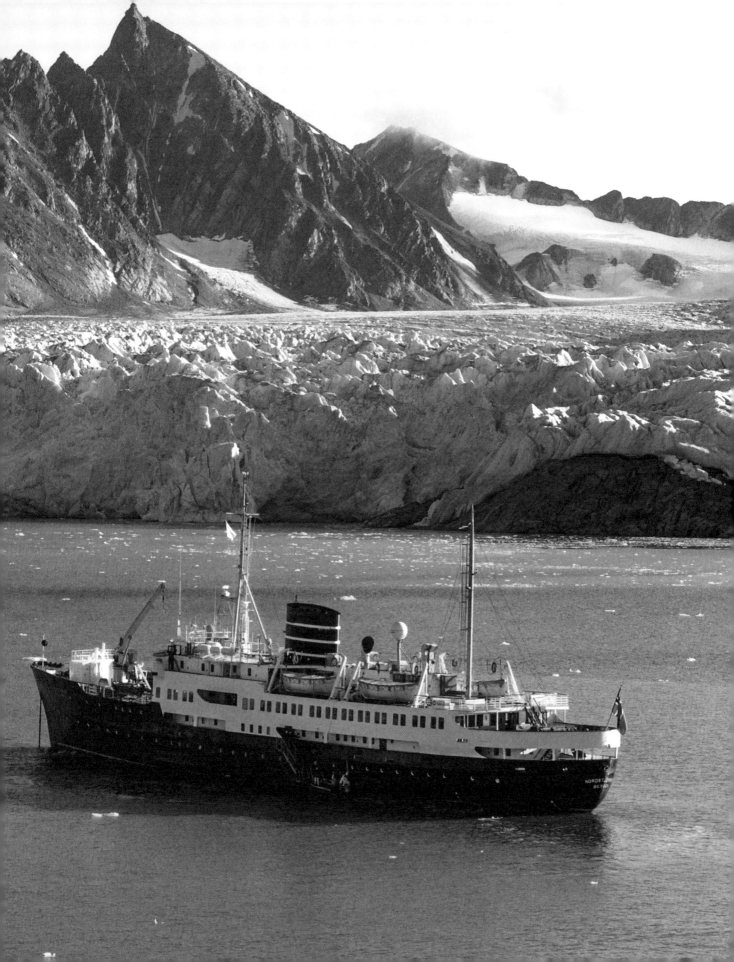

Grim

Did you really think we could go through this entire book without a chapter dedicated to Grim, the light of my life? It would be a crime. So, allow me to present Grim and the story of how we became best friends!

He's a 9-year-old, brave and fearless Finnish Lapphund, as the song about him by Puppy Songs proudly sings. As it turns out though, he is actually not very brave or fearless at all. He's afraid of floors and jumps in surprise at his own farts. However, since the song about him went viral online, he's been bestowed with this title, so we'll just pretend these things are true and go with the flow. While many people follow my social media platforms to discover life on Svalbard, a significant portion of my audience also tunes in to catch up with Grim. He is frequently featured in my content, and his endearing energy and charm seem to resonate deeply with people. I collaborated with the talented Matt, who runs the @PuppySongs account, which is dedicated to creating humorous tunes about dogs. This led to the creation of Grim's very catchy theme song.

I never imagined having my own dog, since I have been a dedicated cat person all my life. Then I met Grim. The story of how I got Grim is just as unusual as he is. It was a regular day working at Huset in 2016, and I was sitting at my desk, taking reservations for the restaurant, when the door burst open and two very fluffy creatures stormed in. Rushing behind the creatures and repeating the words "nej nej nej" and "Grim! Fenris!" came Olivia, my new colleague and soon to be one of my best friends. The word *nej* means "no" in both Swedish and Norwegian, and it is a word that Grim heard a lot during his early years. Let's just say he has always marched to the beat of his own drum. During the weeks we worked together, Olivia's dogs were regular fixtures in the office, allowing Grim and I to become fast friends. Of course, Olivia was fantastic too. But there was an immediate connection between Grim and me. His goofy and cheerful energy resonated with me, and he adored the attention I gave him.

Whenever Olivia and her husband, Einar, left town or needed a dog sitter, I eagerly volunteered to help out. It was a chance for me to spend quality time with my newfound best friend, Grim. Fenris, the older of their two dogs, would stay with someone else, leaving Grim in my care. Arranging separate sitters for the dogs was often easier due to Fenris's calm and undemanding demeanor. In contrast, Grim's nervous disposition called for extra care. While Fenris enjoys the company of other people and is a beautiful dog in his own right, his bond with his human dad, Einar, is truly unmatched.

Whenever our eyes met, it felt as though we had an unspoken bond, a mutual understanding that we belonged together.

Grim became my constant companion, often joining me at work, where he would lie beside my desk and find safety and contentment in my presence. Our afternoons together started to fill with leisurely walks around the village or adventurous hikes up the nearby mountains. We were often accompanied by my friend and adventure buddy at the time, Mattias Hemhagen. This was all taking place during my first year on Svalbard, when I didn't own my own firearm or even a snowmobile. So, having a good friend like Mattias to go on adventures with, who knew his way around the terrain, was invaluable. Grim would greet everyone he met on the mountain as if they were long-lost best friends. His gentle nature and unwavering loyalty epitomizes pure goodness.

Since that first day in the office, a deep connection formed between Grim and me. Whenever our eyes met, it felt as though we had an unspoken bond, a mutual understanding that we belonged together. It may sound silly, but it's truly the best way to describe it. I believe we offered exactly what the other needed. With patience and understanding, I helped Grim in overcoming his nervousness and fears, guiding him toward confidence. In return, I found a loyal companion, not only for adventures but for every aspect of life, brimming with endless happiness.

So how did I end up with Grim? Did I dog-nap him? After spending over a year on Svalbard, I moved in with Olivia and Einar and their two fluffy Lappunds into an apartment we aptly named "Casa el Dumpo." This apartment fell short in terms of coziness. It had bright, fluorescent ceiling lights akin to those in hospital exam rooms, a corduroy sofa with burn marks salvaged from a neighbor's moving-out sale, and an overall vibe of being constructed from odds and ends. Nevertheless, with the limited housing options available to us at the time, we were grateful to have this space, even if we couldn't help but laugh at some of its less-than-desirable features.

Despite its shortcomings, I spent nearly 2 happy years here, enjoying the company of Grim and communal living with friends. Fast forward a year or two to when Christoffer and I found ourselves purchasing our cabin to make it our permanent residence. With amazing nature right outside our new doorstep, it seemed like the ideal setting for Grim. He had always been an anxious and uncertain pup, so we thought the serenity of cabin life would help him find peace. As we made the move out to our cabin, the decision was made that Grim would come to live with us permanently. Olivia and Einar had also bought a cabin in the same area as ours a year earlier. This familiarity was reassuring for Grim, and it meant he would see them at least every weekend when they spent time at their cabin.

Separating two dogs who have spent their entire lives together might be uncommon, but we observed a significant improvement in Grim's confidence when he was on his own. Both Fenris and Grim became more relaxed and content once they started living separately, and neither of them felt the need to be constantly seeking attention as they used to.

On Grim's fourth birthday, after Grim had been living with us permanently for a year, Olivia gifted me with adoption papers. It might seem strange for someone to give up their dog, but Olivia had been in a similar situation herself once, falling in love with her neighbor's dog and eventually adopting it. Also, I had been part of Grim's life since meeting him when he was just a year old, and Olivia had observed our bond grow stronger over the years. I'd been hinting at the possibility of taking full responsibility for Grim as I couldn't imagine my life without him. So on Grim's fourth birthday, surrounded by our friends, whom I had invited over to celebrate, he officially became mine! It was an incredibly selfless act by Olivia and Einar, allowing Grim to choose his people.

I feel so lucky to have been chosen by Grim!

Polar Night Returns

As September unfolds, it brings with it a subtle shift in the atmosphere, enveloping us in moody days and darker evenings. The weather shifts between rain, mist, and sunshine as we wait with anticipation for the first snow to fall. We often don't have to wait long; we can witness the nearby mountains gradually trading in their golden coats for a light dusting of snow. It serves as a subtle reminder of winter's approach, even if the snow melts swiftly at first.

The tundra is a prominent indicator of the shifting seasons and so too is the sky. Once more, we are treated to breathtaking sunsets, as if nature is compensating for the sunsets we've missed. With the night sky reclaiming its deep-blue color and the stars twinkling above, the northern lights are summoned back to the archipelago, returning from wherever it is they've been hiding during the sunlit months.

As the evenings grow darker, my favorite time of day returns: cozy afternoons. The slightly chillier temperatures create the perfect excuse to light a fire, adding an extra layer of warmth and coziness to our cabin. There's nothing quite like sitting with a cup of coffee in hand, gazing out over the fjord and witnessing the faint glimmer of stars reemerging in the twilight.

As early as the first week of October, autumn typically surrenders to winter, the golden hues giving way to shades of whites, pinks, and blues. The mountains boast a more-enduring snow cover, and temperatures linger a few degrees below freezing. Mornings welcome us with a delicate frost, while rivers and streams flow beneath a thin veil of ice. It's as if you can watch the landscape freeze before your very eyes.

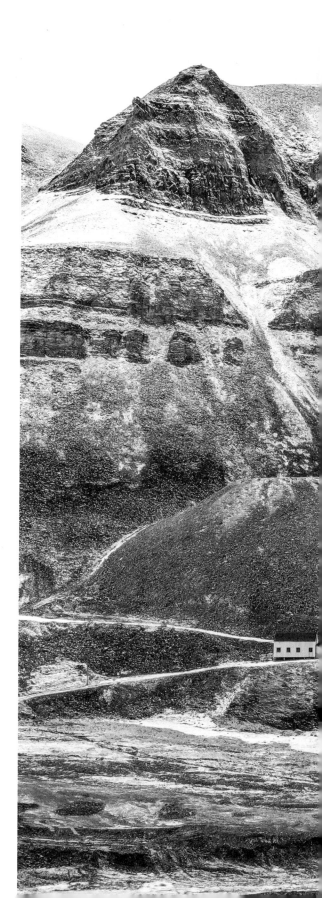

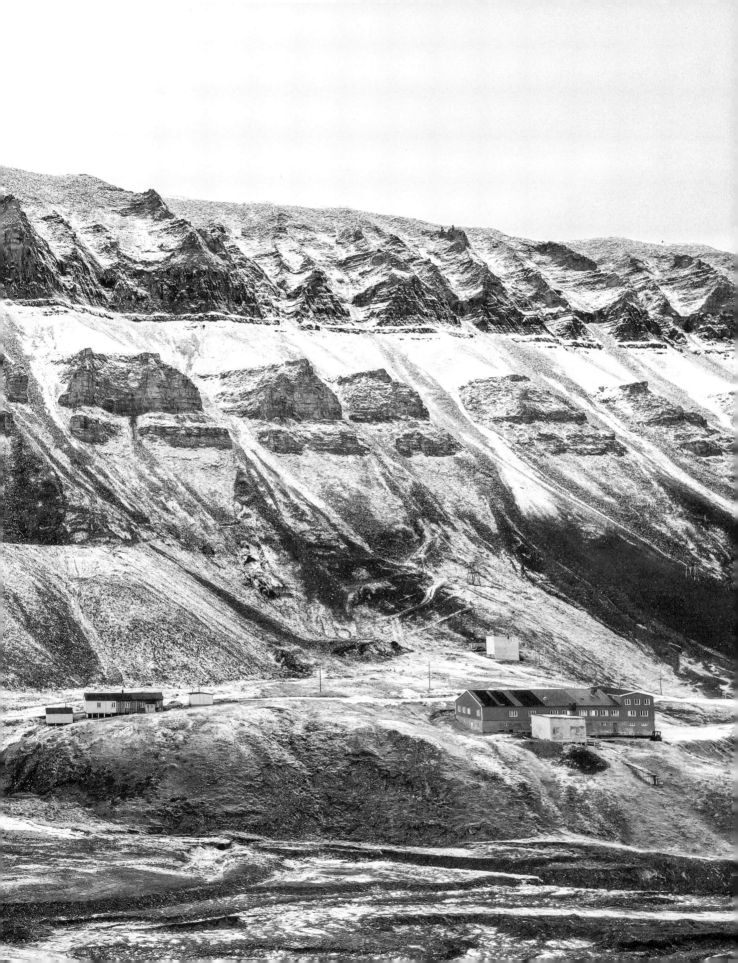

The impending darkness can pose challenges, even for someone who loves it as much as I do.

Now that you've made your way through this book, you may have noticed my frequent attention to the changing seasons. Here on Svalbard, where our lives are intimately intertwined with nature, the seasons hold immense importance to our daily lives, guiding our activities and necessitating various preparations throughout the year. As October arrives, I find myself actively preparing for what lies ahead. It's not just about the practicalities of winterizing the cabin—stocking up on wood and bringing out the winter duvets—but also about fortifying myself mentally. The impending darkness can pose challenges, even for someone who loves it as much as I do.

By mid-October, the days grant us only 6 hours of light, as the sun sets as early as 4 p.m., signaling the approach of polar night. The afternoons stretch into extended hours of twilight, taking on hues of pink and blue, reminiscent of the pastel winter palette earlier in the year when we were eagerly anticipating the sun's return. This time though, these colors serve as a reminder of the sun's imminent departure. With each passing day, daylight dwindles by around 20 minutes, culminating in the final sunset of the year on October 25, which marks the start of polar night.

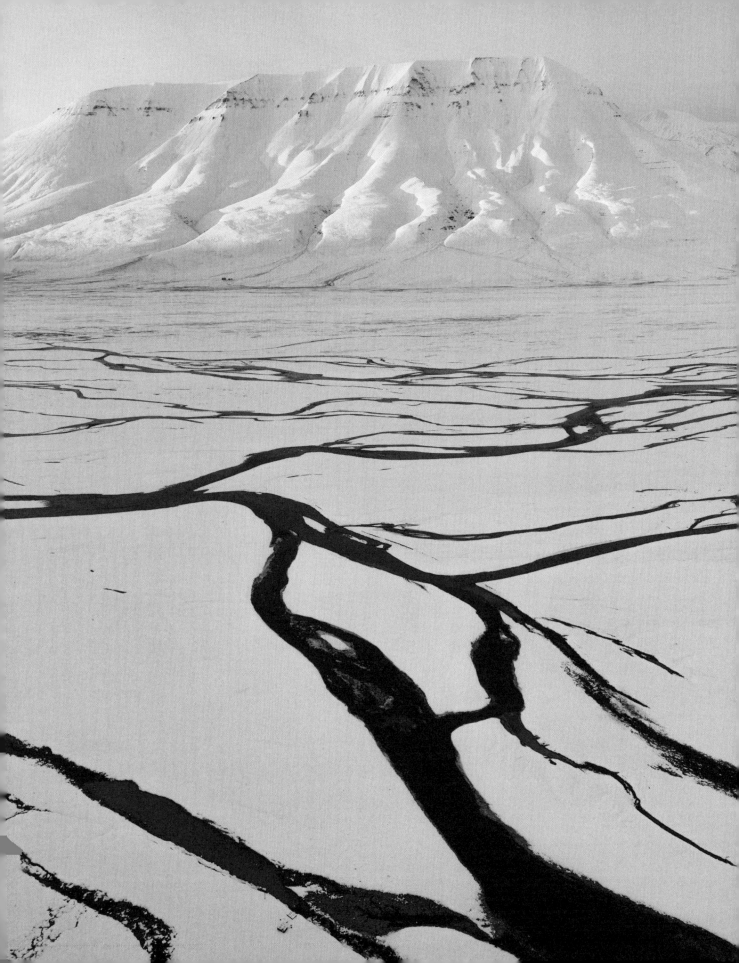

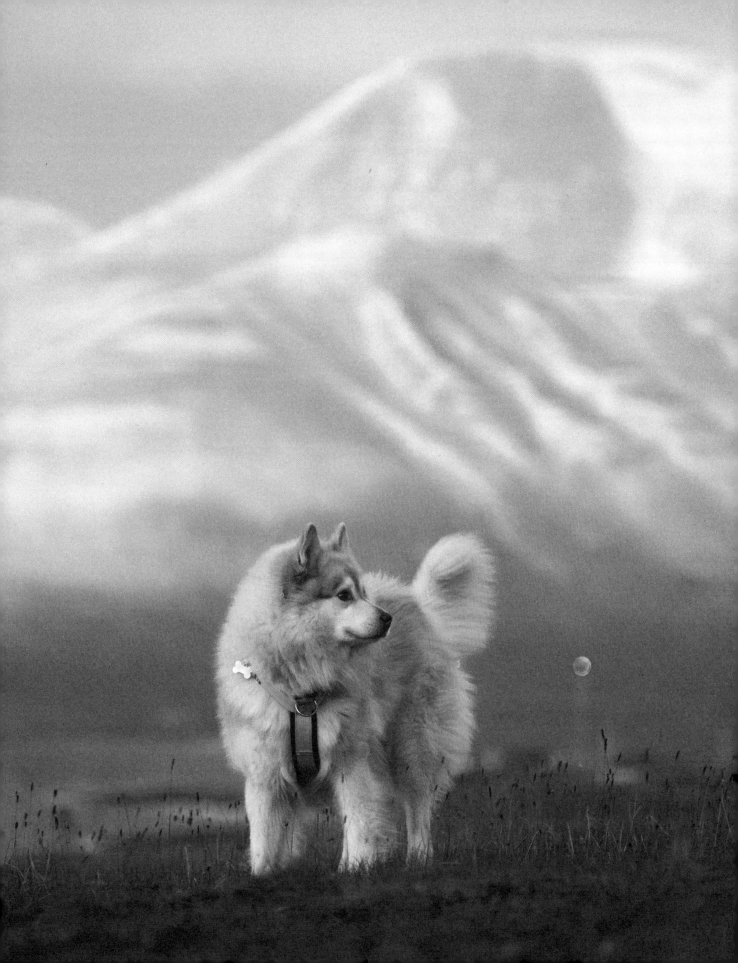

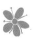

I actually feel a sense of excitement as the sun dips below the horizon for the last time for quite a while. It signals the arrival of dark, starry skies, cozy days, and the embrace of winter's darkness. Don't get me wrong, I appreciate the charms and beauty of summer when we can enjoy countless hours exploring the ocean, visiting glaciers, hiking mountains, and swimming in icy waters. However, there's an undeniable magic to the polar night that captivates me, year after year.

Following the final sunset, we're treated to days of cobalt-blue twilight skies before the deep darkness of polar night settles in around mid-November, shrouding our island in darkness until February. I always eagerly await this time—it's truly magical and one of my favorite parts of the year. After months of longing for the dark sky, millions of stars twinkle down at us once more from light-years away up in space. The aurora borealis graces us again, painting the night sky with vibrant dances of green, pink, and purple. It's a time of year when the village transforms into a scene straight out of a fairy tale, where the enchantment of our Christmas traditions unleashes my inner child and the embracing darkness gently nudges us toward a slower, more contemplative pace of life.

Since the last sunset, each day has brought increasingly shorter daylight hours, with our early afternoons now resembling evenings. Even our mornings have begun to dim, as we enjoy our morning coffee under the company of the moon and stars.

We're treated to days of cobalt-blue twilight skies before the deep darkness of polar night settles in.

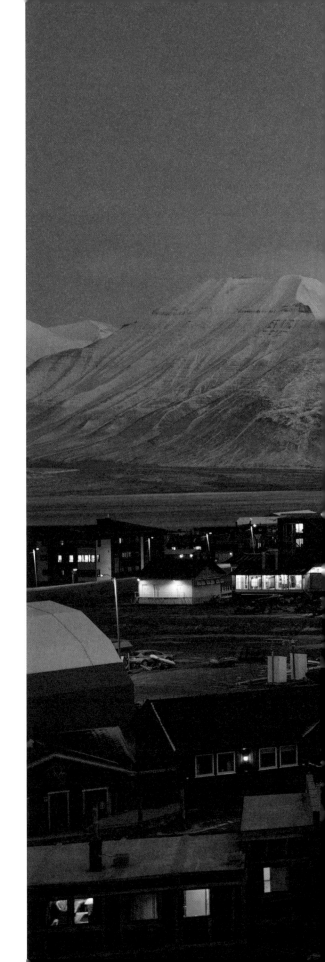

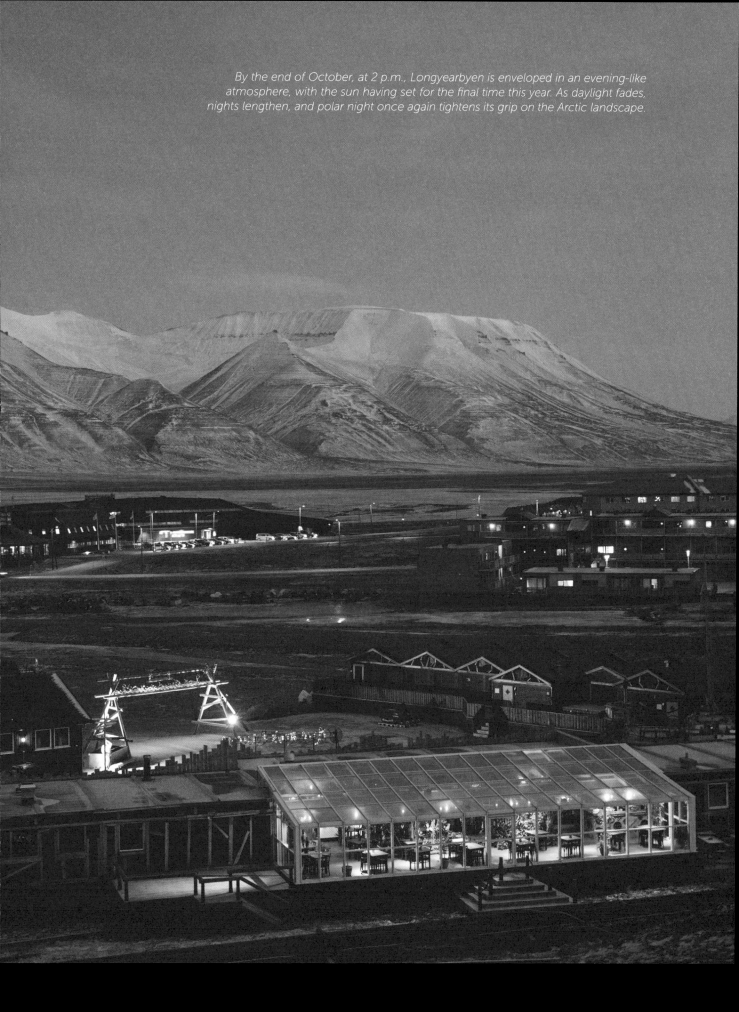

By the end of October, at 2 p.m., Longyearbyen is enveloped in an evening-like atmosphere, with the sun having set for the final time this year. As daylight fades, nights lengthen, and polar night once again tightens its grip on the Arctic landscape.

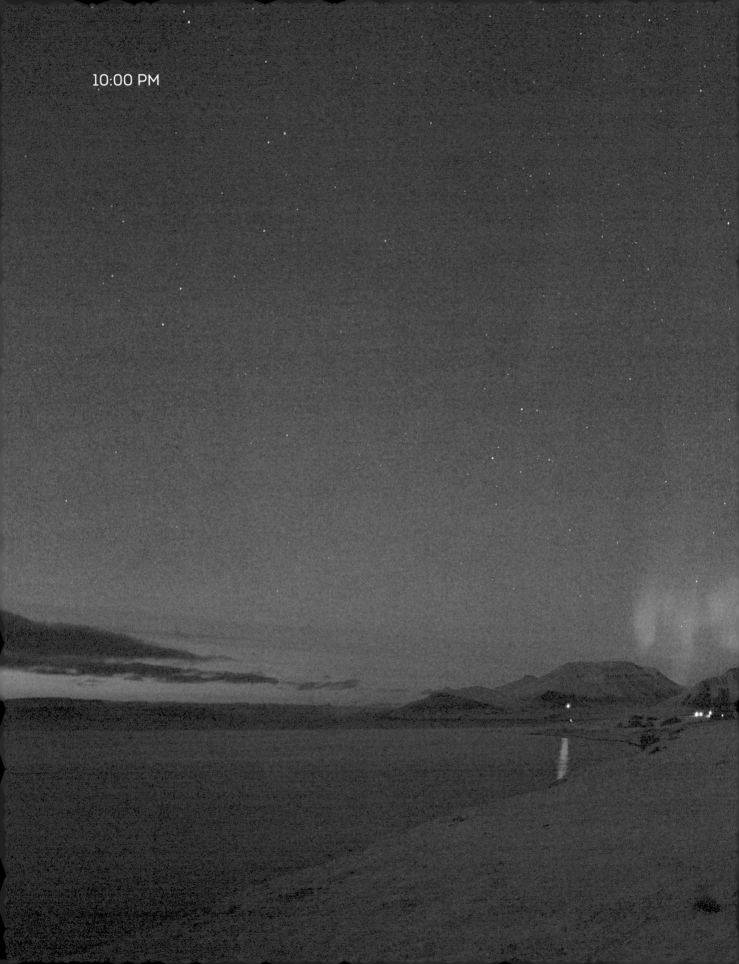

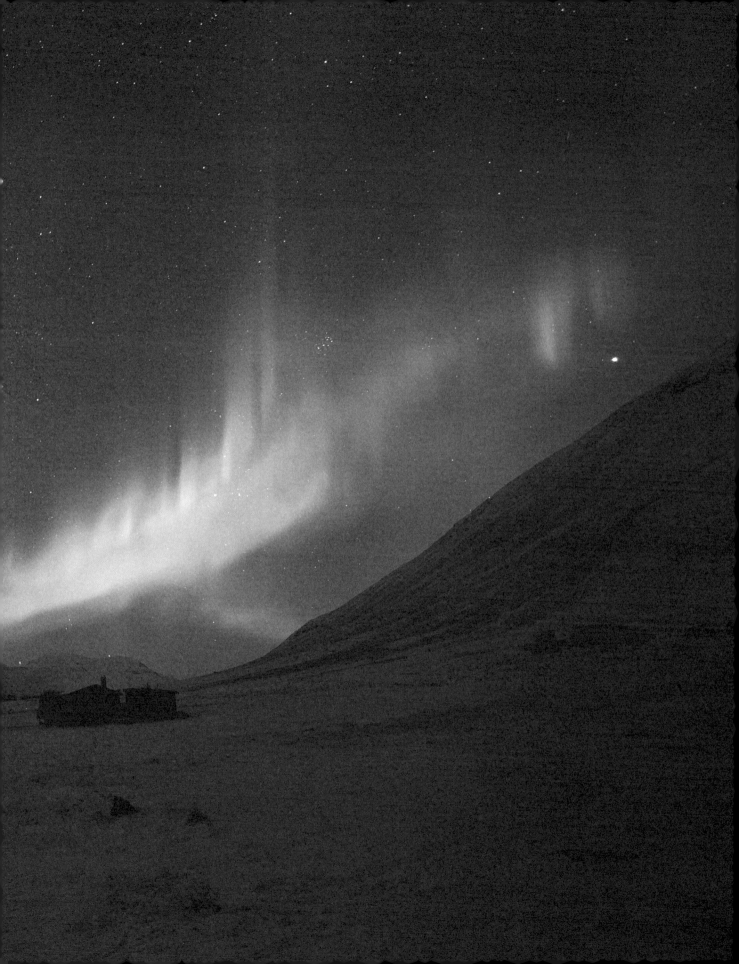

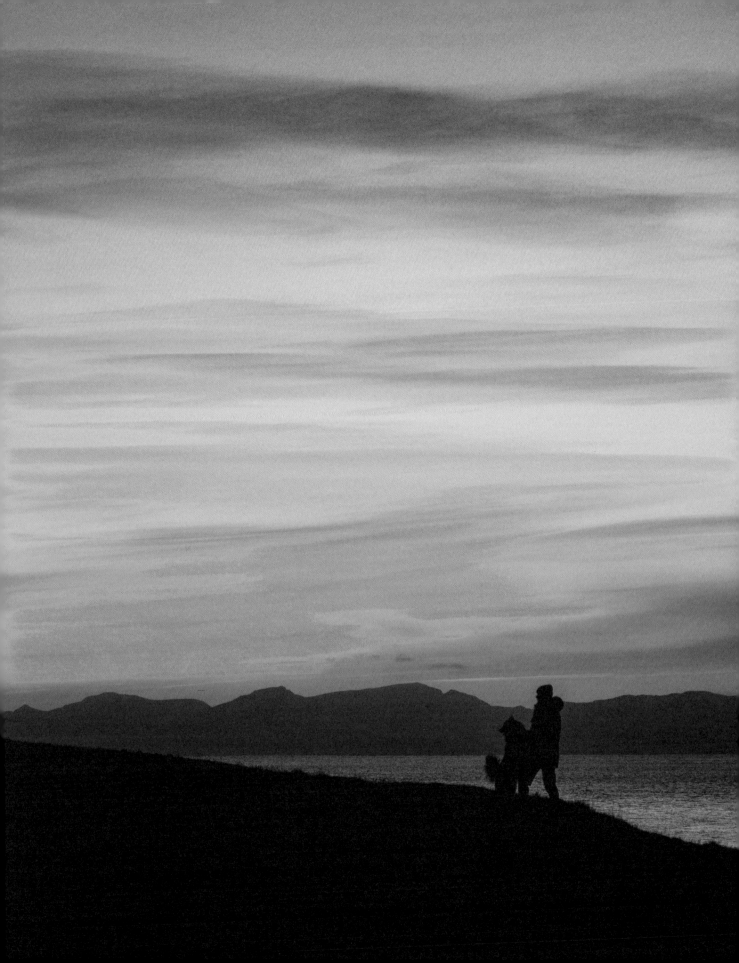

Conclusion

Now that you've turned to the last few pages of this book, you've traveled with me through the stark beauty and wild wonders of life on Svalbard. My hope is that my experiences have kindled a spark of inspiration within you, urging you to explore the uncharted territories of your own life.

Living among the extremes of the Arctic has reshaped my perspective, showing me that life's greatest adventures often lie beyond the familiar and the comfortable. From the silent darkness of polar night to the endless daylight of polar day, each season offers me a lesson in resilience and adaptability. Sometimes, we find home in the most unexpected of places.

I've particularly come to cherish the dark winter months on Svalbard. Despite the biting cold and long period of night, there's a serene beauty to be found. The untouched snowscapes, the mesmerizing views of the northern lights, and the stillness that settles over everything—these are the moments to be savored and embraced. So often, we shy away from winter's harshness, but there's so much to gain from going outside and immersing ourselves in nature, even when it seems unforgiving.

As you reflect on my experiences, I encourage you to consider your own path. What dreams lie dormant within you, wanting to be pursued? What fears are holding you back? Whether your path leads you to the frozen wilderness of the Arctic, to the bustling streets of a distant city, or just out into your own backyard, sometimes all it takes is the courage to take that first step forward.

I hope my journey serves as an encouraging example that shows how life always has the potential to be an extraordinary adventure that's just waiting for you to get out there and start exploring. May your own journey be filled with wonder, discovery, and the joy of living life to the fullest. Thank you for being here!

To conclude this book fittingly: OK, BYEEEEE.

PS: Grim says hi!

Acknowledgments

To Christoffer: Thank you for always being an ocean of calm while I somewhat chaotically navigate our lives through my newfound career. Your endless support and stability behind the scenes have been invaluable and have made this journey so much fun. You fill my life with joy and adventure. I'm so excited to see what our future holds.

To Grim: You will always be the light of my life. Having you by my side enriches my world. Your presence touches the lives of countless people across the globe. I will continue to love every moment I have with you.

To Mikaela: Your unwavering guidance, attentive listening, and genuine support are invaluable and mean more to me than words can express. Thank you for not only being a steadfast best friend, but for also stepping into the business realm alongside me as my manager. I couldn't have asked for a better teammate. Your contribution to my success, both personally and professionally, is immeasurable. With all my love and gratitude!

To Mom: You are the cornerstone of my journey. Your belief in me has been a source of strength as I've navigated life's challenges. With each decision I've had to make, you've been there to offer guidance and encouragement, making my journey brighter and more fulfilling. Thank you for consistently being my rock and for embodying not just the role of my mom, but also that of one of my most cherished friends.

To Dad: You've always been an immense source of inspiration to me. The important lessons you shared about business have been instrumental in shaping the life I lead. Your support of my aspirations has been the foundation of my growth, and I'm so grateful for the freedom you've given me to forge my own path. I'm sure the idea of me living on Svalbard wasn't exactly on your radar for my future, but your encouragement has empowered me to explore uncharted territories with confidence. Thank you.

To Alex: I'm deeply grateful for the opportunity you've provided me with and for your role in bringing this project to fruition. Your exceptional editing skills not only guided us through every phase with ease, but also infused each step with enthusiasm and excitement, even during my moments of self-doubt.

To my audience: Without your support and genuine interest in my experiences on Svalbard, none of this would be possible. Your excitement fuels my passion to share the wonders of life in the Arctic through my content. Thank you for joining me on this adventure and for being the driving force behind my creative endeavors!

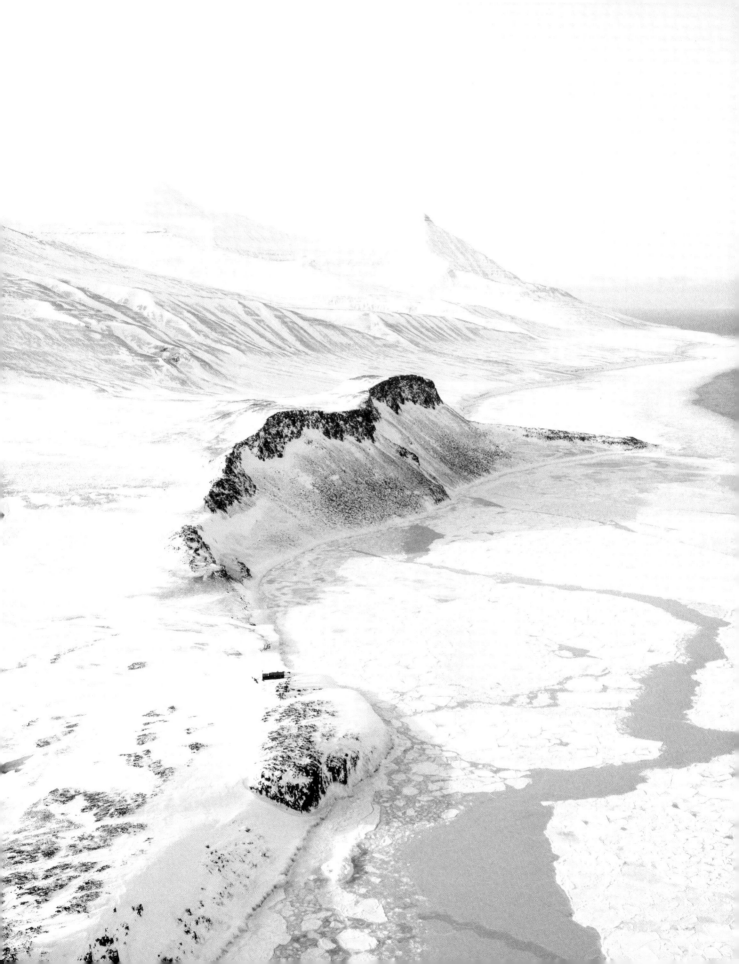

Index

Resources for More Information

Governor of Svalbard
www.sysselmesteren.no/en/

Norwegian Polar Institute
www.npolar.no/en/

Svalbard Museum
www.svalbardmuseum.no/en/knowledge

About the Author

Cecilia Blomdahl is originally from Sweden and moved to Svalbard in 2015. Her social media journey began when she started posting content online about living in an environment where polar bears rule the tundra and winter is spent in complete darkness. She has amassed more than 4 million followers across YouTube, Instagram, and TikTok. Cecilia's content focuses on daily life on Svalbard in a positive and educational way.

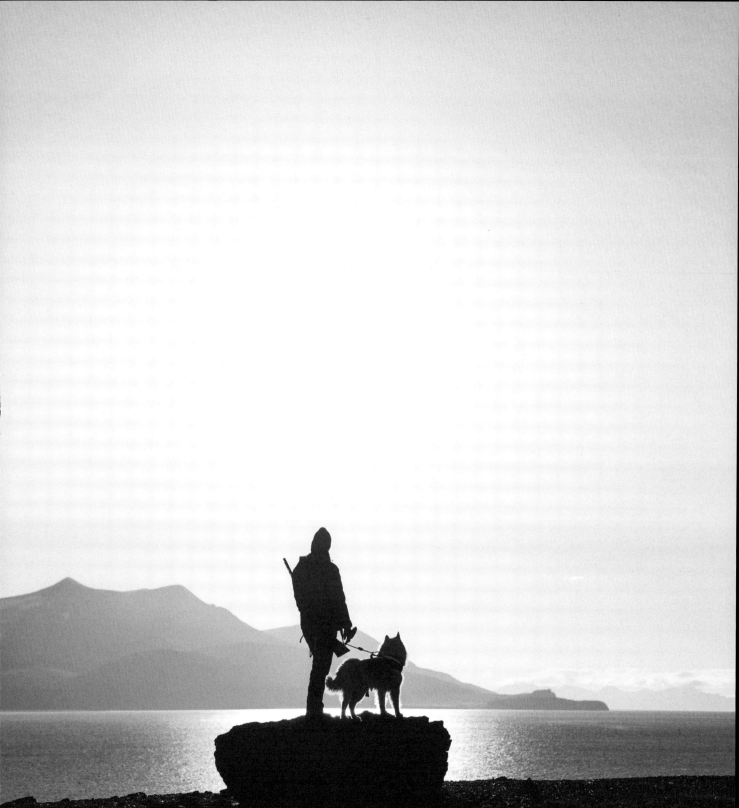

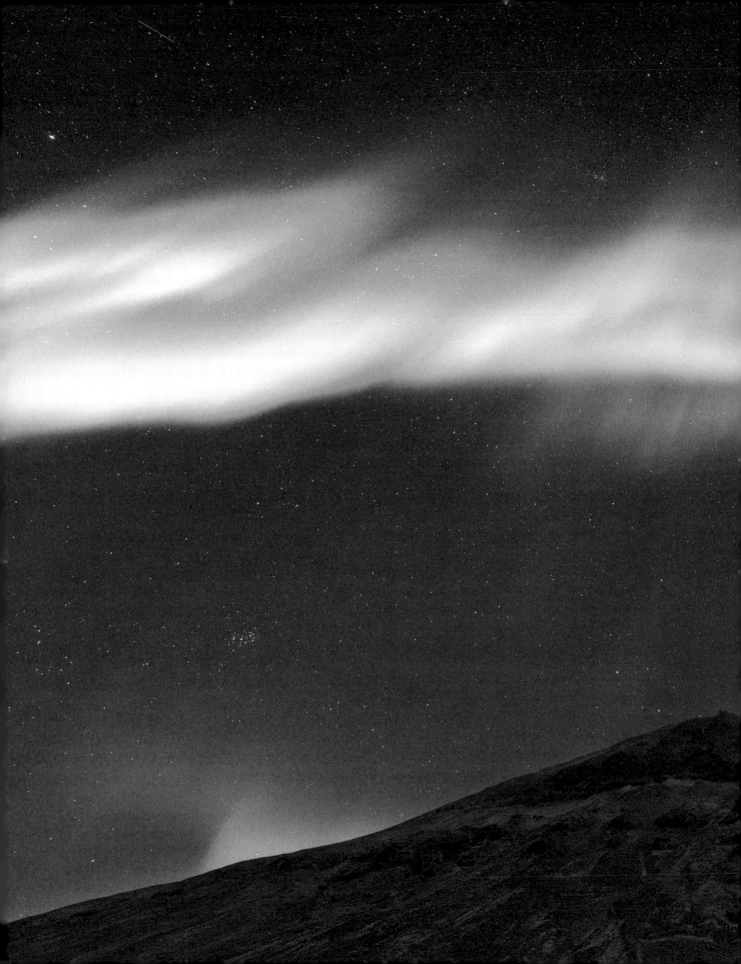